The Chicago Picasso

A Point of Departure

Patricia Balton Stratton

AMP&RSAND, INC.

Chicago · New Orleans

"An idea is a point of departure and no more. As soon as you elaborate it, it becomes transformed by thought."
Pablo Picasso

Pablo Picasso (1881–1973), in Mougins, France, 1967, with one of his studies for Civic Center Sculpture, white chalk on plywood, 39⅜ x 31^{57}/$_{64}$ inches, gift of the artist to the Art Institute of Chicago; photograph © SOM, artwork © 2017 Estate of Pablo Picasso / Artists Rights Society (ARS), New York

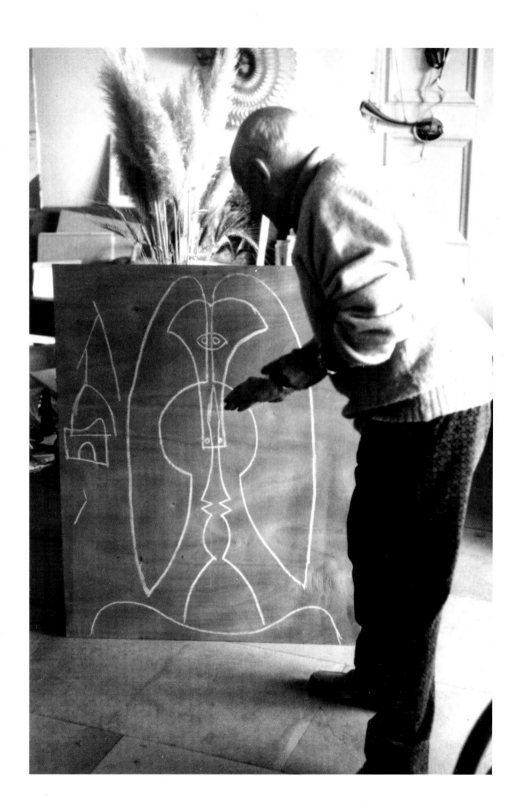

ISBN 978-099744939-6

Published by
AMPERSAND, INC.
515 Madison Street
New Orleans, Louisiana 70116

719 Clinton Place
River Forest, Illinois 60305

www.ampersandworks.com

Design
David Robson

Printed in Canada

www.chicagopicasso.com
chicagopicassobook.tumblr.com
twitter.com/ChiPicassoBook

**On the hardcover: Drawing of
Picasso maquette, front view,
1966; © SOM**

Contents

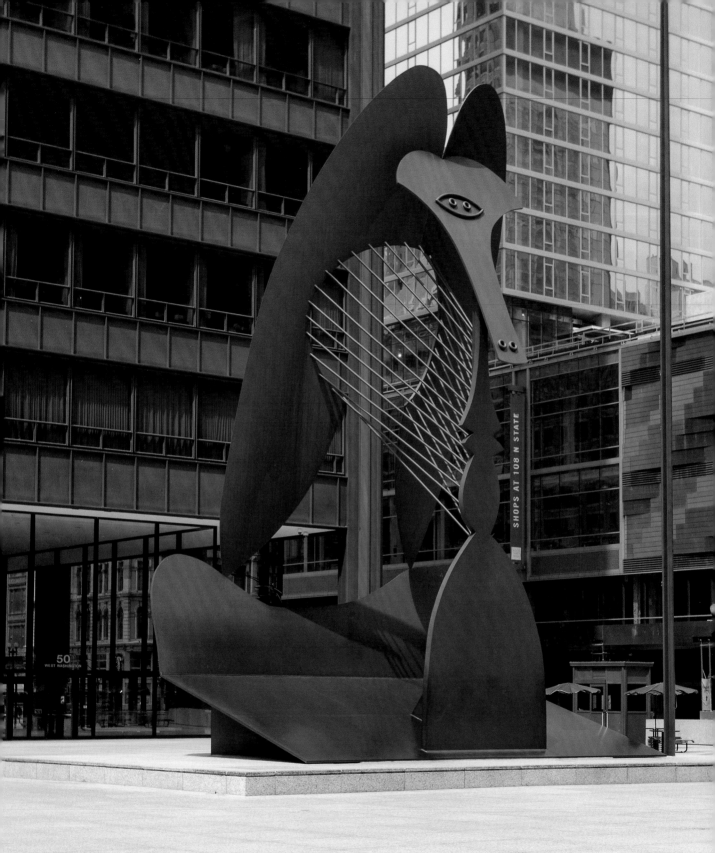

Chicago Picasso at Daley
Center, 2015; photograph by
Mike Schwartz Photography,
Chicago

Foreword

Start, if you would, at the old Dearborn Street Station at Polk Street and head north on Dearborn for an architectural history of Chicago: Printer's Row, the Old Colony with its Chicago windows, the Monadnock's masonry height, Mies's federal buildings, Skidmore's Inland Steel, and the former Brunswick Building with its structural homage to the Monadnock.

But, don't limit your tour to architecture on Dearborn. Look at the art—the Calder stabile, the Winged Victory, the Marquette lobby, the Chagall mosaics, and the Miró just west on Washington.

… And then, the Picasso!

Stop and then resume your tour by going east on Washington to Frank Gehry's Pritzker Pavilion and sinuous bridge over Columbus, Anish Kapoor's *Cloud Gate,* and Jaume Plensa's *Crown Fountain.*

Now with that context, return to the Picasso and begin your gaze at her—for a long time and see what you can see—Sylvette, Jacqueline, Afghan dog or bird, or a creature of your own imagination.

Often, we deal in results but lose the stories of how all of this happened. Patricia Stratton has brilliantly told the story of the Picasso—the artist, the architects, the civic ambition, the negotiations, the design and fabrication, the ownership, the controversy—all the elements that lie behind this most famous of all Chicago sculpture and its transformation from drawing and maquette to a monument in 162 tons of Cor-Ten steel 50 feet high.

Chicago is an outdoor art gallery—the Polish heroes along Solidarity, Lincoln seated between the Gettysburg Address and the 13th Amendment, Shakespeare in his garden, the Oldenburg *Baseball Bat* on West Madison, Linnaeus at the University of Chicago, Lorado Taft's *March of Time* at the end of the Midway, the equestrian statues of Civil War Union generals, the Agora of 106 iron sculptures in Grant Park.

Urbs in horto—City in a Garden—with sculpture.

Thank you, Patricia, for telling and preserving a great story of Chicago's iconic Picasso.

John W. McCarter Jr.
Chicago, February 2017

Unveiling of the Chicago Picasso on dedication day August 15, 1967; Mayor Richard J. Daley, at right, and William E. Hartmann, at left, pulling the cord; photograph © SOM

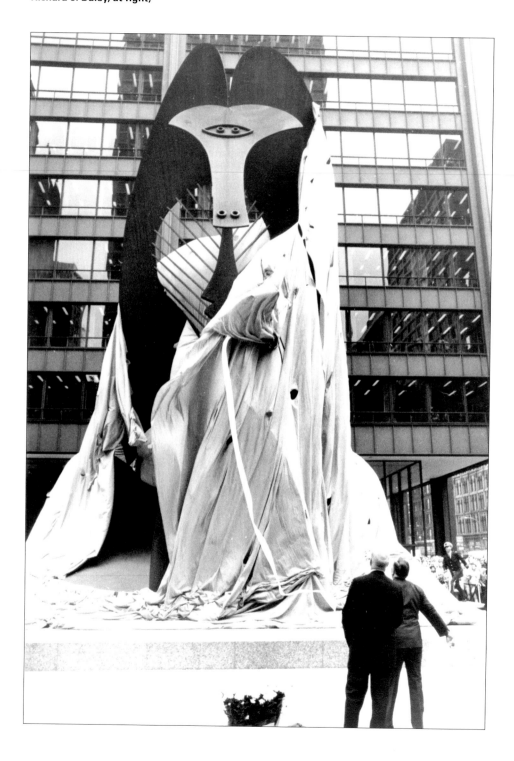

Introduction:
The Unveiling

Tuesday, August 15, 1967 was a perfect summer day, clear and warm in downtown Chicago, where thousands of people had been gathering all morning at the Civic Center Plaza, the vast open-air space at the corner of Washington and Dearborn Streets. Across town the second-place White Sox were getting ready to play the first game of a doubleheader against the Kansas City Athletics; in far-off Washington, DC, President Lyndon B. Johnson was conferring with his generals on how best to win the war that was already bitterly dividing the nation. The throngs pouring into the Civic Center Plaza that morning had other things on their minds, however, for they were there to bear witness to an undeniably historic event in Chicago's history: the unveiling of the monumental new sculpture designed by Pablo Ruiz y Picasso.

The day, which had been announced by Mayor Richard J. Daley as "Picasso Day in Chicago," began with a half-hour concert by the Chicago Symphony Orchestra, conducted by Seiji Ozawa, and included speeches and dedications by cultural leader and architect William E. Hartmann, whose persuasiveness and perseverance were responsible for acquiring the Chicago Picasso; National Council of the Arts Chairman Roger L. Stevens; Illinois Lieutenant Governor Samuel Shapiro; and Chief Circuit Court Judge John S. Boyle. Pulitzer Prize-winning poet and Chicago native Gwendolyn Brooks read a poem she had composed especially for the occasion:[1]

Does man love Art? Man visits Art, but squirms.
Art hurts. Art urges voyages —
and it is easier to stay at home,
the nice beer ready.
In common rooms
we belch, or sniff, or scratch.
Are raw.

But we must cook ourselves and style ourselves for Art, who
is a requiring courtesan.
We squirm.
We do not hug the *Mona Lisa*.
We
may touch or tolerate
an astounding fountain, or a horse-and-rider.
At most, another Lion.

Observe the tall cold of a Flower
which is as innocent and as guilty,
as meaningful and as meaningless as any
other flower in the western field.

Just before noon, Mayor Richard J. Daley took the stage to dedicate the sculpture formally. It would come to define the city's image. "I am very happy that you have come," the mayor told the assembled multitudes, "to share in the dedication of this great gift to our city by the world-renowned artist Pablo Picasso. Today, with its unveiling, it becomes a permanent part of the Chicago scene. As mayor, I dedicate this gift, in the name of the people of Chicago, confident that it will have an abiding and happy place in the city's heart."[2] The mayor then pulled the ribbon that dropped a 1,200-square-foot blue percale veil, revealing, to cheers and gasps, the 50-foot-high, 162-ton steel sculpture. In the words of *Chicago Tribune* art critic Edward Barry, "there, looming against the sky and against the glass and steel of the Civic Center, was a huge, rust-colored object calculated to baffle the mind and stir the imagination."[3] The artist's colossal head of a woman regally took command of the city's first open civic space and boldly provided a sophisticated focus to the severe granite plaza.

The unveiling of the Chicago Picasso was the culmination of a bruising, nearly decade-long dance of conception, negotiation, courtship, collaboration, and manufacturing, and the product of a public-private partnership the likes of which can hardly be imagined today. It was a triumph of creative urban planning and a testament to the ambition and persistence of a small circle of men who had the vision to enlist Pablo Picasso in a quest to give their city a peerless example of public art at its boldest and most iconic.

The story of the sculpture actually began in 1956 with the creation of the Public Building Commission of Chicago, a city agency charged with planning the design and construction of a brand-new civic center complex for expanded law courts and municipal government offices. Forward-thinking leaders in cities like Chicago were working to embrace revitalized and updated strong modern architecture in the style promoted by Ludwig Mies van der Rohe. Mies had relocated to Chicago from Germany in 1937, where he led the Illinois Institute of

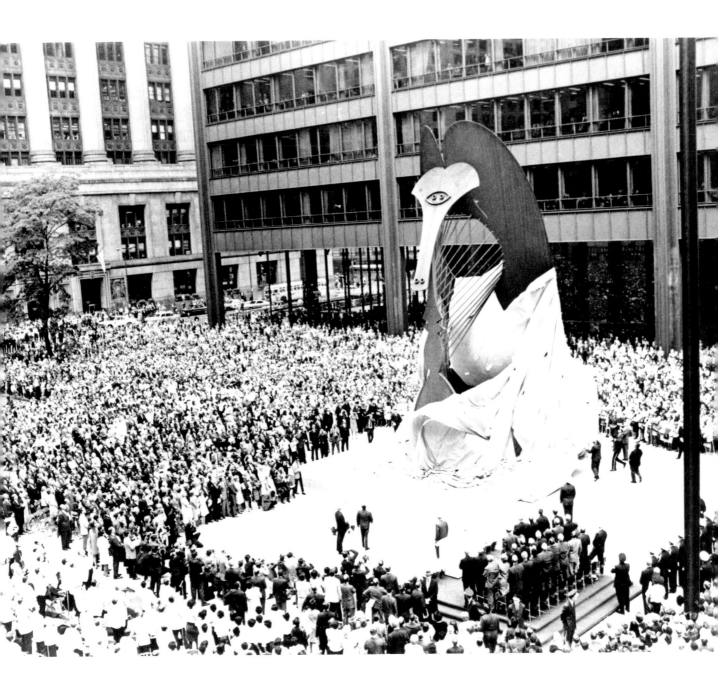

The Chicago Picasso: A Point of Departure 11

Technology for 20 years. In 1962 the city hired Charles F. Murphy Associates as the supervising architectural firm with Skidmore, Owings & Merrill (SOM), and Loebl, Schlossman, Bennett & Dart as associate architects. Jacques Brownson of C. F. Murphy, a Mies student, was the principal design architect for the Civic Center project. As construction began on the building, the joint-venture architects decided to contact Picasso about a significant sculpture for the new plaza.

William E. Hartmann emerged as leader in the effort to secure Picasso's interest and cooperation for the project. After two years of endeavor and clever courting of the elusive artist, he procured the design and maquette (or model) that Picasso donated to the city and the Art Institute of Chicago respectively. Three distinguished Chicago philanthropic foundations quickly stepped forward to fund the $300,000 estimated construction costs: Chauncey and Marion Deering McCormick Foundation, Field Foundation of Illinois, and Woods Charitable Trust.

The 41¼-inch maquette was modified for multiple structural reasons by SOM engineers and translated to heroic scale by American Bridge Division of U. S. Steel Corporation in Gary, Indiana. The Civic Center building and sculpture were fabricated of Cor-Ten steel—a trademarked name for U. S. Steel's low-alloy, high-tensile steel, a material resistant to corrosion that was just beginning to find use in large-scale construction.[4] Within a few years both had transformed from the initial orange-rust color to a deep purple-brown patina. As with a bridge, which the Chicago Picasso resembles in certain structural elements, the construction required massive amounts of densely forged and welded steel, yet retained the effect of lightness and grace with its open transparent design of steel plates and rods.

The immediate reaction of confusion and irritation—"Oh, mommy, it's terrible," one boy was quoted in the *Chicago Tribune* as saying;[5] Alderman John Hoellen said only a statue of Chicago Cubs shortstop Ernie Banks was appropriate ornamentation for the plaza[6]—did not last long. Eager to prove that they were every bit as visually and aesthetically sophisticated as their East Coast counterparts, and perhaps equally eager to shed some of Chicago's rough'n'ready reputation as an overgrown cow town, intellectuals and citizens alike soon embraced the sculpture. Some of the conversation, indeed, turned from *what* is it? to *who* is it? as speculation about the identity of the sculpture's model began to rage—a controversy that simmers to this day. And once the cultural barrier was broken by the installation of this first public abstracted figure of art, many citizens, businesses, and artists welcomed future creative endeavors for the city. The celebrated recent 2015–16 Museum of Modern Art retrospective of Picasso's sculpture continues to refine views of his achievement; the curators of the show, Ann Temkin and Anne Umland, remarked that "the sculpture in Chicago has received relatively little discussion by art historians; its significance has been read as more sociocultural than aesthetic."[7] It is my hope that this book will, in its own small way, help to advance this discussion.

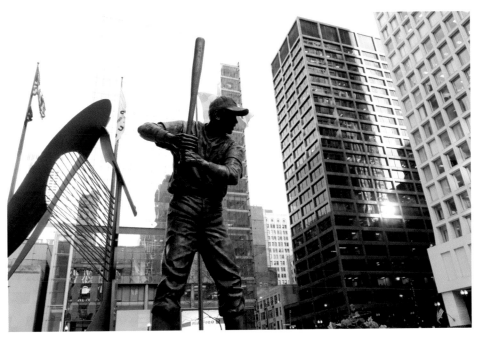

Ernie Banks statue on display at Daley Plaza, after his January 23, 2015 death; bronze, 8 feet, 2008; statue **designed by Lou Cella (1963–); Picasso sculpture to the left; photograph by Karina Wang, PhotoScapes, Chicago**

Picasso once said, "An idea is a point of departure and no more. As soon as you elaborate it, it becomes transformed by thought,"[8] a statement that gives insight into the marvelous flexibility of his mind and artistic spirit. And as it turns out, the germinal point of his sculpture became a point of departure not just for this specific monument, but also for a whole city, a city whose image and identity was indeed "transformed by thought." The Chicago Picasso proved to be a triumph for so very many: for Picasso with his dreams of monumentality, for Hartmann's indefatigability, for cooperation between art and industry, for Chicago as a new symbol, and for all the people who care to contemplate and enjoy the piece.

Patricia Balton Stratton
February 2017

Mies van der Rohe (1886–
1969); photograph by
Dirk Lohan, architect and
grandson of Mies van

der Rohe; background bust
of Mies, 1961, by Swiss artist
Hugo Weber (1918–1971)

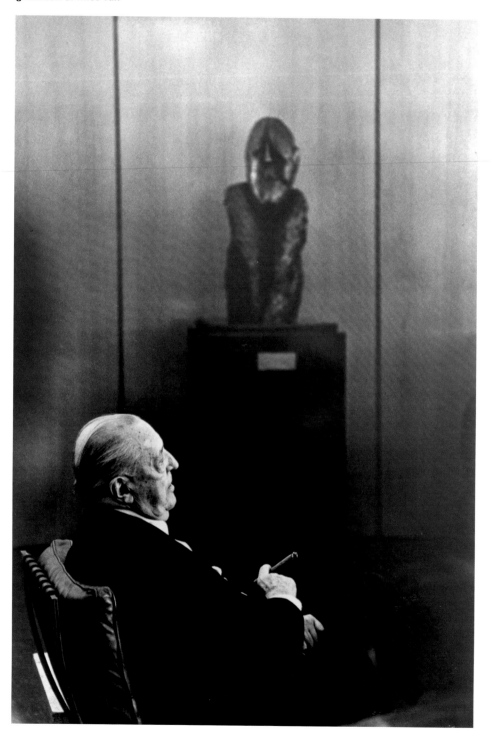

The Chicago Picasso: A Point of Departure

1. City: The Revitalization of Downtown Chicago

The story of the Chicago Picasso really begins with two powerful men who could not have been less alike: Mayor Richard J. Daley and architect Ludwig Mies van der Rohe. A born leader, a canny backroom politician and dealmaker, devout Catholic, and practitioner of an especially rough-and-tumble brand of Chicago politics, the gruff, sturdy Daley's election in 1955 would prove to be the starting point for a bold re-envisioning of downtown Chicago. The patrician, German-born Mies, in contrast, was the former director of the German Bauhaus, with its austere, programmatic intellectual dicta about aesthetics and utility in public design. Mies left Hitler's Germany in 1937 and settled in Chicago; his theories and practice, especially his famous pronouncement that "less is more," would come to define the vaunted International Style that would dominate not just Chicago architecture but urban design worldwide. Together the two men would set in motion a vision for Chicago whose culmination would be Picasso's iconic sculpture.

The complex web of highly formal principles that guided Mies van der Rohe's architectural theories were daunting even to the most cerebral of architectural theorists. The result, however, is perfectly evident: the large steel-and-glass skyscrapers built with clean, geometric lines, often around open-air plazas structured to give an impression of space and light, have come to dominate the modern urban landscape so thoroughly that it is difficult to remember how revolutionary the concept and execution both seemed in the immediate postwar years. "In Mies van der Rohe's hands," his architecture student and later associate Peter Carter observed, "the critical interaction between building function, construction, and structure, which is at the heart of architecture, frequently touched true poetic expression" via "a modern interpretation of the Greek, Roman and Gothic principle of manifest structural order."[9] The result was a "spatially varied yet conceptually unified environment" that is "restrained and humane, and one and the same time, in scale with the city."[10] In place of heavily ornamented buildings of brick and brass, Mies's aesthetic took advantage of the new technologies of reinforced steel and glass; in lieu of statues, memorials, war artifacts, and other specifically representational sculpture, abstraction became de rigeur. The Chicago scholar Franz Schulze observed, "because Miesian buildings are so abstract, Mies is actually responsible for the whole development of urban sculpture—due to the resulting need to provide relief and humanize the environment."[11]

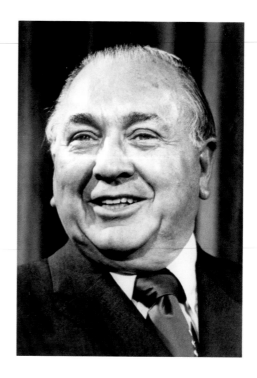

The Civic Center Plaza, as it happened, was not specifically a Mies design like the nearby Federal Plaza. However, the conception and the general approach bear out Mies's design philosophy, along with his long association with Skidmore, Owings & Merrill, Chicago's premier architecture firm and a budding international powerhouse. Indeed, Mies's student, Jacques Brownson of C. F. Murphy, the lead design architect of the building and plaza, referred to Mies as the plaza's "godfather." When some of the structural engineers and executives voiced misgivings over the Civic Center building's grand scale and huge spans, Brownson "talked the structure over with Mies who told me 'not to worry, you can make it work.'"[12] Mies's grandson, the architect Dirk Lohan, remembers the conversation, and Mies's imprimatur of the Picasso sculpture, almost identically. According to Lohan, Mies was explicit in his faith that the Picasso was a workable solution for the plaza;[13] he later reportedly said to Brownson: "I wish I had done it." Brownson:

He called me one day and asked if I would take him to see the Civic Center... I think he really respected the scale ... and (our) approach to (the) building problem. He could sense that ... there were people who were involved with that building at one time or the another (who) had been his students, almost all of them (in important roles). When he saw the building coming up out of the ground and he saw those very long spans and the detailing of the ... spandrel beams, he said that was architecture. He said you could sense it immediately.[14]

Brownson's sense that a legacy was being endorsed and a heritage passed down is acute. Mies's two decades as the director of the Center for Architecture at the Illinois Institute of Technology, as well as the success of his designs for the instantly famous Lake Shore Drive Apartments (1948–51) and the Farnsworth House in nearby Plano, Illinois (1945–51) gave him unimpeachable authority.

Intellectual authority will only get you so far in middle America, however, and it took a politician of unusual drive and ability to put the modernist stamp on downtown Chicago and pave the way for the advent of the Picasso. One of Richard J. Daley's first acts after his inauguration as mayor of Chicago on April 20, 1955 was to pass, on July 5, the Public Building Commission Act, which put in place a set of legal and financial instruments for the city to raise funds for civic renewal and construction. Just over a year later, the act's mechanisms became fact in the form of the Public Building Commission of Chicago (PBCC). In legal terms, the PBCC was a municipal corporation of the state of Illinois, formed as a governing body as part of the legislative process of democratic civic governance. In practical terms, however, it was Richard Daley's private fiefdom.

Of the 11 members of the PBCC, six were appointed by Daley, who also served as president of the commission for virtually its entire working existence. Of the other five members of the commission, two were drawn from branches of the Cook County bureaucracy and the Democratic organization of which Daley also remained president. The other three came from the Chicago Board of Education, the Parks Commission, and the Sanitary Department. The PBCC was essentially a hand-picked organization, a "shadow government operating in a clothes closet," as one alderman called it.[15] Between July 20, 1966, when final legal and funding details were being arranged for the Chicago Picasso with great secrecy, and the unveiling in August of 1967, public records indicate only four on-record meetings of the commission. Major decisions were made at private gatherings, often at one of Mayor Daley's preferred neighborhood restaurants.

To his credit, though, Daley wanted only what was best for Chicago, and knew the limits of his own expertise. As city planner and architect John D. Cordwell put it, Daley held to a "very simplistic philosophy: If it is good for Chicago, then it is good for the family and the Catholic Church. He was Chicago, first, last, all the time."[16] The men who worked on the design of the plaza were unanimous in their praise for Daley's unconditional support and open-mindedness. Years later, for example, Brownson recalled:

I knew Mayor Daley well. He was a more sensitive man than he was given credit for. Look what he was doing with building new schools, to get libraries and parks — to get it all working together for the people. He may not have understood lofty ideas about the sculpture, but he wanted the center of government to be recognized by the people in the city. No client really ever gave me cooperation like he did, and no politics entered in.[17]

Normally contrarian critic Paul Gapp concurred, writing of the mayor that, "to his credit, he listened to big league architects."[18] When Daley's henchman Colonel John "Jack" Reilly objected to the choice of Picasso owing to the artist's earlier communism—he had drawn the famous dove peace symbol for the Communist First International Peace Conference of 1949—Daley rebuked him flatly, saying "Politics we handle ourselves. Picasso is the best artist in the world and that is what we care about."[19]

The idea of a grand Renaissance-style plaza in the heart of the Loop appealed to Daley's sense of civic pride and to his tradition-minded aesthetics. In Brownson's conception, the "city's front yard … will be given over to a scenic plaza or town square—the first big one in the congested Loop. The whole effect will be somewhat similar to the main plaza in a mellowed Italian city." He continued:

This was an historic exploration. No one plaza was more influential above the others on the Civic Center design; and all had openness, light and space. Michelangelo's Campidoglio in Rome had an impact on me; and the severity and relationship of space of the Piazza del Campo, Siena, had an influence on the design here. We were interested in them collectively because of the quality of light in all of them and to convince the politicians of the need for such a plaza in principle. The one that had the most effect on Mayor Daley was the slide at St. Peter's with an old man and woman amidst the dramatic lighting of the colonnade crescent. Daley said this is what he wanted here. I was interested in the various size comparisons and most were much larger than Chicago; and I was trying to convince the mayor of the need for this kind of space which these historical plazas had.[20]

Brownson succeeded; and the decision-making and execution was, by today's standards, exceptionally efficient. The PBCC approved the Central Area Plan, calling for revitalization of Chicago's downtown, on February 10, 1960, with Daley appointing a three-firm team for the design of the plaza, which would be a collaboration among Charles F. Murphy, SOM, and Loebl, Schlossman, Bennett & Dart. The unusual arrangement seems to have been another of Daley's exercises in the shrewd calculus of ethnic prerogative: in Franz Schulze's words, "C. F. Murphy was chosen to represent the Irish Catholics, SOM the WASPs, and Loebl, Schlossman, Bennett & Dart the Jewish."[21] However unwieldy, the arrangement bore fruit with remarkable speed. On February 23, 1963, groundbreaking ceremonies for the new skyscraper that would dominate the plaza were held; after financing and construction were put in place, the topping off ceremony occurred on September 30, 1964, with the dedication of the new building—a triumph of Miesian purity and minimalism—taking place on May 2, 1966. Now all that remained was to add the humanizing touch that the plaza, however grand and austere, needed to complete its symmetry.

Chicago Civic Center
Architects, C. F. Murphy,
supervising architects,
Chicago Civic Center:
Perspective View of Plaza,
(detail) 1963; suggested
sculpture at lower left;
watercolor and gouache on
board; gift of Helmut Jahn,
The Art Institute of Chicago

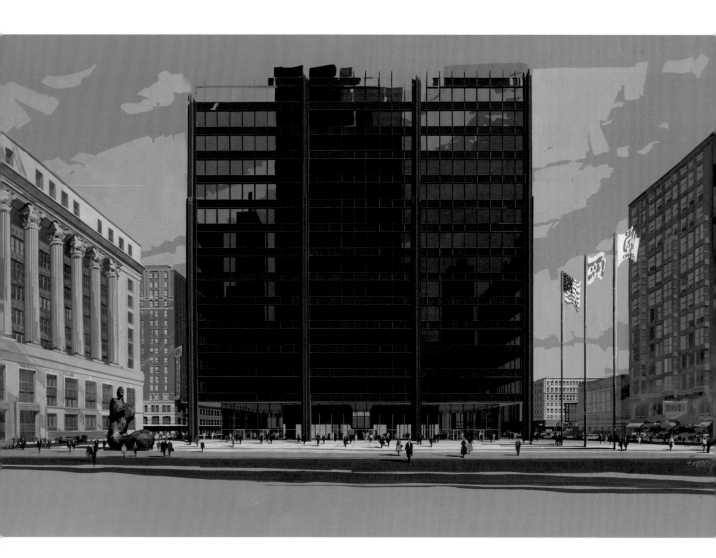

A central tenet of the Miesian dictum was a plaza or city square with a sculpture to offset the starkness of the building's design; the initial instinct was to obtain one of the famous British sculptor Henry Moore's vaguely biomorphic bronze sculptures, as had been originally considered for the Seagram Building in New York, widely esteemed the pinnacle of Miesian architecture. As late as 1961 Albert Francik's rendering of the plaza contained a prominent sketch of a large Moore-style sculpture. The deliberations, in characteristic Daley-era style, were kept private among the principal architects; nonetheless, several of them have affectionate memories of the meeting, held sometime in March 1963 at the august Chicago Club, where it was decided unanimously by secret vote to try for the man who was, at that time, possibly the best-known artist in the Western world.

And now came the hard part: how to convince Pablo Picasso that a sculpture in Chicago would be a natural next step in his career and the defining crown to his legacy. For this, they would end up relying on the charisma and gifts of one man: William E. Hartmann.

2. Courtship: William E. Hartmann, Wooing Pablo Picasso

Born in Springfield, New Jersey, the MIT-educated William E. Hartmann joined Skidmore, Owings & Merrill in 1945 after serving as a lieutenant colonel in the United States Army. Two years later he moved to the Chicago office, where he eventually became managing partner of the firm, and quickly assimilated into the complex, nuanced, and shifting web of Chicago's political and business upper class. In October 1963, just as the PBCC was beginning its reshaping of Chicago's downtown, Hartmann was appointed to the board of trustees of the Art Institute, the social Valhalla of the tight-knit Chicago elite. Tall and aristocratic, with a soft-spoken mien that belied a classic Yankee tenacity, Hartmann carved out a role for himself as the impresario who would take on the daunting work of commissioning public artworks to soften the austere affect of SOM buildings. "Leadership goes to leaders," said fellow Chicago architect Lawrence B. Perkins, "and Bill Hartmann is a leader. He is on his way somewhere and he knows where he is going, and people follow."[22] Franz Schulze seconded this assessment, describing Hartmann as "a sophisticated and persuasive man. He is a businessman-architect, not a design architect, and although he can be tough, he is smooth."[23] Hartmann's earliest triumph had been the procuring, in 1948, of artwork by Joan Miró and Alexander Calder for the Terrace Plaza Hotel in Cincinnati, Ohio.[24] So it was only natural that he was chosen to take the lead on approaching Picasso.

His first step in what was to become a half-decade-long dance of courtship, a quest requiring extraordinary patience, tact, understanding, and encouragement, was to call his friend Allan McNab, the administrative director of the Art Institute of Chicago. McNab suggested that the best way to get to Picasso would be through Sir Roland Penrose, the artist's biographer and confidante. Penrose had published the definitive biography in 1958, and over the years had gained Picasso's trust, as well as that of Picasso's wife, the Frenchwoman Jacqueline Roche.

Accordingly, McNab made the introduction by telephone, and on April 2, 1962, Hartmann followed up McNab's conversation with a letter to Penrose presenting the architects' desire for a maquette (or model) that would be enlarged to monumental size for the plaza. He suggested a meeting with Penrose, Picasso, McNab, two other joint venture architects, and himself to demonstrate the proposal. McNab and Hartmann telephoned Penrose a few days later, and

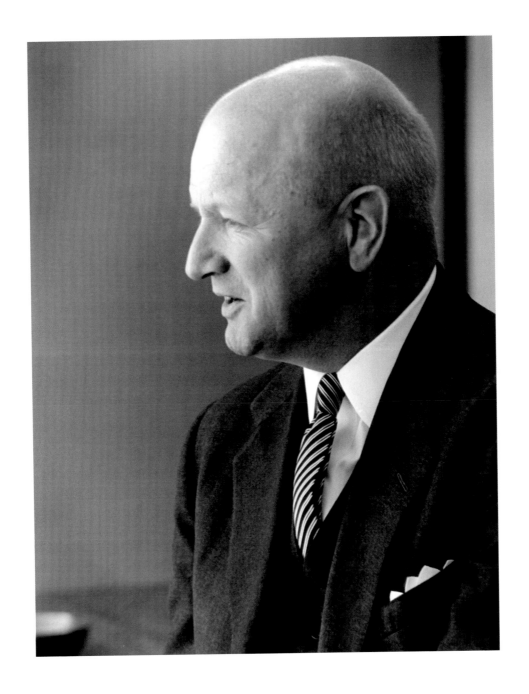

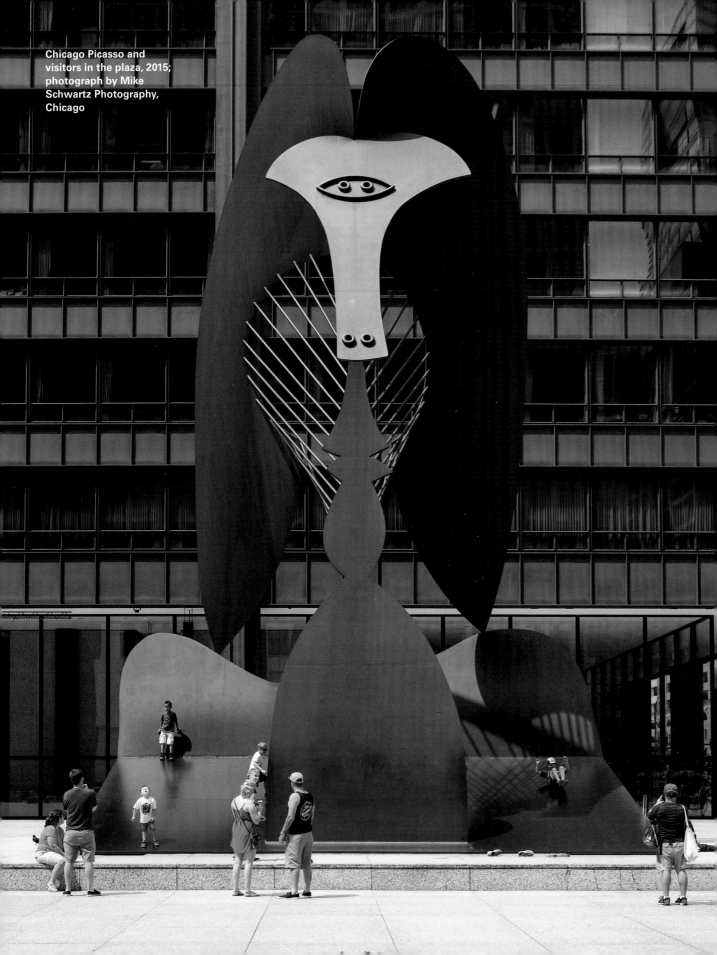

thus began the exploration, dialogue, and correspondence whereby Penrose agreed to act as intermediary on the difficult task of developing Picasso's interest. Penrose recalled:

When I was asked by William Hartmann whether I thought Picasso would be willing to make a monumental sculpture for Chicago, it seemed most unlikely that he would accept. Also, if he did, it might be a very long time before he found himself in the mood to produce something he felt was precisely the sculpture appropriate for the very imposing site for which it was intended. But the unique possibilities offered and the magnitude of the project were factors that weighed heavily in favor of the proposal and made it worth approaching him.[25]

In addition, Penrose discouraged the architects from pursuing a conventional commission-and-payment approach, and also implied his skepticism about the final result:

Picasso has given birth to so many brilliant ideas that for one reason or another have never been fully achieved that even his original acceptance would not mean that he would find his way to the final solution.... The idea of a commission in which he had promised to deliver the goods by a certain date has an inhibiting effect on him, and he will never allow himself to be drawn into an irrevocable contract, which could cause him embarrassment only equal to the disaster it would be for his clients. These considerations made me very dubious about the results.[26]

Nonetheless, Hartmann began his campaign immediately. In the fall of 1962 he drafted, in French, a three-page letter describing the nature of the central city, the new municipal building, and the functions of the plaza in regard to both business and pleasure, and concluding with a bit of unabashed flattery: as the new plaza would be "the site for the most important piece of public sculpture in the United States ... we wondered if the greatest living artist in the world, none other than yourself, might be interested in considering the problem."[27]

Picasso made no reply, but Penrose suggested that the architects should make a visit to the artist in his home in Mougins, in the south of France, in May. The result was a bit like a travel farce out of a film by Renoir or Hitchcock. C. F. Murphy Sr., his wife, and Hartmann arrived in France a few days early; meanwhile Norman Schlossman and his wife were vacationing in Yugoslavia, where Jacques Brownson located them in Dubrovnik and advised them of the impending meeting with Picasso. The Schlossmans hastened to a hotel in Antibes, connecting with the others. The little contingent was facing defeat when out of the blue, on May 20, Jacqueline telephoned Penrose that Picasso would like to see them. Finally, on Tuesday, May 21, 1963, at 2:30 p.m., the Chicago architects and Penrose arrived at Mas Notre-Dame-de Vie, where, in

the words of Schlossman, "Picasso was standing out in the driveway anxiously waiting for us."[28]

Hartmann had sent ahead a 1:600 scale model of the Civic Center site and surrounding buildings and it had been set up on a table. For this first visit all the architects had participated in assembling photographs and mementos that would help the artist understand the project, as well as the flavor of the city and its people. In addition to dozens of photographs of the mock-up and actual site and architectural drawings of the building, there were tourist brochures, a recording of the Chicago Symphony Orchestra, a special poem written by architect and project director Richard Bennett,[29] and photographs of some notable people associated with Chicago: Abraham Lincoln, Louis Sullivan, Frank Lloyd Wright, Ernest Hemingway, Mies van der Rohe, and Carl Sandburg.

Penrose was impressed with the dog and pony show: "The original presentation by William Hartmann and his colleagues was made with persuasive thoroughness. The replica of the site and the albums of large photos of the city gave a clear vision from the start of the importance and the dignity of the surroundings."[30] Hartmann related that "Picasso seemed to appreciate this human element in our presentation, and even became excited when he recognized an old acquaintance. 'My friend!' exclaimed Picasso, when he spotted the photo of Hemingway. 'I taught him everything he knew about bullfighting. Is he from Chicago?'"[31] (Hemingway was in fact from nearby Oak Park, Illinois, and had known Picasso in the 1920s via their mutual friend, Gertrude Stein.)

According to Schlossman's notes,[32] Picasso examined the model while Hartmann added buildings around the site one by one, in a miniature enactment of the plaza's construction. The facsimile of the Civic Center was painted the rusty color of Cor-Ten steel, although all the other buildings were plain white. Picasso questioned the reflecting pool in the plaza, but was informed that none of the amenities were necessary and could be changed to suit him. The artist raised questions about what the architects had in mind for size, material, and number of elements, and was reassured that these, too, were up to him. Although he had given up smoking some years before, Picasso had a cigarette lighter handy and put it in the plaza and asked "Like so?" Its scale relative to the model was about five stories high, quite near the eventual size of the sculpture.

With Penrose interpreting, Picasso suggested the possibility of a large-scale concrete work designed by him and executed by the Norwegian builder Carl Nesjar, such as those that had recently been completed in Barcelona and that would later be erected at New York University, in Greenwich Village. This posed a delicate problem for Hartmann and his contingent, who wanted an original sculpture, not a warmed-over leftover or collaboration, and who preferred the more lasting and grand medium of metal. Penrose:

Picasso proposed that they should make an enlargement of a previous sculpture from 1928, which would indeed have looked magnificent against the background of the enormous glass-fronted walls of the new courts being built. [33]

But the Civic Center architects wouldn't be fobbed off by offers of existing sculpture, no matter how appealing.[34] Hartmann rejected the idea of concrete as being not durable enough to withstand the harsh Chicago winters, possibly by way of steering Picasso away from the idea, as the Nesjar-built 1968 *Bust of Sylvette* in Greenwich Village has endured the equally problematic New York winters just fine. Whatever the reasoning, Picasso seemed to understand and responded with alternative ideas for metal sculpture: bronze, metal sheets, rods, and wire—all materials with which he had worked. He later took the architects on a studio tour and pointed out works executed in various media and sizes, as well as the advantages and disadvantages of some of them for Chicago.

By the end of the visit, Picasso seemed hooked on the idea of constructing a sculpture for Chicago. As Schlossman recalled, "After a while it seemed he was trying to sell us as much as we were trying to sell him."[35] The success of the initial visit was confirmed three weeks later in a letter from Roland Penrose: The artist was working hard and was going to proceed with a monument for Marseille with Nesjar, which Penrose interpreted as a good sign, and related his (now often-quoted) remark: "You know I never accept commissions to do any sort of work, but in this case I am involved in projects for the two great gangster cities."[36]

Now began the waiting. Hartmann continued to send Picasso, by way of Penrose, letters and photos, hoping to keep the Chicago project at the forefront of his mind, but there was no formal word of any progress. Meanwhile, on the home front the Chicagoans were becoming anxious and had only Hartmann's reassurance to keep them in abeyance. At the November meeting of the Graham Foundation the architectural and business leaders formally voted to keep waiting for Picasso, even though they were getting impatient. Penrose understood their anxiety; in a letter of January 12, 1964 he told the artist that the Chicagoans needed to see sketches by March of that year and something even more tangible, such as a maquette, by May.[37] In response Picasso promptly created a series of pencil sketches and three ink drawings, all dated January 1964; the sketches showed an anthropomorphic head, with cubist-inflected eyes and a mouth, rearing up in graceful, steeply angled planes. The result was immediately identifiable as Picassoan modernism at its most distinctive.

On March 5, Penrose sent a telegram to Hartmann that he had seen two maquettes that Picasso indicated he had planned for Chicago—an immense step forward, as the sculpture now had a tangible form for evolution and refinement. The master's mind and hand were beginning to bear fruit. On March 20 Penrose followed up with a letter that Picasso was enthusiastic for a spring

meeting, which was duly scheduled for May 1—almost a year since the initial visit.

The trip turned out to be frustrating, but in the end, productive. Hartmann:

Penrose phoned [Picasso] and then told our entourage, shall we say, that Picasso was not there. So we tried the next day and got the same message. This went on for about a week. Gradually, one by one, the participants began to disappear, leaving only Penrose and me. He had some other business in Paris and I had a mission to meet with Miró in Mallorca. We said we'd do those things and come back and try again in three days. In the meantime we talked to people who might know where Picasso was hiding. It was very puzzling.[38]

Hartmann and Penrose were on the verge of leaving France when they tried one last time to call from the Nice airport:

Picasso came on the line and said, "Where are you? Where have you been? Come on up immediately!" This was after about ten days of trying to see him.

As it turned out, Picasso had been thrown into turmoil by the recent 1964 publication of his ex-lover Françoise Gilot's memoir *My Life With Picasso*. He had sued, unsuccessfully, to prevent publication, and it occasioned a difficult breach with his children, Claude and Paloma, whom he never saw again after their 1963 Christmas visit. Gilot was bitter about being replaced by Jacqueline and retaliated by publishing details about her private life with Picasso.

Regardless of the reason, the wait was worthwhile. The maquettes, in Hartmann's words, "showed a brilliant conception of the problem, and we were more hopeful than ever that he would have an ultimate solution."[39] It had become clear that one of the two was destined for Chicago, but which one? Penrose surmised: "Nothing was certain. Picasso insisted he might want to alter it and demanded an unlimited period to contemplate what he had done. He seemed particularly uncertain about the base, and also, about the scale in relation to people moving around it, and with the immense vertical cliff of the skyscraper as its background."[40]

The first phase of the courtship had been consummated, but Hartmann would have to wait over two years before claiming the final prize, long enough to raise doubt about the future of the project. In April 1965, for example, Hartmann reluctantly "had to agree that if nothing was resolved this year, we might have to look elsewhere for a solution. When I first saw Picasso in the latter part of April, he told me that he was not yet fully satisfied, and that this was necessary, of course, before he could let the design go."[41]

In the meantime the architect patiently continued his visits, his pursuit, his gifts of souvenirs and photos and artifacts. Picasso's almost childlike love of

Picasso with Sioux Indian
bonnet, 1964, gift of
William E. Hartmann at left;
unidentified friend at right;
photograph © SOM

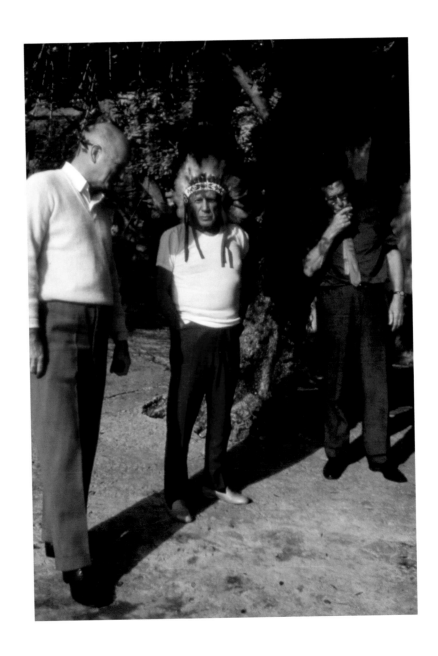

costumes and props has indeed become part of the lore surrounding the sculpture's gestation. As Picasso's friend, the photographer Lucien Clergue, put it, "it was important to take something with you in your hands when you went to see him. He wanted something to exchange, to talk about. He didn't travel much and he wanted to see what you had brought."[42] Picasso "enjoyed the stimulus of odd things," agreed Hartmann, who brought him, over the years, a Sioux Indian War bonnet, a Chicago White Sox blazer, a Chicago Cubs cap, a Chicago Bears helmet, and a Chicago fireman's helmet. Picasso "proudly displayed these artifacts," Hartmann said, "but the baseball mementos baffled him. He could not understand why Chicago named one of its teams after their stockings."[43]

Hartmann knew that while Picasso had traveled within Europe as a young man, including his famously formational years in bohemian Paris and his time in London designing sets for the Ballets Russes, by this time in his life he had foregone travel. A curious and lively intellect, Picasso enjoyed it when Hartmann and other guests brought him mementos and artifacts from faraway lands—a colorful part of the wooing process that Hartmann played with brio.

However, it is not surprising that Picasso never visited the United States. Chicago residents and visitors alike still ask if the artist oversaw the building here, or attended the unveiling ceremonies, but he never ventured beyond Europe and even that was very limited. It was Hartmann and the Civic Center architectural associates who brought the city of Chicago alive in Picasso's mind and reignited his interest in monumentality. That the monument was designed and executed at a distance of over 4,000 miles, an ocean and continent away, testifies to Hartmann's skillful mediation and to the dedication and intelligence of the men who designed and built the sculpture.

Hartmann was able to recall vividly that happy climax in May 1965 when Picasso chose the maquette for Chicago. Both maquettes measured approximately 41 inches high, but there the similarities stopped. One was heavier, more industrial looking, with a bullish strength; the second was lighter, airier, with a more graceful profile. After extensive deliberation, Picasso chose the second one for Chicago, and Hartmann immediately had it packed and shipped to SOM.

It was not until late the following year, however, after many more visits, that Picasso approved the details and placement of the sculpture's final form. On August 8, 1966, Hartmann arrived in Mougins with his typical gifts—this time, a straw hat and an English fishmonger's apron—along with documents regarding necessary structural modifications for the sculpture and the photomontages for the final site location. The following day, Picasso gave his final approval to all the changes by signing the photographs of the aluminum model and site with "*Bon à tirer* (good to go) Picasso, 9/8/66."

After lunch Hartmann delicately broached the financial situation:

Aluminum model designed by Fred Lo, 41¼ inches, held by J. D. Rollins, president of U. S. Steel American Bridge Division, William E. Hartmann of SOM, and Robert W. Christensen, executive director of Chicago Public Building Commission; executed by Richard Rush Studio, Chicago, 1966; photograph by Hube Henry © Hedrich Blessing, courtesy of SOM

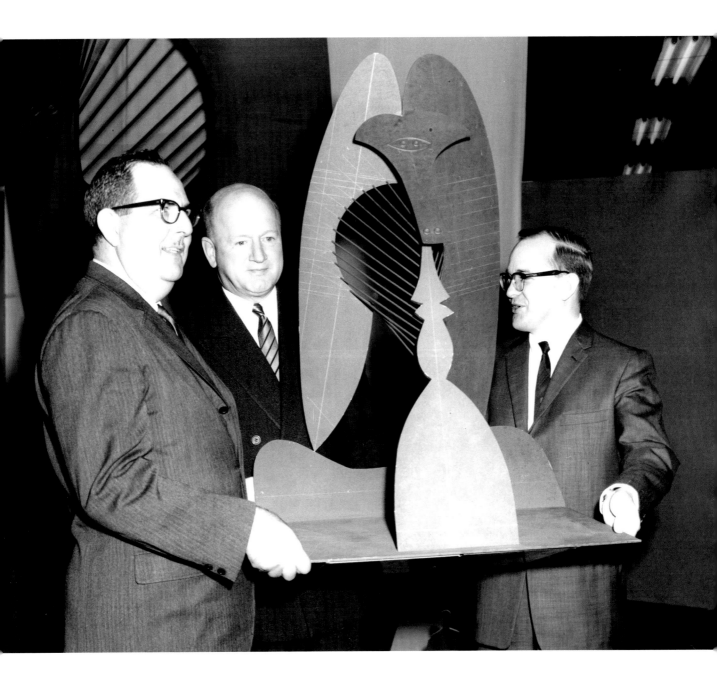

I said, "Pablo, there is not enough money in the world to pay you for what you have done. Everything is all organized, and I have here a small token from the people of Chicago which we'd like to offer." And I gave him the check (for $100,000, authorized by the PBCC and Mayor Daley). He looked at this check; he studied it for a minute and said, "No." He was a marvelous character — and I fell through the floor because I felt he could ask [instead] for a million dollars. Then he went on to say, "No, I want this to be your gift, to be my gift to the Chicago people."[44]

The gesture of extraordinary generosity presented one final hurdle, though, for Picasso refused to sign the document, drafted as a bill of sale, turning over copyright ownership of the sculpture to the PBCC, a decision that was to have far-reaching consequences. Hartmann returned to Chicago and had a new document drafted by lawyers at the PBCC and SOM—a so-called "deed of gift." Hartmann returned to Mougins and Picasso signed the new deed on August 21, 1966. His wife, Jacqueline, and longtime friend and author, Hélène Parmelin Pignon, each signed the document as witnesses. Hartmann had four copies signed: one for Picasso, one for the PBCC, one for Mayor Daley, and one for himself as a souvenir of his arduous adventure. It was a well-earned token; as Clergue said, "Picasso made his gift to Chicago because of the person involved—Bill Hartmann."[45]

Opposite: Pablo Picasso signed Deed of Gift, August 21, 1966; photograph © SOM

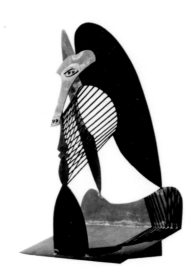

THE MONUMENTAL SCULPTURE PORTRAYED BY THE MAQUETTE PICTURED ABOVE HAS BEEN EXPRESSLY CREATED BY ME, PABLO PICASSO, FOR INSTALLA-TION ON THE PLAZA OF THE CIVIC CENTER IN THE CITY OF CHICAGO, STATE OF ILLINOIS, UNITED STATES OF AMERICA. THIS SCULPTURE WAS UNDER-TAKEN BY ME FOR THE PUBLIC BUILDING COMMISSION OF CHICAGO AT THE REQUEST OF WILLIAM E. HARTMANN, ACTING ON BEHALF OF THE CHICAGO CIVIC CENTER ARCHITECTS. I HEREBY GIVE THIS WORK AND THE RIGHT TO REPRODUCE IT TO THE PUBLIC BUILDING COMMISSION, AND I GIVE THE MAQUETTE TO THE ART INSTITUTE OF CHICAGO, DESIRING THAT THESE GIFTS SHALL, THROUGH THEM, BELONG TO THE PEOPLE OF CHICAGO.

LA SCULPTURE MONUMENTALE REPRÉSENTÉE DANS LA MAQUETTE MONTRÉE CI-DESSUS FUT CRÉÉE PAR MOI, PABLO PICASSO, EXPRESSÉMENT POUR ÊTRE INSTALLÉE DANS LA PLACE DU CENTRE CIVIQUE DE LA VILLE DE CHICAGO, ETAT D'ILLINOIS, ETATS-UNIS D'AMÉRIQUE. CETTE SCULPTURE FUT ENTREPRISE PAR MOI POUR LA COMMISSION DES EDIFICES PUBLICS DE CHICAGO À L'INSTANCE DE WILLIAM E. HARTMANN, AGISSANT AU NOM DES ARCHITECTES DU CENTRE CIVIQUE DE CHICAGO. PAR CES PRÉSENTES JE FAIS DON DE CETTE OEUVRE ET DES DROITS DE LA REPRODUIRE À LA COMMISSION DES EDIFICES PUBLICS, ET JE DONNE LA MAQUETTE À L'INSTITUT D'ART DE CHICAGO, DANS LE DÉSIR QUE CES DONS, PAR LEUR INTERMÉDIAIRE, PUISSENT APPARTENIR AUX CITOYENS DE LA VILLE DE CHICAGO.

SIGNED AT _Mougins A.M_ THE _21_ DAY OF _Aout_ 1966.
SIGNÉ À LE JOUR DE

France

Picasso

PABLO PICASSO

WITNESSES: _H. Brzrus_
TÉMOINS:

Jacqueline

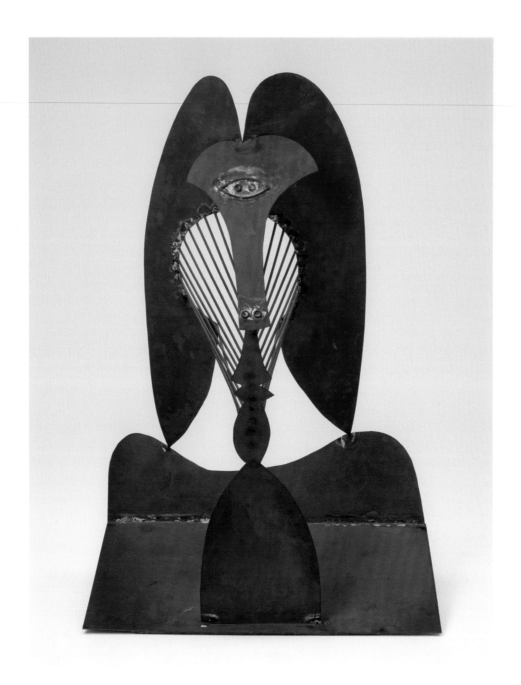

3. Maquette: Evolution of an Icon

The maquette that Picasso produced for Chicago was a product of decades of evolution in motifs and visual elements that were a central part of his artistic identity. With its fractured assemblage of planes, rods, and anthropomorphic facial features, it is a virtual catalogue of cubist effects, a physical manifestation of modernist principles. There have been many artists who were both painters and sculptors, but in Picasso the interplay of ideas and techniques between the two media was especially fruitful. The elements that dominate the Chicago Picasso can be traced to paintings he did years, even decades, before. The sense of unity and play that pervade his career is positively symphonic: that of a maestro composing a many-faceted cathedral of art.

The cubist idea of simultaneity, of combining several physically impossible perspectives in order to reflect a higher reality, or an inner essence, is possibly Picasso's most radical legacy to the history of artistic theory. By 1967 it had become so foundational an idea in the discourse of modernism that it is difficult, at times, to remember how brilliantly the Chicago sculpture expresses this fundamental idea. The idea of a three-dimensional expression of the cubist principles so strikingly illustrated in his favorite paintings was part of Picasso's vision from very early on, including such pieces as a bronze *Head of a Woman (Fernande)* in 1909 and the sheet-metal-and-wire assemblage *The Guitar*, from 1912—the latter, in the words of art critic Robert Smith, "initiates modern sculpture by establishing space itself—hollowness, volume, weightlessness—as one of its primary materials."[46] The maquette for the Chicago sculpture offered, as all sculpture does, multiple views: the frontal face, the profile, visible at a 45 degree angle from either side, and the outline of a head, visible from the rear, resoundingly passing what critic Peter Schjeldahl once called "the essential test that they function in the round."[47] The planar shapes and metal rods enclose a center void, and this transparency enables the observer to see multiple views of the sculpture and its surroundings simultaneously. The "radical transparency and openness of these assemblages," the critic Barry Schwabsky wrote, resulted in sculptures "that, for the first time in Western art, had interiors you could look into and through."[48] On a monumental scale, Penrose foresaw "a noble and severe monument composed of solid forms and the void."[49]

The influence of African masks, which exploded off the canvas in his seminal painting *Les Demoiselles d'Avignon,* from 1907, was another of the elements

of the Chicago Picasso that were visible in his painting from very early in his career. Like his peers Henri Matisse and Gertrude Stein, Picasso became entranced with African reliquaries, including tribal masks, in the early part of the century, having first seen them at the legendary exhibitions at the Musée d'Ethnographie du Trocadéro in Paris. African folk art had a primitive power and expressiveness that appealed to many in the Parisian avant-garde of the time, especially when contrasted with the fussy dictates and emphasis on pure technique favored by the academy. French poet Max Jacob wrote, after a visit to Gertrude Stein's Paris apartment, circa 1904, "Matisse took a black wood statuette off a table and handed it to Picasso, who held it all evening. The next morning when I came to visit his studio the floor was strewn with sheets of drawing paper. Each sheet had virtually the same drawing.… A big woman's face with a single eye, a nose too long that merged into the mouth."[50]

The exaggerated flatness of the masks was also consonant with the aesthetic strategies of cubism, wherein contours and spheres are flattened into planes and then reassembled in new configurations, emphasizing the flexibility in perception while also carrying a sensation of exoticism, of the unknown other. "Picasso believed in the power of art to reinstate the power of sorcery," the Seattle Art Museum curator Pam McClusky wrote in 2011, "to disrupt our lives and change our behavior; all things African art was believed to do."[51] To have this striking motif dominate a sculpture built six decades later in a faraway American city is testament to the transformative power of Picasso's visual imagination, his sense of being able to borrow freely from the vocabulary of other cultures and in doing so, make something new.

In the famous *Les Demoiselles d'Avignon*, African masks actually replace two of the prostitutes' heads on the right side. Picasso's reference to Avignon is not the beautiful French city in Provence, but a narrow street in Barcelona that had a long history of houses and women of ill repute.

In the 1920s Picasso teamed with the young fellow Catalan/Spanish metalworker Julio González for a series of experimental sculptures executed in bronze and iron—a kind of dry run for the Chicago process nearly 40 years later. The work with González and his interest in the possibilities of the new media led by stages to the formative event of this period: the abortive attempt of a monument commission commemorating Picasso's friend and fellow modernist, the poet Guillaume Apollinaire, who had been wounded in France in 1916, and who had died in Paris in 1918.

When the Paris Municipal Council approached Picasso about a monumental sculpture to honor Apollinaire, the artist was initially enthusiastic, so long as he was allowed complete artistic freedom: "Either I do the job that way or you get someone else. If you want me, I'm going to do something that corresponds to the monument described in *Le Poète Assassiné*, that is, a space with a void, of a certain height, covered with a stone."[52] The negotiations quickly went south

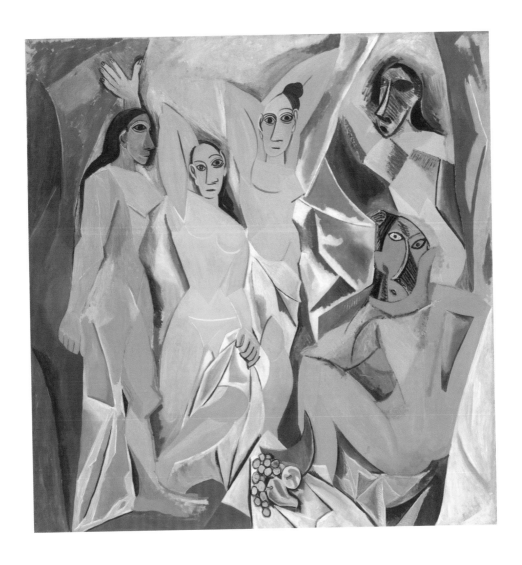

Pablo Picasso, *Les Demoiselles d'Avignon*, 1907; oil on canvas, 96 x 92 inches; acquired through the Lillie P. Bliss Bequest; photograph courtesy of MoMA; artwork © 2017 Estate of Pablo Picasso / Artists Rights Society (ARS), New York; photograph © The Museum of Modern Art / licensed by SCALA / Art Resource, New York

and ended up in a prolonged limbo of mutual distrust and antagonism; the city of Paris was not interested in Picasso's abstractions and open forms, preferring something more traditional.

Years later, Picasso ended up donating a bronze *Head of Dora Maar*, from 1941, which was installed in 1959 at an alternate location behind a small chapel in the Latin Quarter; a most anticlimactic conclusion to a quarter-century of squabbling and unsuccessful compromise. The fallout from the unhappy experience was to have a formative effect on the future of the Chicago Picasso. For one, it made Picasso cautious of accepting commissions of any kind, or of allowing himself to be drawn into a situation where he had less than perfect freedom. For another, it planted the seed in his mind of a large sculptural monument for a city square, a desire that would remain unfulfilled until Picasso was approached by Hartmann and the Chicagoans.

In the meantime, Picasso and González produced a series of wire-construction maquettes for this memorial. In 1962 Picasso authorized an intermediate enlargement, which was eventually installed for display in the courtyard at MoMA in 1972. The maquette for the Apollinaire memorial comprises an open cage work with a round head superimposed on it, an innovation of transparent sculpture—drawn in space with linear iron rods—which had real volume, but did not occupy a solid defined area or mass. In the words of the critic Peter Schjeldahl, "the wonder of the works (done with González) is their appearance from other angles: the image pulled apart, accordion fashion, to drink in the ambient air … emptiness becomes substance."[53] In the past, Picasso had shown many planes of an object; with the wire constructions he represented only the linear edges of the planes, while using these edges almost as a form of three-dimensional drafting. Penrose described these works as

space enclosed by lines and the three-dimensional form they draw in the air is based on a human figure surrounded by planes that create walls or windows around it. A central, transparent void form is enclosed by its transparent environment, giving an architectural homogeneity that would be impossible to create in any other way. Together, these works give us an idea of close association between drawing and sculpture in Picasso's mind.[54]

Similarly, the 1928 ink *Studies for a Metal Sculpture* and the finalized small bronze have evolutionary importance for the Chicago Picasso. In addition to the echoes from African masks and the stylized likenesses of hair, there are parallels in the linear form, the shape of the eye, and the stylization and placement of the facial features in a long central strip.

Simultaneously in his paintings, Picasso was expressing his fascination with monumentality. This is well evidenced in massive beach bathers of this period and in *Abstraction: Background with Blue Cloudy Sky* in the collection

Pablo Picasso, *Figure (Project for a Monument for Apollinaire)*, 1928; iron sculpture, 39 inches high; gift of the artist's estate; photograph courtesy of Musée Picasso, Paris; artwork © 2017 Estate of Pablo Picasso / Artists Rights Society (ARS), New York; photograph by Béatrice Hatala © RMN-Grand Palais / Art Resource, New York

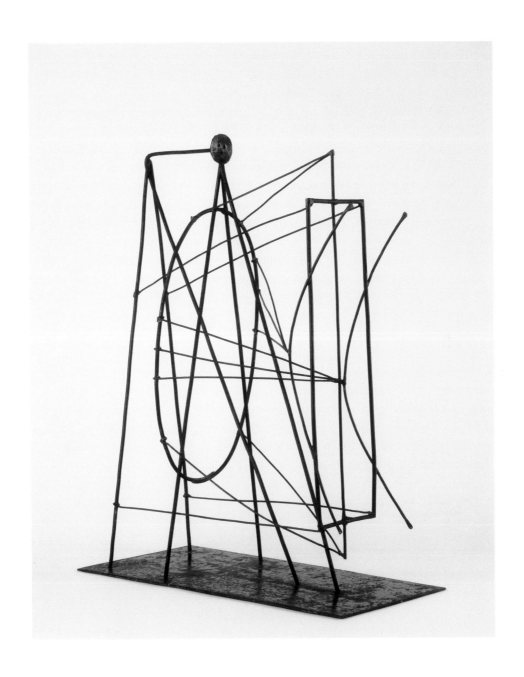

of the Art Institute of Chicago. These late-1920s to early-1930s figures are very sculptural in concept, shading, and modeling. Even some of the facial features have clear similarities to the Chicago Picasso sculpture.

The next stage in the progression of Picasso's sculpture with a thread of connection to the future Chicago piece did not occur until 1954. In that year, Picasso began working with sheet-metal sculptures that could be cut, folded, and assembled, another iteration in his endless quest to explore ideas of perspective and simultaneity in three dimensions, and one that represents a direct precursor to the Chicago Picasso. These sculptures were originally

born from childhood games when he enjoyed amusing his sister by taking paper and scissors and cutting out animals with amazing speed and dexterity ... The immediate pleasure he gives to his friends by his skill in transforming a torn piece of paper tablecloth into an animal, a face, or whatever his fancy dictates has continued, increased by his ability to translate the ephemeral delight of a game into a more-permanent medium with added significance.[55]

The results combined the two-dimensional qualities of drawing and painting, the three-dimensionality of folded sheet metal cut-outs, and the transparent space between the planes. The rhythmic sweep of the curvilinear shapes in simple outline and the subtle contrast of light and shade gave these sculptures and the Chicago Picasso appearances of both complexity and visual richness. These sheet-metal sculptures enabled the artist to present many variations within one motif, and he repeatedly produced heads of his model, Sylvette David, in 1954, and of his then-future wife Jacqueline Roche thereafter.

In 1960 Picasso visited the metalworking factory of Lionel Prejger in Cannes. Impressed by the speed and flexibility of this new medium, Picasso ended up producing more than 120 sculptures with Prejger. The process also contributed to one of Picasso's most famous statements about cubism. Prejger related that Picasso presented him with

a large flat piece of brown paper that looked like an octopus with immobilized tentacles. "It is a chair," Picasso told me "and you can see there an explanation of cubism. Imagine that it is a chair put through a steam roller." After cutting along the charcoal marks he had already drawn, he folds and cuts the paper. The paper is alive.[56]

Once again, the artist conceived a new solution to his continual problem of thorough perception of an object. The result combines the two-dimensional qualities of drawing, the three-dimensionality of bent sheet-metal planes, and the transparent space between the flat surfaces. In these pieces there is a recurrence of favorite themes from throughout his career: birds, animals, a

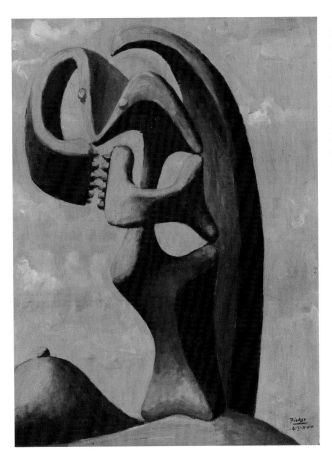

man with a lamb, clowns, heads and figures of women. Within these familiar motifs he varied and paraphrased earlier shapes and subjects, rarely satisfied with a single answer, but pursuing instead a series of solutions for the same theme, which differed only in details. In most of the metal sculptures titled "Woman's Head," the planes for each side meet at a line in the middle, but in two thicker-looking heads, Picasso introduced the motif of a central strip that contains the profile as well as the forehead, eyes, nose, and chin. The 1962 *Head of a Woman (Tete de Femme)*—the sculpture that is most easily identified as the Chicago Picasso's immediate predecessor—features for the first time a flat central strip—the "snout"—with a Cyclopean central eye and ribs of steel or solder rods serving as hair. The facial features and individual strands of hair are applied lines, which are raised from the surface like narrow welded seams of metal solder. Likewise, in the Chicago sculpture the outline of a large central (Cyclops-like) eye, two smaller eyes within it, and the two small nostrils were all welded onto the central strip or snout. The soldered lines of hair also have affinities to the wire rods of the Chicago Picasso, which connect the front and rear sections of the larger sculpture. Unlike the Chicago piece, this 1962

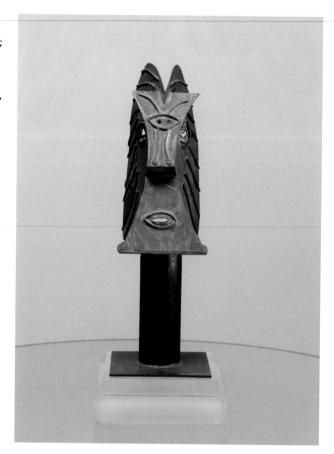

Right and opposite: Pablo Picasso, *Tete de femme*, 1962; sheet metal cut-out and folded, 20 x 10⅞ x 7 inches; collection of Mr. and Mrs. Morton L. Janklow, New York, New York; photograph by Kerry Ryan McFate, courtesy Pace Gallery; artwork © 2017 Estate of Pablo Picasso / Artists Rights Society (ARS), New York

sculpture—in a private New York collection and rarely exhibited—has two ears and a mouth cut through the metal, and appears much heavier, even at just 20½ inches high, and not as graceful as either the maquette or the final sculpture.

In the meantime two other phases of Picasso's exploration of the themes that would find full expression in Chicago were beginning to develop concurrently. The first was the advent of a progression that was a corollary, a dead end, or a diversion, depending on one's perspective. In 1956 Picasso met the Norwegian sculptor Carl Nesjar, who had become engaged with a new technique for monumental sculpture. The process "*Bétogravure*" had been developed in Oslo by the architect Erleng Viksjø and the engineer Sverre Jystad, and consisted of a way of sandblasting dark lines or areas into large bodies of concrete; a kind of combination of large-scale engraving and bas-relief. Picasso was characteristically enthusiastic; in early 1963 (before the Chicagoans' initial visit to Picasso), Nesjar wrote:

Picasso is keen to use this new technique for sculptures on a monumental scale — 100 or 200 feet high. He also envisages combinations of building and

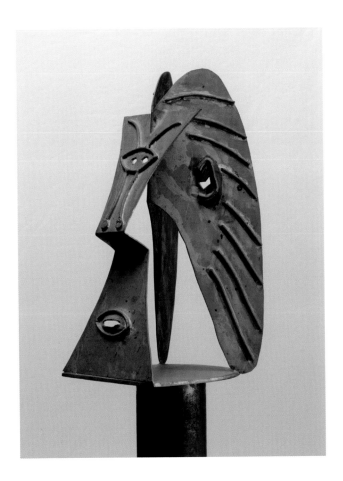

sculpture…. Last year I spent three months on a Picasso sculpture about 18 feet high based on a 13-inch maquette. The finished work is "man-made" as Duchamp might say. It is the expressive result of teamwork by engineers, carpenters, an architect, and an artist, starting from this model by a man of genius. It has the nature of a work of art in the same sense as, say, a Japanese print, which was also something of a collective work.[57]

Beginning in 1958, Nesjar and Picasso collaborated on some 30 of the enormous sculptures. Many of these were located in Scandinavia, although there are examples in Marseille and Israel; in this country there were originally three, one in New York City, one in Princeton, New Jersey, and one in Rolling Meadows, Illinois (this last later relocated to Normandy, France, although the maquette was donated by Gould Inc. owner William Ylvisaker to Harper College in Palatine, Illinois). It is worth noting that Picasso first proposed to Hartmann and the Chicagoans a concrete sculpture for the Civic Center Plaza, only to be gently deflected onto the more suitable idea of a sculpture in bronze or steel. As it happens, the Nesjar collaborations are immensely popular, although some

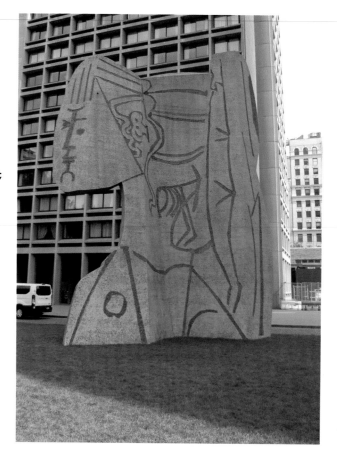

Carl Nesjar, *Sylvette*, 1968; approved enlargement from earlier Picasso metal sculpture, white cement and crushed granite, 34 feet 10 inches; East Building, Silver Towers, New York University, New York, New York, concrete, glass, and reinforced steel; construction completed 1967; architecture by I. M. Pei; director, James Ingo Freed; engineering by Farkas and Barron; designated as a NYC Landmark by the Landmarks Commission of New York City, 2008; photograph by Michael Lindgren, New York

critics have reacted harshly. Barbara Rose called the NYU *Bust of Sylvette* "spurious," adding that

this minor effort is to be blown up to the towering height of over thirty-five feet. Since what was charming and spontaneous in a flimsy construction can only be tacky and ridiculous on a monumental scale, one can predict in advance that the results will be disastrous.[58]

Harriet Senie agreed, calling it "an example of inappropriate scale. Picasso's original small sculpture was enlarged to a size that seemed to suit the setting, but not the sculpture."[59] And Alan Bowness wondered "whether this is not artistic inflation of an especially pernicious kind."[60] Many of these criticisms could be made equally of the Chicago Picasso, of course, although there remains a sense that what seems ungainly in massive blocks of concrete functions with more aesthetic integrity in steel and rods; in the end, the two media produce strikingly different results, as media always do.

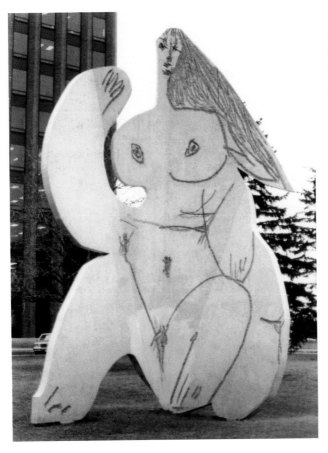

Carl Nesjar, *The Bather,*
1975; approved enlargement
from earlier Picasso metal
sculpture, white cement
and crushed granite, 28 feet;
commission for Gould Inc.,
Rolling Meadows, Illinois;
(maquette gift by Gould CEO
William Yllvisaker to Harper
College, Palatine, Illinois);
photograph by R. Scott
Stratton

At the same time that he was working with Nesjar, Picasso began creating yet more drawings and eventually even paintings for what seemed to be a large sculpture of the head of a woman, featuring the now-iconic two eyes encompassed in a larger almond-shaped eye, a long snout with two small nostrils, a front vertical piece containing the lips, some form of wings of hair, and various attempts for a base. In all cases the drawings present the heads or busts as three-dimensional figures with modeling and planar parts of various thicknesses. A representative 1960 *Tete de Femme*, in the words of curator Frank Verpoorten, "perfectly encapsulates both the tenderness and the ceaseless thirst for innovation that characterized Picasso's portraits of Jacqueline,"[61] and was to that date the closest visual antecedent for the Chicago sculpture. In May and June 1962 Picasso painted, in rapid succession, a series of busts of a woman, heavily modeled, with thick planar elements executed in grisaille. Johnson International, a gallery in Chicago, sold similar drawings from the same period and on the same theme several years later as "Studies for Chicago" even though there was no way really to document that they had been intended as studies for the sculpture. After all, the Chicago architects did not visit Picasso until 1963.

Picasso's prolific experimentation with both the visual themes that contributed to the Chicago Picasso and the process of the Nesjar sculptures has long contributed to a probably unanswerable debate about the relative distinctiveness, or even uniqueness, of the Chicago Picasso. Franz Schulze, for example, insisted that the maquette for Chicago was "knocked off in little or no time" and that it was a "recipe piece" whose idea was just taken off the shelf from these other recent works.[62] A more charitable interpretation, not surprisingly, came from Hartmann, who of course had a vested interest in defending the integrity of the piece:

This work is part of a period, it is germane, it is no oddity, it is part of a stream. It is important to consider for an artist like Picasso — and most artists — there is continuity in the work they are doing. It is only when they have exhausted a particular problem, an aesthetic problem, that they have an evolutionary change. You can find with this piece, you can trace its historical (antecedents) in Picasso's work, maybe up to ten years preceding (the Chicago Picasso). So this fits into the continuity of his work, which I think is terribly important.[63]

Harold Joachim, prints and drawings curator at the Art Institute, split the difference: he asserted "for the Civic Center, Picasso did not create anything new. He ruminated on sculptural ideas made from his past,"[64] but he also said definitively that the drawings made from 1962 on were made with an eye toward monumental sculpture, which occupied a place near the forefront of Picasso's conscious thinking.

In a sense, of course, it cannot be had both ways: the Chicago Picasso cannot be both unique and a natural outgrowth of the artist's themes and techniques. The freedom that the Chicagoans granted Picasso to do as he liked was what made the whole project feasible; if an outgrowth of this freedom was a recycled or second-hand artifact, then that was part of the deal, as it were. And there is no denying that the themes and motifs that had been developing across the several media for almost a decade were rapidly approaching what would become their apotheosis. Whatever the details of its genesis, the maquette that Hartmann saw in Mougins in May 1964 was a nearly perfect crystallization of the major elements of cubism that had so dominated and shaped Picasso's aesthetic. Now the only challenge left was to build it.

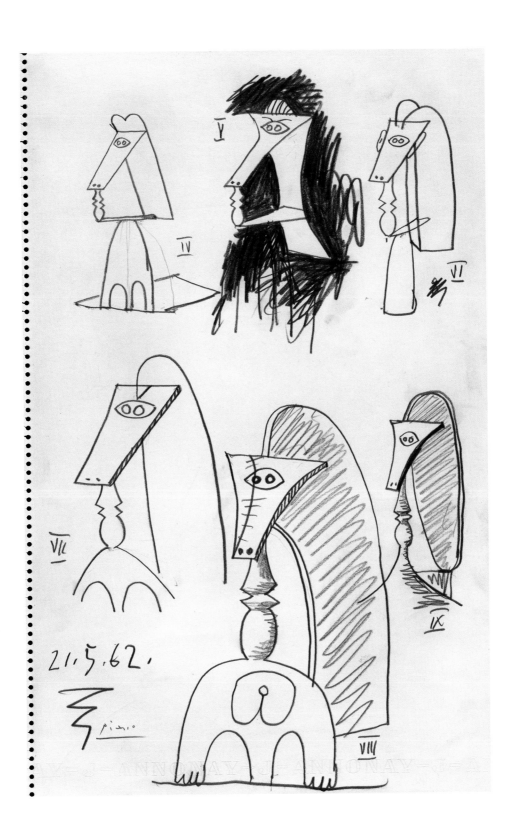

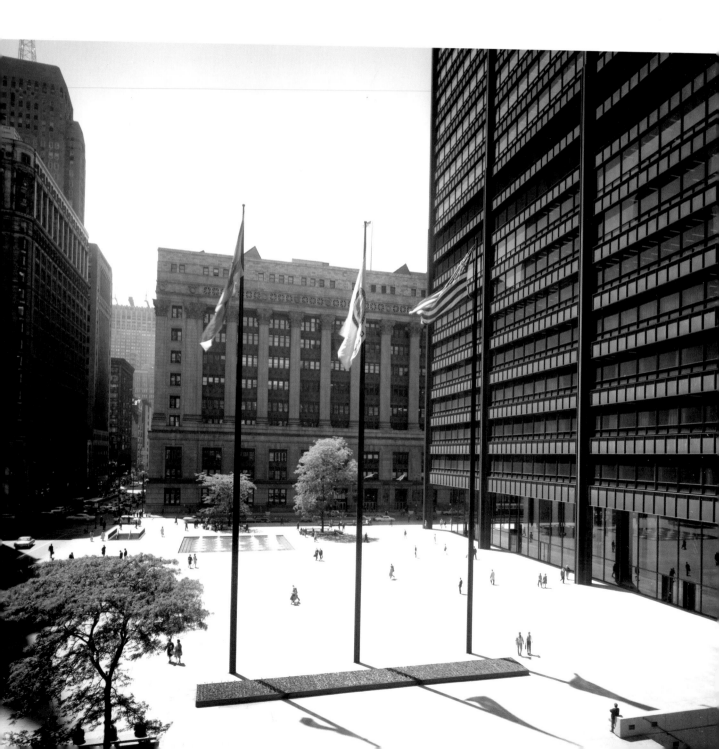

Civic Center Plaza, 1963;
photograph by Bill Engdahl
© Hedrich Blessing, courtesy
of SOM

4. Construction: Cathedral in Steel

As with all large-scale projects of urban design, the funding, construction, and implementation of the Chicago Picasso presented immense challenges. The first of these was integrating the sculpture into the particular milieu of which it would be the defining visual element. The full block of the Daley Center (renamed after the death of Mayor Richard J. Daley in 1976) site is 123,100 square feet of which the 145-by-261-foot Civic Center building (648 feet high) takes up slightly more than 30 percent. The plaza area was covered with 2.83 acres of dark grey granite from Coal Springs, Minnesota, with the sculpture mounted on a 33-by-52-foot granite plinth, designed to be a comfortable 17 inches high for sitting. Other elements of the plaza include a 58-by-58-foot fountain, three large honey locust trees, three Cor-Ten steel flagpoles, stairs to the lower-level pedestrian system to the subway and other buildings, and recessed ramps to the lower-level garage and truck service facilities.

To understand this great urban space it is necessary to take notice of the frontage. To the west, facing Clark Street, is the old City Hall-County Building designed in classical Beaux Arts style by Holabird & Roche in 1907 and 1911. To the south, facing Washington Street, are the Chicago Temple and Brunswick Building. The smaller temple building, also designed by Holabird & Roche in 1923 in a gothic revival style, stands 550 feet high, including its elaborate spire. In 1964 SOM designed the Brunswick Building, with its richly sculptural load-bearing concrete walls and small open court; in 1966 SOM also designed the only other notable building facing the Daley Center block at the southeast corner of Washington and Dearborn Streets—the Connecticut Mutual Life Building, a curtain-glass and painted-steel structure. To the Center's east on Dearborn Street at that time was a conglomeration of undistinguished buildings housing small stores, a restaurant, and the first of several neon-style movie theaters to fill the northeast corner. This city Block 37 was redesigned as Gallery 37 (for arts programming, per Mayor Richie Daley's wife's wishes) and endured renovation again as an architecturally uninspired vertical shopping mall/office/apartment complex. Along Randolph Street to the north are a parking ramp and garage, but the former Greyhound bus terminal has been moved over a mile away. Chicago's Goodman Theatre now occupies the eastern half of the block at Randolph and Dearborn Streets; on the western half resides the former Chicago Title & Trust tower. However, since the monumental Daley Center stands at the north side

of the site, it forms the backdrop and northern perimeter of the plaza. Here is eclecticism par excellence—in style, size, material, and function. About the only common denominator for all these buildings is their chance location together.

The visual diversity of the existing plaza center was a boon to the project, for it allowed considerable latitude in determining the mechanics of placement and construction. When the maquette arrived, in great secrecy, at Hartmann's office at SOM in June 1965, the first challenge was to analyze it for structural concerns, a project that was to result in the moving of the sculpture's final position from the earlier considered reflecting pool to the east side of the plaza. Years later, architect Carter Manny, of C. F. Murphy, allowed that he had "always wanted it to be placed differently in the plaza, but the foundation for such a heavy work necessitated it be located where it ended up. The original fortified foundation had become the place of the fountain … it had to be located where it could be supported because of the weight."[65]

SOM project architect Fred Lo was given the task of analyzing the maquette for its structural integrity and for making sketches that would indicate how the maquette could be translated into its giant size. Under the direction of chief structural engineer Joseph P. Colaco, Lo began an exhaustive series of analyses and tests. "The maquette was kept in a basement storage room at the Art Institute," Lo recalled. "I went in to make a set of drawings.… Only the guard there and (Art Institute President John) Cunningham knew me.… It was my mission to do the job without saying anything. It was confidential, but our work is often confidential. I made full size drawings, exactly 41¼ inches from all four views and the top. Then I graphically took the maquette apart and drew each in detail, part by part."[66] It was reported later in the press that "Lo made his descent into a little basement hell in the summer of 1965 … for July in Chicago is quite hot. The temperature was about 100. There was no air-conditioning, no window, only a glass block but no air. They gave him a little fan."[67] Although these were working drawings for the architects, Lo captured the linear delicacy and spirit of Picasso's maquette. While Hartmann perused the drawings, Lo photographed the maquette, examining it from all possible angles in order to understand it better visually. It became his duty to analyze and to supervise the photographic record of the sculpture's entire evolution through the unveiling for Hartmann, who then selected photos to keep Picasso abreast of the progress.

In August 1965, after several weeks of analysis, Colaco presented Hartmann with the structural problems:

Since the maquette was all the same in thickness, Hartmann thought it was Picasso's intention that the final version be all the same thickness.… Hartmann did not like tampering with the work of art, but I said we needed to make some changes to make it stand. My analysis showed the front vertical piece needed to be thicker than the wings and so did the inclined piece (the face). All three

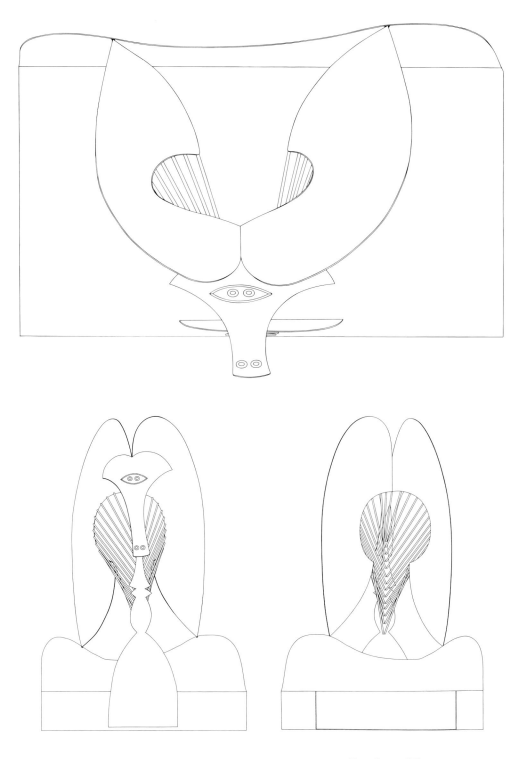

Drawings of Picasso maquette, top, front, and rear views, 1966; © SOM

parts needed different thicknesses, but that violated the uniform thickness of the maquette. Unless the vertical post was thicker, there would be difficulties with wind-flutter at fifty feet. A stiffener needed to be added behind the vertical post, and I suggested a triangular steel plate.[68]

However, Hartmann found the tall triangle artistically disconcerting and, together with Lo, gave it a curved shape that made it visually less obtrusive. Some observers see a head within a head from the rear view, although the artist never planned the rounded reinforcement.

The most important result of the initial testing, however, was the most dramatic: the decision to change the material from bronze to steel. From its inception, the understanding held by Picasso and by the architects was that the sculpture would be cast in bronze, as befitted a major monumental piece. Because bronze is not as strong as Cor-Ten steel, it eventually became apparent that this elemental part of the sculpture's conception would have to be changed. According to Hartmann, "We wanted to see all the possibilities vis-à-vis the material. So we looked at bronze and it quickly became apparent that it would be difficult to have the same spirit as in a thing made of steel."[69] Colaco put it even more bluntly:

I investigated bronze as an option very early on, but within a month or two the idea was dismissed. The decision was due to aesthetics according to Hartmann, who one day just came in and told me it would be Cor-Ten. The unity of the building and the sculpture in Cor-Ten lends to the ambiance of the plaza. But there would not have been any structural problems with bronze; it could have been built fifty feet. But Hartmann said it would be Cor-Ten only; the decision was made entirely by him.[70]

Whether the decision was ultimately aesthetic or practical, it ended up reaping immense benefits. For one thing, the steel was easier and more practical to manufacture; for another, having the sculpture match the material of the Civic Center building behind it became visually very pleasing. There was something to be said, too, for having the sculpture made of such an archetypically American material, something brash and industrial and, well, Chicagoan, that seemed appropriate. As M. W. (Bill) Newman wrote in the *Chicago Daily News,*

Steel is the muscle and sinew of this factory city. What more fitting material for both civic design and civic art. We should be pleased and proud that Chicago officials, seldom known for innovation, risked both building and its sculptural companion piece to this new material. We should welcome the new, bold, and unfamiliar.[71]

Wind tunnel test, up to 185 mph, executed by SOM engineers;

photograph © Paul Weidlinger, courtesy of SOM

The next step for Hartmann was the delicate task of presenting the maquette to Mayor Daley and to the PBCC for approval and the go-ahead. The secret meeting took place in June 1966, with the maquette dramatically lighted in a dark, private gallery at the Art Institute. Hartmann gave a presentation imparting the bona fides of several art experts and public relations experts, convincingly framing the project as a massive boon for Chicago's image. Architect Carter Manny of C. F. Murphy recalled the presentation:

The PBCC officials were not art people and they were making jokes about it. They all seemed baffled, but once the mayor supported it, then the commission gave its OK. The mayor was very positive about it and liked it. He said: "I see the wings of justice." He wanted something purposeful in it to justify it. Then the commission was more enthusiastic.[72]

Jacques Brownson and city planner Ira Bach both recall, of the vernissage and its aftermath, that Daley withheld final approval until some days after the presentation. Once it had received his imprimatur, however, there was no

going back. Two months later Hartmann was back in France with an aluminum model, fabricated by Richard Rush Studios of Chicago, incorporating all of the structural changes that the SOM team had implemented in order to make the sculpture executable. Picasso was impressed. "As I understand it," the master said, "some 20 architects have been working on this for more than a year. If I thought of all that while I was working, I don't know if I'd been able to do it."[73] He gave his approval in unequivocal terms: "I think it's really fantastic, don't you? In fact, I'd go so far as to say it's better than the original."[74] Lo reported years later that he was extremely pleased and proud of Picasso's recognition of his own fine work.

Less than a month later, on Wednesday, September 16, 1966, subscribers to the *Chicago Sun-Times* awoke to a front-page headline blaring PICASSO DESIGNS A STATUE FOR THE CIVIC CENTER. The article, by John Adam Moreau, solemnly declared that the "statue … depicts a bird," and helpfully explained that Pablo Picasso "is considered by many to be the greatest figure in 20th-century art."[75] It remains to this day a mystery, and an amusing one at that, whether the feckless Moreau really dug out the story by himself (an anonymous "spokesman" is quoted as saying "I can't figure out why Picasso donated the thing") or whether it was an especially clumsily-handled publicity plant by Hartmann, who was quoted as saying "This is Mayor Daley's story." In any event, the cat was officially out of the bag. The news created such excitement that Daley was forced to make a brief confirmation about the project and scheduled the official announcement for the following week at the Art Institute. For this event Lo was called in again to attractively arrange the Woods Gallery for the press conference and the two-week exhibition that followed. All the principals were there for the public climax of the three-and-one-half-year project, including Mayor Daley, Hartmann, the joint venture architects, Art Institute officials, and the members of the PBCC, who had initially been so skeptical.

Moreau's bombshell explicitly said that "three foundations … which were not identified, will pay $300,000 for the fabrication and emplacement of the Picasso," tacitly giving cover to Daley, who was careful not to be seen as spending public funds on a piece of artwork that many Chicagoans might not like or understand. The upshot was that Hartmann and the others would have to find the money from philanthropic sources: another labyrinthine process for the dauntless Hartmann to surmount.

Hartmann's first instinct was to go to the B. F. Ferguson Monument Fund at the Art Institute, a trust established in 1905 upon the death of Benjamin F. Ferguson, a local lumber merchant. Hartmann had become a board member of the Art Institute in 1963 and managed to negotiate a Ferguson Fund gift of $100,000 for the sculpture, which was formally accepted by the PBCC on December 10, 1963.[76] As it turned out, however, the Ferguson Fund was explicitly for the purpose of "commemorating worthy men and women of America, or

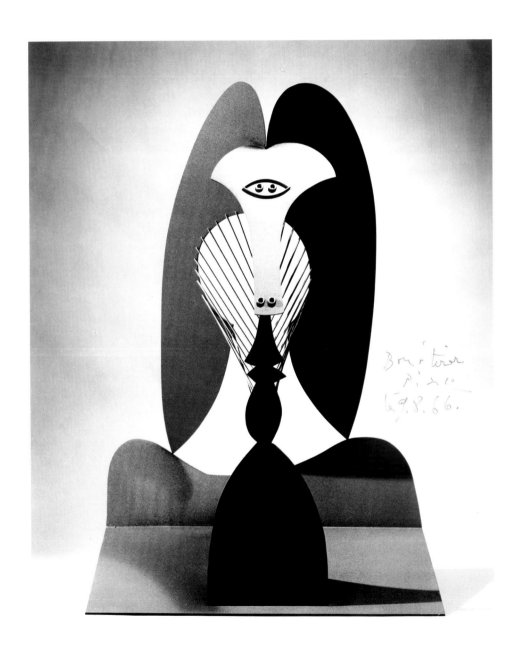

important events in American history,"[77] which the Picasso sculpture decidedly did not, so the Ferguson funds were withdrawn in 1966. This left the resourceful Hartmann with only private sources for the funding of the sculpture. He was exasperated but undeterred; as he wrote to Penrose in May:

I have been working on this so long, I guess it's into its fourth year now, and the effort is a little wearing. Ever since receiving the maquette here I've done something on this matter almost every day, balancing the delicate nuances of attitude, cajoling, sustaining interest, professing confidence. I am not really completely discouraged, however, and now must try to figure out how best to ... try to secure financial support elsewhere.[78]

Hartmann's next step was to consult with James Brown IV, executive director of the Chicago Community Trust, Chicago's largest philanthropic body, and former chairman of the School of Social Services at the University of Chicago. Brown felt that the Picasso sculpture was too avant-garde to draw the interest of Community Trust, and instead worked his connections to come up with the three foundations alluded to in Moreau's article: the Chauncey and Marion Deering McCormick Foundation, the Field Foundation of Illinois, and the Woods Charitable Trust. In July 1966 the three men—Brooks McCormick, Marshall Field, and Frank Woods—decided, after yet another presentation by Hartmann, to arrange for their foundations to share the $300,000 construction (valued at over $2.25 million today).

A principal executive for one of the three foundations shared some succinct observations:

The funding for the Picasso sculpture happened very fast. The whole thing took less than a week, which is unprecedented in this kind of deal for foundations. We do not have large amounts of cash on hand because the law requires that it be reinvested.... This was a substantial contribution, the largest we ever made on a one-shot deal.[79]

Again, the speed and decisiveness with which the final funding for the sculpture fell into place seem purely a function of the specific time and place: Chicago, Illinois, in the mid-1960s. When the men who moved the levers of city government wanted something to happen badly enough, bureaucracies and nonprofit boards were no obstacles. It is difficult to imagine a similar project being funded with such alacrity today.

During the time that Hartmann was working out the financing with Brown and the three foundations, SOM was arranging with the American Bridge Division of U. S. Steel for the manufacture and emplacement of the sculpture itself. It is worth noting that American Bridge was the only contractor who bid on the

project—another example, perhaps, of Daley-style efficiency—although it is also conceivable that American Bridge was in fact the only company in America at the time capable of manufacturing such a massive and yet delicate piece of steel to such precise specifications. (Bethlehem Steel was the only other firm making weathering steel—Mayari-R—but did not get the contract for the building, only for the 2,352 weathering steel windows.) Whatever the mechanics, on September 19, 1966, American Bridge submitted a contract to the PBCC for $337,500 (over $2.5 million in today's dollars) to furnish "all labor, material, and equipment necessary to fabricate and erect all elements required to re-create a Cor-Ten Sculpture from the 41¼-inch high aluminum model as made by Richard Rush Studio and approved by Skidmore, Owings, & Merrill."[80] The PBCC duly submitted a first payment of $148,500 on August 1, 1966.

Once again the project received sensitive and passionate handling from the men responsible for making the dream come true. Born in Poland, educated in Germany, senior design engineer Anatol Rychalski came to the United States in 1949 and quickly became the point man for all U. S. Steel's dealings with designers and architects. His artistic sensibilities made him the perfect man to oversee the Picasso sculpture translation and guide it through the fabrication shop amidst workers who were usually involved with the construction of bridges and buildings. "This is the greatest thing personally that's ever happened to me," Rychalski said just before the unveiling. "I feel sentimentally grateful for the opportunity to do this. This country has given me the opportunity to do something of lasting value."[81]

There is perhaps no city more poignantly American, more symbolic of the now long-gone industrial might of the American heartland, than Gary, Indiana. Once thriving, now not much more than a sardonic punch line, the city was the site of U. S. Steel's main steelyard, and it was where the Chicago Picasso was built. The process started with the construction of yet another copy, this one made of balsa wood, designed to give the steelworkers and engineers even more precise illustration of the pieces to be forged, rolled, and cut. According to Rychalski, the new version

gave us an opportunity to view it artistically as it expanded ... Also it gave the people in our shop a chance to see the intricacies and dimensions to be dealt with. This was a piece of art and had no lines from geometry or formula; it was all free hand and this nonconforming movement had to be translated into geometry. We wanted to be certain of every detail and to meet the burden of being in tune with the original. We were very enthusiastic about it, but I had to massage some egos to get it done.... When I first went to the shop to get workers to accept it and to work on it, I had to get them to understand it — not to complain or see it as a waste of time or as a stupid exercise they had to perform. They were used to building

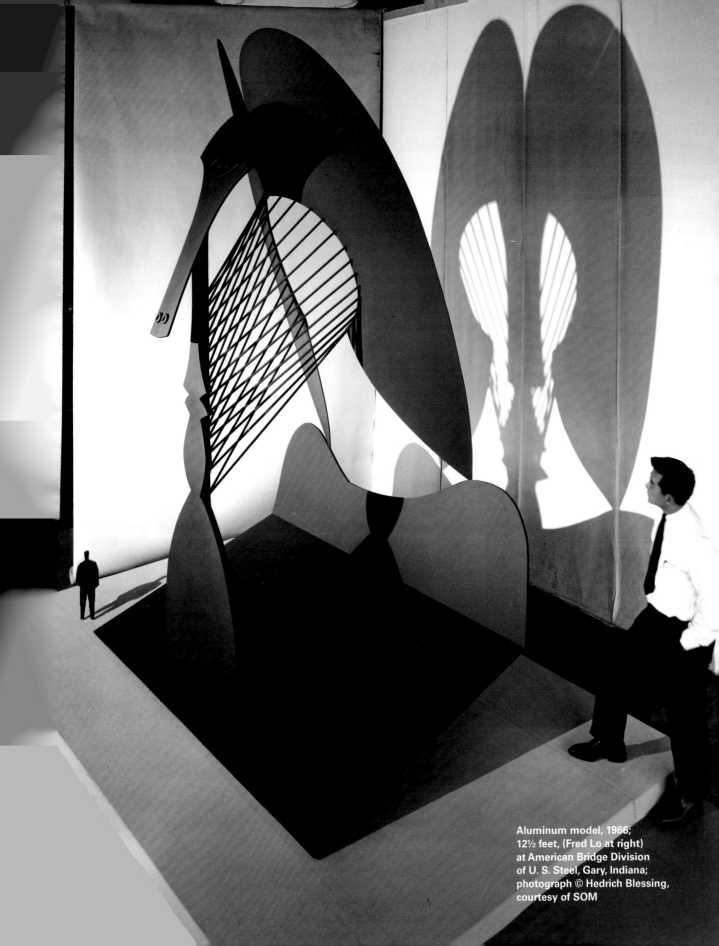

Aluminum model, 1966;
12½ feet, (Fred Lo at right)
at American Bridge Division
of U. S. Steel, Gary, Indiana;
photograph © Hedrich Blessing,
courtesy of SOM

**Chicago Picasso under
construction at American
Bridge Division of U. S. Steel,**
**Gary, Indiana, 1966–67;
photograph © Williams
& Meyer, courtesy of SOM**

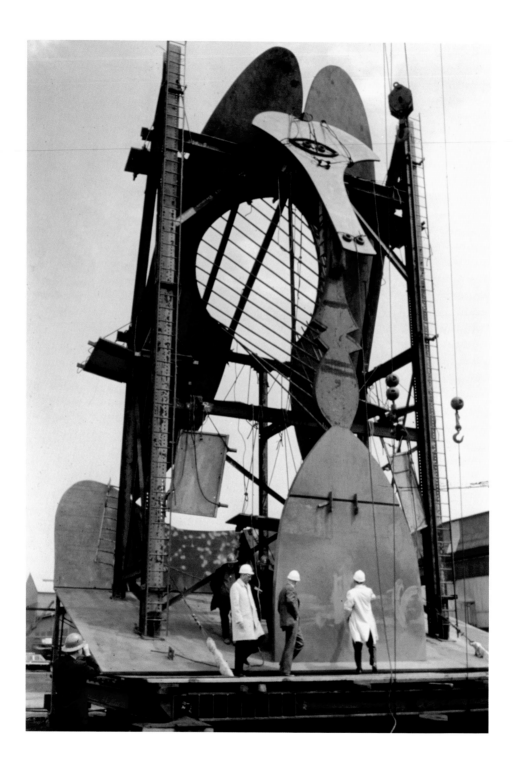

The Chicago Picasso: A Point of Departure

bridges. They did not understand this huge piece of art, nor did they approve of this foolish waste of money.[82]

This indifference did not last long. A number of the men who were involved in the construction and planning described a feeling of camaraderie and passion surrounding the construction of the Picasso that seemed almost to surprise them. This was a rare opportunity for these men who normally worked in a world of quantities, estimates, money, schedules—the parameters and pressures of the industrial world. The Chicago Picasso stimulated them, challenged them, and moved them to new feelings, as a true work of art should do the receptive mind. With Eastern European soulfulness, Rychalski put it perhaps best and most poetically:

As time went on, with a tremendous effort in persuading, explaining, and romanticizing the Picasso work to our people, some even agreed to work for nothing.... On weekends these steelworkers brought their families to the site to show them what they were doing. They were happy, pleased, and proud to have worked on something that will be here for centuries. Over the course of making of this sculpture there was a tremendous transformation in the attitude of the workers. Everyone has the soul of an artist; some must dig to find it.[83]

There was only one artistic difference that occurred between Rychalski and Lo. It had been decided by Hartmann that the flame-cut edges of Cor-Ten plate were to be left in their rough finish, which gave the pieces more affinity to the handicraft of the Picasso maquette; only the welding marks were to be ground off, in agreement with the artist's desire that it be built like a building. According to Lo, Rychalski wanted to smooth out a notch on the rear bow-tie piece of the base. The notch had originally been caused by Picasso's metalworker hand cutting the piece with shears. Lo thought that "Rychalski wanted to show how technically well U. S. Steel could cut this material, but I said no … I am trying to keep it as close as possible to Picasso's original maquette."[84]

As might be expected from such a challenging amalgam of art and manufacturing, the process was unbelievably intricate and involved. Templates were made from the Picasso-approved model by tracing and scaling the drawings, first up to 12½ feet for a wooden prototype and then up to full size. The template workers tried to translate the spontaneous impulse of the artist by numerical methods of manufacturing, converting the model into a multitude of exact lines of varying dimensions. Then, after multiplying the length of the lines by 14.5454 (the relationship of the finished work to the maquette), they converted their exact geometry back to Picasso's original curves and shapes. Next, diagrams in the final sizes were made on sheets of heavy brown resin-coated paper that had the appearance of leather. Masonite boards were cut to the

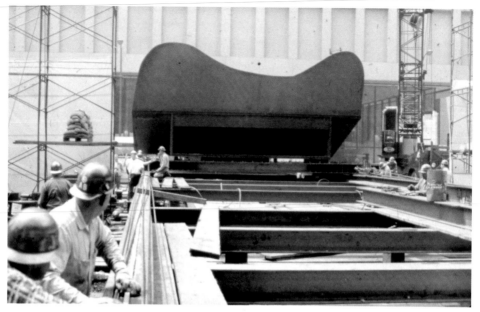

Above: Railroad track skidding material in place on Civic Center Plaza for installing Picasso sculpture in sections before welding, 1967; photograph © SOM

Opposite: U. S. Steel American Bridge worker welding together front face plate at Civic Center, 1967; photograph © SOM

same pattern as the paper diagrams, and then painted white and edged with black tape. Lo went to Gary about once a week to approve each of the pieces individually, after which it was sent to another department where it was actually cut.[85] Using the template patterns, a flame-cutter with an electric eye specially rigged for following the black tape outline cut each piece out of huge Cor-Ten plate into the exact shape of the diagrams. Plate sections, such as the base, were shop-welded by the vertical submerged-arc method, while each wing was cut from one piece of plate.[86]

All the while the foundry in Gary was churning along, Hartmann continued his visits to Picasso in France, keeping the artist abreast of the developments, and bringing drawings and photographs as well as full-sized examples of the steel connections and Cor-Ten samples for the artist's criticism and review. In Hartmann's telling, Picasso was interested, respectful, and obliging, and displayed a sound sense of the challenges of manufacturing such an immense artifact. He "didn't object to anything," Hartmann related later. "He expressed great interest in working with the architects and engineers from the technical point of view. We were much in touch and he did make comments. The spirit was such that we had no problems."[87]

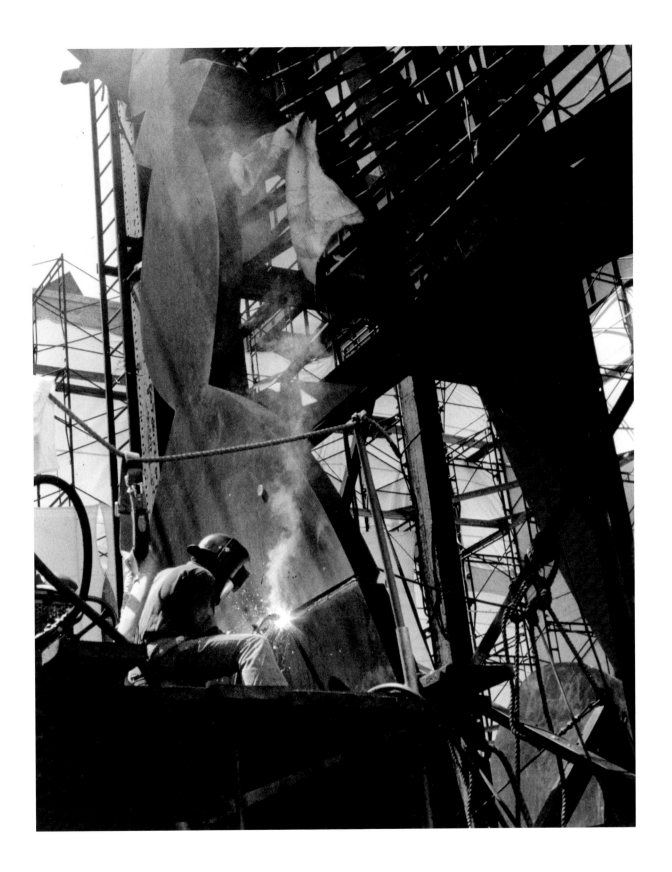

Once all the sculpture pieces had been cut to specifications, American Bridge preassembled them at their Gary plant to insure proper fittings, with Hartmann taking pains to keep the steelyard closed to intruders, journalists, and observers. In May 1967 the sculpture was dismounted and prepared for transport to the Civic Center. Groundbreaking ceremonies took place on May 25, 1967, at which Hartmann, operating a forklift truck, raised the first block of granite from the plaza pavement.

On June 5, 1967, temporary railroad tracks were placed on the plaza so that heavy pieces of equipment and 162 tons of steel sculpture could be transported to the site for assembly. When it came time to transport the sculpture to the Loop, American Bridge contracting manager James E. Maloney made elaborate arrangements. He plotted the route and the necessary clearances and notified city officials of the timing: June 10, 1967, a Saturday, when there would be less traffic, fewer people watching, and less chance of a spectator getting hurt. The rail skidding laid down was particularly important for the heavy and massive base of the sculpture, which was placed on the tracks and skidded into position. A crane was used to raise the other sculpture pieces into place and they were held by falsework supports until field-welded. All construction at the Civic Center Plaza took place behind a canvas-covered scaffolding that kept the project cloaked with secrecy and mystery.

The surfaces were sandblasted to remove construction marks and to permit even weathering of the Cor-Ten steel. The sculpture was mounted on a granite plinth, 33 by 52 feet, elevated 17 inches above the plaza level. All granite base work and cleanup were carried out by August K. Newburg Construction Company, which had served as general contractors for the Civic Center Building. The construction was finished by mid-July. On July 28, 1967, Hartmann sent a letter encouraging Penrose and his wife to attend the ceremonies:

The sculpture itself is all completed on the plaza and work now going on consists of installing the low granite base. This should be completed next week. It is perfect! It is still surrounded by scaffolding with canvas so that no one can get a really clear external view of the piece. We plan to have it veiled, for a dramatic unveiling at the dedication. As you know, we sandblasted the sculpture at the very end and it has already turned a rust color, which is delightful. The scale and character of the piece are just right.[88]

The Chicago Picasso was ready for the public.

Opposite: U. S. Steel American Bridge workers hoisting 30-ton front face plate into position at the Civic Center, 1967; photograph © SOM

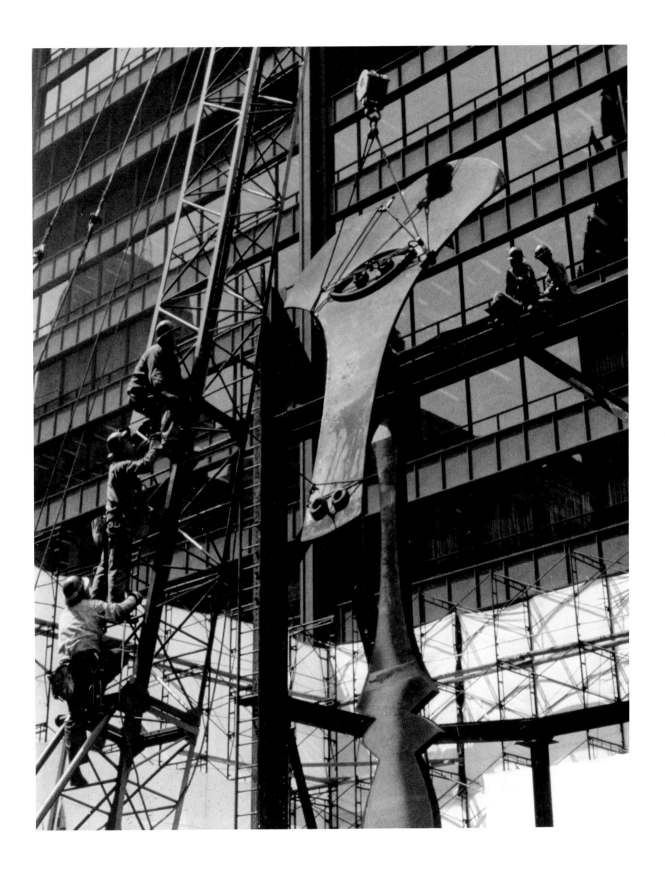

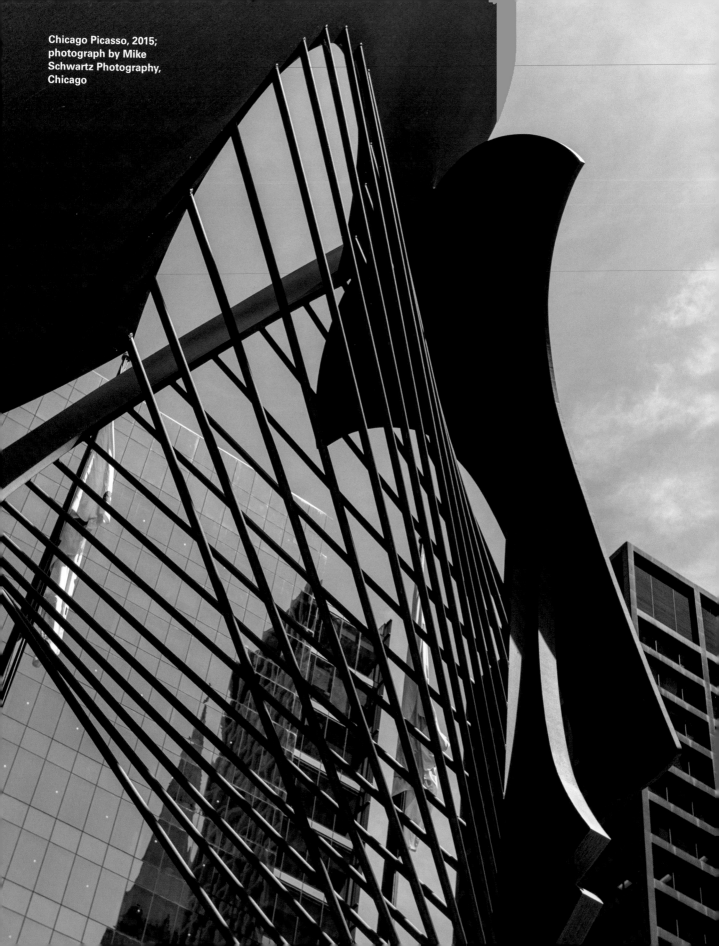

Chicago Picasso, 2015; photograph by Mike Schwartz Photography, Chicago

5. Identity: The Mystery in the Plaza

The initial reaction of Chicagoans to their new sculpture was decidedly mixed, with the ecstatic mixing with the baffled. Along with predictable man-in-the-street opinions, the *Chicago Tribune* featured a sober appreciation by critic Edward Barry, who noted both the sculpture's "rude power" and its "austere, off-beat attractiveness," with its "orderly arrangements of planes and curved surfaces."[89] The *Sun-Times* quoted Mayor Daley as saying that the sculpture promoted "dialogue and difference of opinion," while also recording the presence of everyone from bongo-playing hippies to hooky-playing businessmen at the unveiling.[90] The out-of-town *St. Louis Post-Dispatch,* meanwhile, sounded a distinctive note of envy:

Whatever the views on Picasso's art, we hope Chicagoans appreciate what they possess in this Civic Center on the north edge of the Loop. They have something as exciting as St. Mark's Square in Venice: an open space in the midst of cliff-high office buildings, surrounded by nineteenth and twentieth century architecture amicably intermixed…. What is really significant is that the Picasso acts as a powerful magnet, bringing people together in the heart of the city, giving them a common bond of light, air, and satisfying design, creating an island of pedestrianism in a sea of skyscrapers and wheels.[91]

The mayors of six other major American cities told a Chicago newspaper in 1967 that they would be delighted to have the Chicago Picasso or something like it by the master.[92] New York, Detroit, Boston, Los Angeles, Houston, and St. Louis all expressed enthusiasm for such a work of public art; Chicago had become a city worthy of envy, a paragon of public-private cooperation, and an innovator in the arena of public art. Illinois Senator Charles Percy helped set the tone with an enthusiastic and even moving public reaction of great appreciation and optimism. The new sculpture, in Percy's words, "portrays the dynamic nature of a great city. Perhaps, somehow, we can relate this great work of art to seeing a solution to the city's problems. I think the sculpture is one of the greatest things that has ever happened to the city."[93] The tone for this reaction had been set, in part, by Daley's remarks at the unveiling. The mayor had said,

with remarkable perspicuity, that although it was impossible to know Picasso's exact intentions,

we do know that the work was designed especially for this city and we are grateful to be singled out for recognition by this great artist. I think the great significance of the Chicago Picasso and its real value lies now and for all years to come in its stimulation to appreciation of all the fine arts. I believe that it will become, as time goes by, a moment symbolic of a very exciting era in our city's history. I think it will mark an age of acceptance in this community — a time of great awareness for the most rewarding values in urban living. We dedicate this celebrated work this morning with the belief that what is strange to us today will be familiar tomorrow, and that the genius of the creator coupled with the spirit of our city will establish in this plaza a monument that portrays the creative courage of the people of Chicago.[94]

A few weeks after the sculpture was unveiled, the Republican majority in the Illinois State Legislature joined their Democratic rivals and overwhelmingly approved a resolution to commend Mayor Daley and the city for acquiring the Civic Center conversation piece.[95]

The nexus of public art, modernism, no-nonsense Midwestern pragmatism, and changing ideals of the meaning of the avant-garde made it impossible, of course, for the Picasso to satisfy all comers. *New Yorker* critic Adam Gopnik observed in 2013 that "Picasso was no longer a fashionable artist in the mid-1960s — indeed, avant-garde taste had … passed Picasso by."[96] Artist David Hockney, however, disagreed with the art world's tendency to "view Picasso as though he'd died in 1955, whereas in fact he lived for nearly 20 years after that, and continued creating vigorous and difficult pictures during that time."[97] No matter: the Chicago Picasso was here to stay, and the reactions to it would continue to evolve.

The natural next step in the reaction was open speculation on who, or what, the sculpture represented. The average citizen may not have been up to speed with the latest trends in artistic theory, but he certainly could see that the sculpture, rather than being a pure abstraction, was representative of … something.

The identity of the sculpture's inspiration was to be an ongoing controversy that to this day has not been definitively resolved. Mayor Daley tried hard to cooperate with the public relations men by declaring that the sculpture was a beautiful head of a woman. When pressed by newsmen, he said that modern art is what you make it. So it was natural that the Mayor, who had wanted a symbol of justice since the building's inception, would see the wing-like members as the wings of an eagle of justice, and would accept the sculpture as a woman since the traditional symbolic figure for justice is female.

With a population diversified by economics, national heritage, education, and art awareness, it was not surprising that the general-public responses

were varied. Most people were primarily concerned with what the sculpture represented and proffered their own identification: baboon, bird, phoenix, horse, seahorse, dog, nun, Barbra Streisand, Viking helmet. The cultural commentator and television personality Norman Ross Jr. offered an unexpectedly generation-sensitive reaction of sturdy common sense, asking "Why can't the Chicago Picasso be a large, sophisticated work that titillates and amuses and may speak to the young in ways our eyes, dulled by looking at too many statues of men on horseback, cannot comprehend?"[98] Former Milwaukee Art Museum and Museum of Contemporary Art CEO and dealer Russell Bowman recalls coming to Chicago in 1972 as a young University of Chicago scholar and finding that while the sculpture's austere, soaring profile had been quickly accepted as a central part of the city's profile, the identity of Picasso's muse was still hotly debated.[99] This in spite of one reporter's assertion that the controversy was officially old hat: after the first-birthday celebration in front of the Chicago Picasso, the *Daily News*'s Donald Zochert declared that the tiresome controversy over what the untitled sculpture represented had already died down, and the answer was left to the eye of each beholder. Zochert also pointed out, with true Chicagoan brio, that the sculpture had become a success by Chicago's standards as the city just put a chain fence around it (which has been since been removed).[100] Picasso's great peer and fellow Spanish sculptor and painter Joan Miró had a different reaction. When commenting on the initial controversy over Picasso's sculpture (located just across Washington Street from his own 1981 gift to Chicago at the Brunswick Building), Miró stated: "That is as it should be. A great work takes time to appreciate, bit by bit. If something is understood immediately, it is mediocre!"[101]

Part of the reason for the uncertainty, of course, was that Picasso himself refused to speak about the sculpture's provenance or even to name it, an act of negative creativity that opened up the sculpture's field of meaning and made it truly public. This, even more than the refusal of the $100,000 commission, was the measure of Picasso's generosity: by allowing the public to take ownership of the sculpture's essential meaning, he created a space for an open and genuinely democratic discourse. Chicago native and world-renowned sculptor Richard Hunt said Picasso should not have named the important metal sculpture. "I do not always title my own works either. I suggested it should be referred to as the Chicago Picasso right after the unveiling. Twentieth-century modernism gave the artist the opportunity to do things that did not have to be held to a narrative."[102] Others felt the gesture was wasted. Art critic and professor Franz Schulze, with characteristic asperity, wrote that the controversy over the sculpture's inspiration

has been good for the publicity, but the people should get to thinking about the meaning of the work ... It is more than irritating, it is depressing to see the

meaning of the sculpture sacrificed to press agentry, to the fun and games of the communications media, for it underscores again the enormous extent to which image-promotionalism dominates art in our society. Evidently the last thing we will pay attention to in the Chicago Picasso is the work itself.[103]

Schulze, years later, elaborated on his frustration with the confusion of intent and of identity, which he saw as a murky intersection of public relations, civic design, and artistic egotism:

Whatever else the piece was, then, it had to be Art — sculpture, that is, hardly just a statue — if for no other reason than that there was no history to be recalled from looking at it, no civics lesson to be learned, neither a hero to be remembered nor a saint to be revered. The experts recognized it simply as the bust of a woman, chiefly because it bore a close resemblance to other Picasso works certifiable as female heads. The public was less sure. From the summer of 1967 onward the Picasso head has been the steady subject of such debate, while becoming a civic fixture. Perhaps more significantly, however, it cleared the way for the appearance of many more objects like itself: large, often mammoth works executed in the "modern manner" (seldom definable as somebody or something), erected in public spaces at considerable public expense, and accompanied by public fanfare.[104]

Schulze, who elsewhere dismissed the piece as "a monument to Picasso, rather than a monument by Picasso,"[105] was not alone in his cynicism on this front. Others had long suspected that Hartmann was behind the hiring of the prestigious advertising firm Foote, Cone & Belding to drum up publicity for the sculpture, and at least one insider architect dismissed the Picasso as "very important to Hartmann, but not so important for our firm."[106] In any event, opinions about the nature of the sculpture's inspiration were not confined, of course to Chicago. John Canaday, of the *New York Times*, felt that tying the sculpture's identity to a person, that is, anthropomorphizing it, detracted from the abstract purity of the imagery. "Rather than not looking enough like something," Canaday wrote,

it looks too much like something. Simply as an object, as a thing all by itself, the sculpture is a handsome design.... Regarded as a huge abstract stabile (borrowing Calder's term) the Picasso is a brilliant success in situ. The trouble comes when the abstract stabile turns out to be only a semi-abstract sculpture.[107]

Hartmann was no help, saying "Picasso thinks the sculpture ought to speak for itself, and I, moreover, do not believe I should act as the interpretive intermediary between an artist and his work,"[108] a statement consistent with an earlier

formulation of Hartmann's: "Picasso is a controversial figure and he would not find controversy unexpected. He would find silence less bearable."[109]

An early and visually compelling case was made for the inspiration for the sculpture being Kabul, the Afghan hound who was Picasso's household companion in France for many years, including the time during which he was working on the maquette. Picasso's affection for dogs was famous—the photographer David Douglas Duncan published a whole book of photographs of Picasso with his dachshund Lump—and their images often made their way into his artwork along with birds, reptiles, sheep, cattle, and other animals. Duncan wrote a letter to the *Chicago Tribune* in 1967 from Saigon, where he was on assignment covering the war in Vietnam, explicitly stating that the sculpture was a portrait of Kabul, pointing out the obvious afghan characteristics of long snout and long ears, and suggesting that the artist confirmed this identification.[110] The shape of the snout and the ear structure does have a certain canine tilt to it, to be sure, an aspect reinforced by a famous photograph taken after a snowfall in 1967 in which the Chicago Picasso takes on more of an afghan appearance than

Pablo Picasso, *Portrait of Sylvette David*, 1954; oil on canvas, 51⁷⁄₁₆ x 38¹⁄₁₆ inches; gift of Mary and Leigh Block, The Art Institute of Chicago; artwork © 2017 Estate of Pablo Picasso / Artists Rights Society (ARS), New York

the artist probably ever would have imagined: the snow looks like the shaggy coat and ears of a real Afghan dog.[111] Hartmann dispatched this photograph to Picasso who, reportedly, was amused. In the end, though, it seems unlikely that Picasso would have molded such a monumental project, such a central part of his legacy, in the image of even as a beloved an animal as Kabul.

Another supposition is that the inspiration for the sculpture was Sylvette David (now known as Lydia Corbett), a young Frenchwoman whom Picasso met in Vallauris in 1953 and whom he subsequently used for a few months as the subject of a series of paintings and small metal sculptures, including the bust that became the basis of the Nesjar concrete enlargement sculpture at New York University. Picasso, of course, had a lifelong habit of turning the women in his life into muses. Critic Roberta Smith once wrote of Picasso's art that "depictions of women, predominantly his wives and mistresses, form its very core. Few artists have invented so many ways to convert the machinations of ego and id into image."[112]

In 2004, Olivier Widmaier Picasso, Picasso's grandson via Marie-Térèse Walter, Picasso's mistress from 1927–35, identified Sylvette as positively the

model for the Chicago Picasso in an interview with the *Chicago Sun-Times*, while on his book tour in Chicago,[113] a view that is explicitly propounded by Olivier's sister, Diane Widmaier Picasso. It is undeniable that several of the 1954 portraits of Sylvette, with their angular framing and radii of pulled-back hair, bear a striking resemblance to the Chicago work. Art Institute curator Stephanie D'Alessandro, a knowledgeable and perceptive historian, has come to the conclusion that the Widmaier camp's claim has merit and that the inspiration for the Chicago Picasso is, indeed, Sylvette. "The wonderful thing about Picasso," in D'Alessandro's words, "is he is constantly returning to other moments in his work and bringing them back into new works. Of course, since the artist never named the sculpture, there is great value in debating the other possibilities as the inspiration."[114] However, returning to the young Sylvette seems an unlikely justification here over 10 years later. Picasso did, of course, return to visual motifs and themes repeatedly during his career—it is one of his defining traits as a modernist—but once a woman was out of his life he never again used her as a model, a pattern that dates back to his earliest days with Dora Maar and with all of the many subsequent women who served him as muse.

The more obvious possibility for the motivation is, of course, Jacqueline Roche, Picasso's mistress and later wife and the woman who was his closest companion over the last 20 years of his life, including all of the time that he worked on the Chicago Picasso. Contra Widmaier Picasso, the evidence seems extraordinarily persuasive. From about 1960 on, portraits of Jacqueline—whom Picasso wooed with a single rose, daily, over the course of six months for his first date in 1954—dominated a large part of Picasso's oeuvre in every medium. According to the artist's close friend Hélène Parmelin,

All the portraits are like her, even if they are not like each other. All the heads are hers and there are a thousand different ones. All the eyes are black, all the breasts are rounded; it is raining Jacquelines all over the house.[115]

Parmelin's book about this fruitful period in Picasso's life includes a charming poem that the former wrote, which runs, in part:

None of the Jacquelines is like another.
What then is a portrait?

A ribbon holding the hair one morning –
result: the birth of twenty iron heads.[116]

Make it 21 iron heads. In the end, one is tempted to add the ultimate monumental Chicago sculpture. Picasso returned to Jacqueline as his subject hundreds of times because he seemed to keep seeing more, and therefore,

had more to say both on canvas and in sculpture. As critic John Berger wrote, "a woman's head is drawn in a dozen different ways, is almost endlessly improvised upon, because no single representation can do her living justice."[117]

At least two scholars have hedged their bets by maintaining that the Chicago Picasso is a representation of both Jacqueline and Kabul, a kind of hybrid woman/animal synthesis. In a 1977 *Art International* article, the historian William B. Chappell traced Picasso's previous inclusion and metamorphosis of his earlier Afghan Kazbek during the artist's Dora Maar years (late 1930s to early 1940s), in coming to the conclusion that the subject of the sculpture was this indeterminate hybrid.[118] In the dual portrait of June 7, 1962 the Afghan's Cyclops-styled eye, long snout, and nostrils have obvious likenesses to the Chicago work. However, Chappell only looked at the hound, which was painted into the lower left corner, and ignored the more dominant figure of Jacqueline in the composition. This Jacqueline figure also has affinities to the design for Chicago: permanent Cyclops eye, multiple profiles, lines along the head where the hair is pulled back with a ribbon, and large coifs of hair.

Between December 1961 and 1962, Picasso painted six canvases, which included portrayals of Kabul and Jacqueline. Sir John Richardson, one of Picasso's biographers, vividly describes their genesis:

Shortly before Picasso's eightieth birthday (October 1961), the construction of a skyscraper next door to La Californie forced him to move away, and he is now installed in a large villa in the country near Mougins. Here, in seclusion, he has been painting his favorite subject, Jacqueline, whom he recently married. Once again his style has changed, and he sees her partly in terms of Manet and partly in terms of his Afghan dog, Kabul. But these "dog faced" portraits are painted with affection and humor.[119]

Another of Picasso's biographers, the psychologist Mary Mathews Gedo, came to a similar conclusion:

The Chicago Picasso seems to have originated as a magical metamorphosis; in this case he fused the muzzle of his afghan hound, Kabul, with the features of his wife, Jacqueline. Earlier analogies for this transformation can be found in paintings of the late thirties which depict a similar merger between the face of his mistress, Dora Maar, and that of an earlier afghan, Kazbek. The Chicago Picasso, fruit of this synthesis, is a marvelous hybrid; at once feminine and canine.[120]

It is, Gedo concluded, "a recapitulation of earlier works. It goes back to 1929 and the monumental projects and buildings ... the sculpture clearly represents Jacqueline when viewed from the side."[121] This squares with Parmelin's account of how "Kabul, royal afghan, joins the seated Jacquelines in the pictures with

his infinite nobility.... Sometimes something even passes between the head of a nude and that of Kabul—on the canvas appears an afghan's nose, a human face—as much the one as the other."[122] Or as Abrams editor Milton S. Fox wrote in his introduction to Parmelin's book, these "amusing dog-and-woman mélange(s)" are the result of Picasso's perceptions becoming "entirely free and fluid":

He feels no inhibitions whatsoever in taking traits or aspects of one thing and infusing them with traits of another. And so, bold female images — the emphasis is on full breasts, rounded haunches, sex, eyes — are parallel with the nonchalant movements and pose of Picasso's Afghan hound, Kabul, and suddenly the faces become as much Kabul as human.[123]

The hybrid hypothesis is interesting to mull, but eventually must yield to the far more substantial conclusion that Jacqueline, and Jacqueline alone, was the inspiration for the sculpture. A close study of Picasso's working methods since

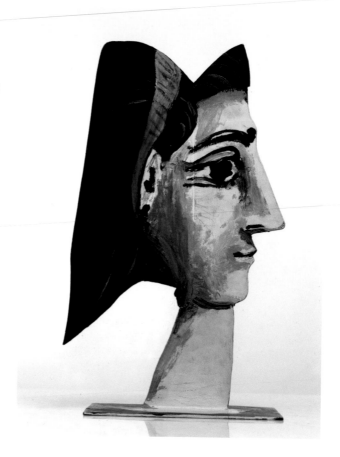

their meeting in 1954 shows that she permeated his work with a presence unmatched by any of the many women who preceded her in roles as Picasso's muse. Richardson, again:

During the first half of 1954 Picasso's morale was low. In the absence of female companionship he traveled restlessly around the south of France visiting friends and going to bullfights. Toward the end of this bleak period Picasso painted some fifteen tender portraits of Sylvette David, which have had wide appeal, anticipating the fashion for the kind of looks that Brigitte Bardot has popularized. In the final portraits of Sylvette the features subtly change their cast; this is because the artist had fallen in love with the young and beautiful Jacqueline Roque and, as always, had begun to see other people in terms of his beloved. A number of portraits done in a new style in keeping with the looks and appearance of his sitter, reflect the artist's new-found happiness. Later in the year, when he went to Paris, Picasso took Jacqueline with him, and while there he painted the impressive series of variations on Delacroix's *Femmes d'Alger* — oblique allusions to the Delacroix-like looks of his companion.[124]

Jacqueline as muse was perhaps the most complex, psychologically daunting, and ultimately unknowable dynamic of Picasso's career—the operations of her influence on his understanding and execution of portraiture are nearly limitless. For starters, "to list all the portraits of Jacqueline is," in the words of Klaus Gallwitz, "a fruitless undertaking, for the traces of identity are elusive—and indeed sometimes escape us altogether, although the 'legibility' of the situation and its biographical content are usually beyond question." He continues:

Picasso slipped into the role of painter, Jacqueline that of model. But the partners are no longer recognizable: The dialogue leaves all private motives, experiences, and reflections far behind; the ever-changing combinations soon reveal the painter's conversation with his model to be an exemplary self-examination.... Every one of these multifarious portraits not only presents a new formal concept, but also opens up new psychological realms, reflected outwardly through posture, glance, and color.[125]

Viewed this way, the Chicago Picasso with its serene, soaring profile can be seen as the ultimate psychological realm to be explored, presented, and made manifest.

Many who were present at the initial phase of the "multifarious portraits" confirmed Gallwitz's understanding of this unique relation. During a 1954 visit David Douglas Duncan observed Picasso working with a three-dimensional sheet-steel head of Jacqueline, in which the neck was a vertically welded section of three-inch pipe. As he rotated the triple-flanged head, the artist said: "Jacqueline! It is something very rare!" Duncan then related how when Picasso then "sat back with Jacqueline, laughing about the whole thing, I suddenly saw the thrust of the sculpture's steel profile when compared to that of the girl herself. They were the same."[126] Effused Duncan: "Cézanne–Matisse–Modigliani ... masterpiece upon masterpiece ... for Pablo Picasso, the masterwork was Jacqueline!"[127] Lionel Prejger, working with Picasso on the metal cut-outs that directly preceded the Chicago maquette, confirmed Duncan's observation. "Before the chair and after the eagle," the metalworker wrote of one such series, "there were portraits of Jacqueline, some peaceful and some tortured, and folded in such a way that life was visible in this cold material of sheet metal."[128] Penrose noted that "Picasso began very young to make portraits of those for whom he had particular affection," a pattern that culminated with

the devoted and tenacious presence of Jacqueline with the serene eye of an Egyptian goddess. The likenesses are convincing and penetrating.... The portraits can be divided into those that are representatives and those that are conceptions of an idea generated by the woman who dominated his emotions at the time.[129]

Implicit in Penrose's statement is that out of the thousands of sculptures and paintings Picasso made of his wives and mistresses over six decades, never did he return to depicting a former inspiration once the woman, whoever she may be, had left his life. Jacqueline and Picasso married in 1961; she was with him until the day he died. The photographer Lucien Clergue, whose own daughter was Picasso's goddaughter, remains in the Jacqueline camp,[130] as does SOM architect Fred Lo. Diana Widmaier Picasso met with Lo twice in late 2014, and gave him a gift of her book *Sylvette, Sylvette, Sylvette;* nevertheless, Lo remained firm in his conviction that the "Chicago Picasso is not Sylvette, but Jacqueline."[131]

Picasso and Jacqueline themselves were reportedly amused by the baffled reactions of the Chicagoans to the monumental sculpture. "Can't they see it's a woman's head?" asked Jacqueline.[132] She could just as easily have asked—can they not see who she is? For both the sculpture and Picasso's muse and wife, the profile is classic, the eyes are large and almond-shaped. Jacqueline was usually quite casual about her hair, often tying it back with a triangular scarf or pulling it back with a ribbon or headband. In the latter styles her hair at the back of the ribbon rose up slightly at the crown of her head and then separated, a characteristic that is explicitly represented in the planar hair shapes of the Chicago sculpture.

Why the secrecy and confusion? It is unpleasant but perhaps necessary to note that the topic of the identity of the sculpture's inspiration has been a painful one for the Picasso heirs, many of whom were treated peremptorily by Picasso and Jacqueline, and who were openly resentful of the control Jacqueline exerted over the aging artist, including access to his very presence. She controlled all visitors so that the master was able to continue his amazing productivity even as he aged. The conflicting views of his final muse were made especially evident by a 2014 show at Pace Gallery in New York dedicated to the art that she had inspired; the *Wall Street Journal* made special note, in a review, of

the ambiguous role she played for Picasso's family and friends. Early on, she developed a reputation for being manipulative, avaricious and conniving, initially because she came between Picasso and Gilot. Once installed at La Californie, the artist's grand Cannes villa, she guarded his privacy jealously, shutting out even his children and grandchildren so he could focus on work. After his death, Jacqueline disappeared into seclusion for three years, emerging only to battle with his heirs over the disposition of his estate.[133]

In 1964, Picasso threatened legal action against Françoise Gilot for publishing *My Life With Picasso*, first in English and then in French; Picasso retaliated by cutting off all contact with their children, Claude and Paloma. Actually,

the artist was so distraught about the publications that he was unavailable to Hartmann and the Chicago architects in 1964 and delayed meeting with them, although he already was preparing for the Chicago monument. As it happens, Gilot went on to move to southern California and marry Jonas Salk, the inventor of the polio vaccine. Other women who fell into Picasso's orbit were not so lucky; both his first wife Olga and his mistress Marie-Thérèse Walter committed suicide—as would Jacqueline, in 1986, after grieving for 13 years after Picasso's death.

Gedo noted "eventually, not only the artists' ex-mistresses, but his three illegitimate children were denied all access to him. Finally this ban was extended to include even his grandchildren and the offspring of his legitimate son Paulo."[134] After so many decades of mistresses and heartaches, the children and grandchildren have had great difficulty accepting that the new woman Jacqueline controlled the artist's visitors and daily life. Perhaps this sadness contributes to the Widmaier Picasso camp's insistence that Sylvette, and not Jacqueline, was the true representation for the ultimate monumental sculpture, although it is worth pointing out that the Widmaier Picassos never knew the great man and were established as his legal heirs, by French law, only in 1972. Jacqueline and the offspring of his late first wife Olga were always considered entitled to full legal status with inheritance, legal paternity, and use of the famous Picasso name—but the children and grandchildren born to two of Picasso's mistresses challenged them. The court battles lasted six years and cost over $30 million in legal fees, but the end prizes were worth it for all concerned. A 2016 *Vanity Fair* article stated Picasso left behind 45,000 works at his death and that the Picasso empire is now valued as a multi-billion-dollar empire.[135] More to the point here, the offspring were unwilling to recognize that Jacqueline became the source of the artist's creativity his last 20 years, while Picasso lived in the present, not the past.

For the millions of people who have enjoyed the sculpture over the last half century, though, the debate hardly matters. What is undeniable is that over time, the work has gradually seeped into public consciousness as a woman's head and is universally referred to in the feminine gender. The monumental work became a "she" and no longer an "it." The year 2017 is not just a civic sculpture's anniversary, but also her 50th birthday. Chicago has grown accustomed to her face.

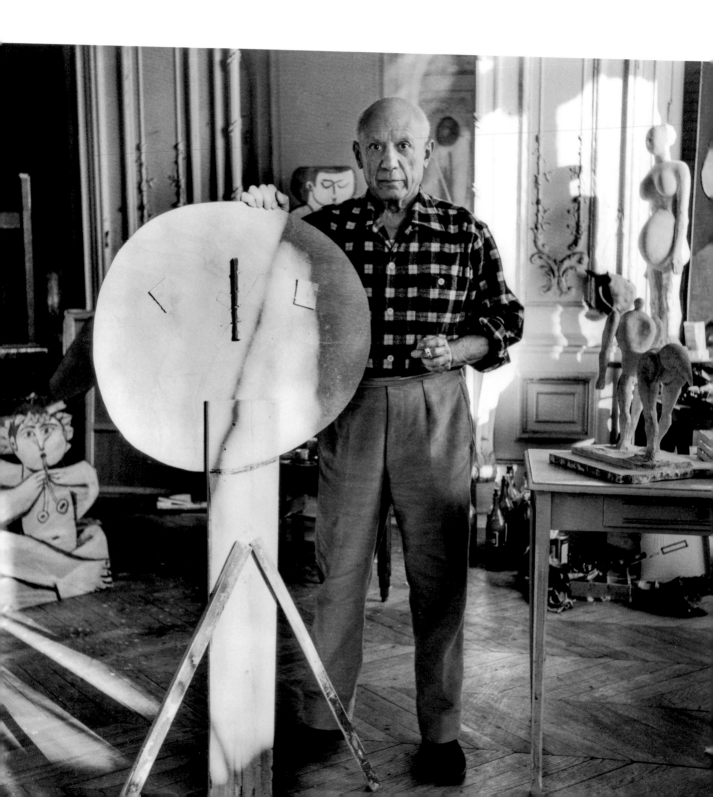

6. Legacy: A Point of Departure

In one of his rare statements about the Chicago Picasso, the artist said, soon after its unveiling:

I am touched that the public could mysteriously share my joy over the results of many years' work in sculpture. In a way, my sculptures are more my children than my paintings; I am caught up in shaping my vision on the world. In sculpture I cut though appearances to the marrow, and rebuild the essentials from there. I cannot invent a detail that has not been carefully planned, and my wish is that the public, through thinking and meditation, may retrace my intentions.[136]

In the half century since, those intentions and their ramifications have extended in myriad ways: into ideas of public art, into questions of ownership and identity, and into the very fabric of the city's character. As a defining element of a world-famous city, as an inspiration for countless sculptors, architects, and urban planners, as the site of dozens of movie scenes, protests, guerrilla acts of vandalism, riots, and celebrations, its significance seems to expand exponentially: the maquette on the table in the villa at Mougins was indeed a point of departure of the most profound impact and scope.

The first, and perhaps most lasting, facet of the sculpture's legacy came almost immediately with questions about, essentially, who owns the image of the Picasso? The tortuous resolution of this question would have lasting ramifications for the future of public art universally. Just days before the unveiling, the Public Building Commission of Chicago affixed a plaque to the base of the statue reading: "© 1967 Public Building Commission of Chicago, All Rights Reserved." The copyright registration was filed by the PBCC in January 1967, indicating publication on the official date of the dedication ceremony. The formal registration was followed by the announcement of a policy that individuals could make photographs, sketches, and replicas for personal noncommercial purposes, but reproductions for commercial purposes were subject to a license grant by the PBCC, with fees and royalties for a new scholarship and civic affairs program.

A flood of applications were filed immediately, including requests for use as or on statuettes, etchings, jewelry, medallions, pajamas, greeting cards, candy boxes, commemorative plates, mugs, and souvenir items such as stickers,

playing cards, and key rings. (Hartmann bought several 14K gold pendants of the sculpture and gave one to Jacqueline and one to his own wife, Bente.) Initially the PBCC granted some exceptions: Rand McNally was not required to pay a fee for using the image on the Illinois Bell Telephone Directory cover, nor was local journalist Jory Graham for the use of the image on the dust jacket for her book *Chicago: An Extraordinary Guide.* But when a national liquor company ran a print ad with a picture of the sculpture and a whiskey bottle with the copy "I don't know much about art … But I know what I like,"[137] the PBCC tightened the restrictions considerably.

The tipping point in the situation came when a local barber across Washington Street from the sculpture wanted to use a picture on his business card, and was refused. This seemingly small action started a chain reaction of events that would ultimately end in the placing of the Picasso in the public domain, as the property of the people of Chicago. Enter Barnet Hodes, an attorney at the firm of Arvey, Hodes, and Mantynband, a law firm long interested in pro-bono-publico work. Hodes had amassed a substantial art collection and was well known as an art activist; he had also served as corporation counsel for the city of Chicago for nearly 15 years, before Daley became mayor. Hodes's son, Scott, recalled, "Many people felt the PBCC shouldn't have this public work of art all locked up, and so my father took up the cause. You don't have to be an art enthusiast to be offended by the city's exploitation of this major gift from Picasso and three local charitable foundations."[138]

Barnet Hodes was well acquainted with William Copley, an artist and collector, who, as it happened, had recently commissioned a piece by the famous sculptor Claes Oldenburg, based on the Picasso. Oldenburg had expanded his reputation with sophisticated "soft" sculptures replicating common objects in oversized, flexible canvas and vinyl: an intellectually playful turn of the screw in the spiraling collective *jeu d'esprit* that was Pop Art in the 1960s. Oldenburg built a 42-inch cardboard version of the original maquette and added patterns sewn in rust stained canvas, as well as a spine that enabled the piece to be twisted into any shape. "It really biomorphized the object," Oldenburg was quoted as saying. "Picasso is known for the hardness of his work and I just wanted to see how it would look soft…. It is no lampoon of the Picasso, which I like very much."[139] Indeed, Oldenburg respected Picasso's ambition to reinvent monumental sculpture. He said, "Picasso's Chicago sculpture was a special subject for me because it was one of the first sculptures of architectural scale—the scale I would later work in—put up in an American city. And of course I grew up in Chicago." More than mere homage, Oldenburg considered his own sculpture a natural extension of the theoretical implications of cubism, a sort of "Super-Cubism." *Soft Picasso*, according to the artist, "was more cubist than most cubism: in a cubist sculpture, you can see an object from perhaps ten different viewpoints; in mine the viewpoints were unlimited."[140]

Claes Oldenburg (1929–), *Soft Version of the Maquette for a Monument Donated to Chicago by Pablo Picasso*, 1968; canvas and rope painted with acrylic, 38 x 28¾ x 21 inches; courtesy of Musée National d'Art Moderne, Centre Georges Pompidou, Paris; reproduced with permission of the Oldenburg van Bruggen Studio, New York; photograph by Philippe Migeat © CNAC / MNAM / Dist. RMN-Grand Palais / Art Resource, New York; artwork © Claes Oldenburg / Artists Rights Society (ARS), New York

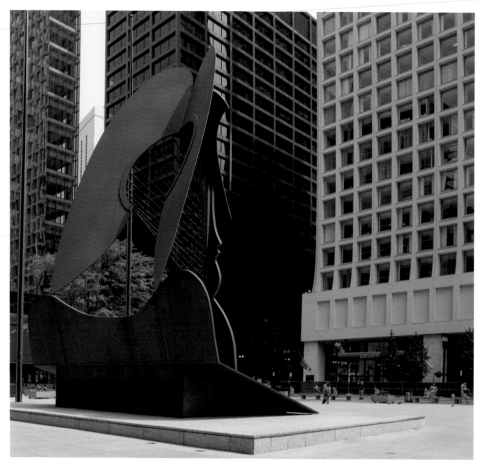

**Chicago Picasso, 2015;
photograph by Mike
Schwartz Photography,
Chicago**

Copley wanted to include a photo of Oldenburg's pieces in his recently incorporated magazine, *S.M.S.,* that was published by his own short-lived press, Letter Edged in Black Press, without getting permission from the PBCC. So with Hodes representing the barber and Copley representing his magazine (and Oldenburg generally), the two formally filed an appeal against the PBCC's assertion of copyright. The case was sent to adjudication before federal circuit judge Alexander Napoli, who promptly requested that letters between Hartmann and Picasso be turned over, to which request Hartmann did not accede, maintaining that the letters were of private concern to him only. (It is worth noting that Hartmann did not have a problem with the copyright itself, but felt it was his duty to intercede on behalf of Picasso against the possibility of poorly executed reproductions.)

Meanwhile, Oldenburg's *Soft Picasso* made its first appearance in Chicago at the Feigen Gallery in the spring of 1969. Later that year it appeared at Sidney Janis Gallery in New York and in a MoMA exhibition of Oldenburg's sculpture, for which Barbara Rose published the catalogue with a soft-vinyl cover in approximation of the artist's soft pieces. Perhaps sensing that the tide was turning against them, in 1970 the PBCC allowed that *Soft Picasso* did not violate the copyright, as Oldenburg held the prerogative to his own form of expression as a recognized artist himself. The admission turned out to be moot, for in December, Napoli issued a decision stating that the copyright to the work known as the Chicago Picasso is invalid and that it is part of the public domain. Further, he said a provocative piece of public sculpture can only have the end result of benefiting society.[141]

It was a resounding rejection of the PBCC's attempt to control the image of what art historian and curator Robert Rosenblum had accurately called "Chicago's own Statue of Liberty,"[142] and a forceful statement of the value of public art as being located in its communal accessibility. On Christmas Day, 1970, Oldenburg wrote to Hodes: "Dear Barnet, Hooray for your victory, for justice, soft sculpture, and every mother's barber son's right to use Pablo Picasso's paperweight for the City of Big Shoulders! Will I now be able to buy my postcard at O'Hare Airport? Happy Holidays."[143]

As the Chicagoans grew used to their sculpture their affection for it began to increase. The evolution of the sculpture's reputation among the professional class of architects and art historians, however, remained widely varied. Several felt that the translation from maquette to monument was not handled well. Jacques Brownson, for one, felt the final piece lost some of the artist's personal feeling because it lacked the handicraft qualities of brazing and assemblage visible in the maquette.[144] He thought the flexibility and delicacy of the thin metal cut-out were missing in the stiff and static monument, having been sacrificed by the over-conservativeness of the engineers, a view shared by Joshua Kind and Morton G. Neumann. According to the latter the sculpture was less a piece of art and more

an engineering job by Hartmann and his associates. The workmen worked on the basis of the scale model, but the finished piece lacks aesthetically of Picasso's handwork and supervision.... A scratch by the artist is better than anything by engineers. It gives Picasso and the city a name and makes people aware of the artist, so I guess it is better than nothing.[145]

Gedo was also ambivalent: showing caution about the originality of the piece as well as the artistic merit of any work from so late in Picasso's career, she called it "the masterpiece of his late period," while noting that "in his late years he worked because he could not stop, not because he had anything

Top: Richard Hunt (1935–), *Freeform*, 1993; welded stainless steel, 26 x 35 x 2 feet; State of Illinois Building, 160 North LaSalle Street, Chicago; photograph by Karina Wang, PhotoScapes, Chicago

Bottom: Alexander Calder (1898–1976), *Flamingo,* 1974; painted steel stabile, 53 feet; Federal Center, Chicago; photograph by Karina Wang, PhotoScapes, Chicago; artwork © Artists Rights Society (ARS), New York

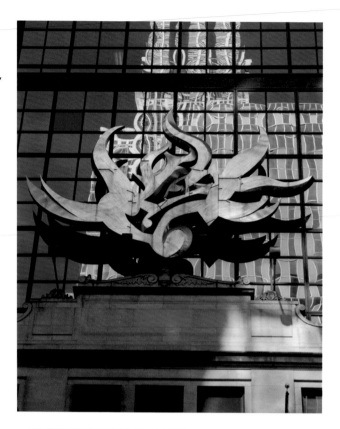

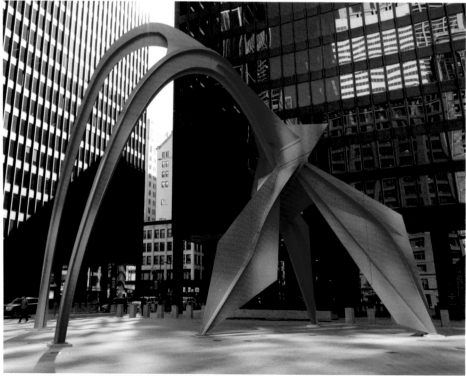

to say."[146] Franz Schulze's assessment ran along similar lines with Gedo: he stated that "It is not a masterpiece or even a distinctly original creation," but that nonetheless "Picasso's customary and most impressive strengths—his monumentality of form and content—are asserted here."[147] A half century has not softened Schulze's judgment; the venerable critic recently confirmed his impression that the maquette was "a third-rate Picasso, at best," adding the qualification that "the sculpture is successful in the sense that its purpose is now identified with Chicago."[148]

Others pronounced it an unqualified success. International art critic Robert Hughes appraised it "a beautiful success in the juxtaposition of the Picasso head against the building, with the identicality of the material to the advantage of both. There is a play-off of scale, too, that occurs due to the grid of the building design and the metamorphic character of the sculpture."[149] Chicago critic Dennis Adrian stated flatly that the Chicago piece was Picasso's most successful monument, that it is amazingly good, and the plaza would be deadly without it.[150] And virtually everyone agreed that the sculpture was a boon for the city specifically and for the idea of public art in general, a point perhaps best made by art dealer R. Stanley Johnson: "Picasso's sculpture will catapult this nineteenth-century city into the twentieth century. For the first time the average person may learn to see—really see. Picasso will open new horizons and new scenes for all of us."[151]

This last statement did indeed come true in more ways than one. The many sculptors and artists in the Chicago area may initially have been irritated that an outsider, a foreigner no less, was given the opportunity to construct the city's best-known installation, but the success and fame of the Picasso quickly redounded to their benefit. Although there is currently much emphasis on local artists for public commissions, they were not considered for work on such a colossal scale in the early 1960s. While some might have been able to rise to the occasion, the primary concern of local artists and art groups was that a major piece of sculpture would be included in Civic Center Plaza. Richard Hunt, who was a young sculptor during the early 1960s and product of the School of the Art Institute, was executing metal sculpture of only five to six feet. About the Chicago Picasso he commented: "Well, I think it's very fine… Unlike the *David* in the Palazzo Vecchio, you know the arms won't break off when they climb on it… It's like a sculpture that's very much public in that… it's indestructible [and] it's being used."[152] To Hunt, the sculpture's monumentality is central to its meaning; as pleasing as the maquette is, the sheer size, the tonnage, the raw power, of the monument in situ is deeply intrinsic to its affect. In terms of the totality of impact, only Calder's *Flamingo*, from 1974, truly compares to the Picasso. It too sits in a plaza, and its open structure and steel frame invite public interaction, even play. In contrast, the nearby Chagall is a mosaic and rather decorative; the Dubuffet is colorful and seems like it is a Disneyesque

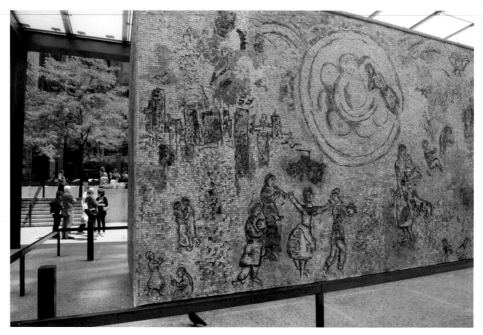

Marc Chagall (1887–1985),
The Four Seasons, **1972;**
mosaic, 70 x 14 x 10 feet;
Chase Tower Plaza, Chicago;

photograph by Karina Wang,
PhotoScapes, Chicago;
artwork © Artists Rights
Society (ARS), New York

building block set; and the Miró is not large enough and is in a dark space so is hardly noticed.[153]

On a broader plane, the influence of the Picasso was even more radical, if subtle, than its progenitors could have imagined. In showing that a high modernist piece could exist as a public statement on a grand scale, the Picasso pushed against conventional assumptions in a way that would set a precedent for other artists to follow. The land art of Robert Smithson and Walter de Maria is inconceivable without the Picasso. Richard Serra's famous—or notorious, depending on whom you ask—piece *Tilted Arc*, its 1981 installation in downtown New York, and the ensuing outcry and heated controversy plays out like a postmodern reprise of the Picasso's advent.

The Picasso's impact went beyond the purely artistic. The preeminent Chicago gallerist, Paul Gray, pointed out that the Chicago Picasso acted as a spur for business and as a visible and highly public endorsement of the value of sculpture. Similarly, the sculptor John Henry has even gone so far as to state that the Picasso served as a flash point for a nascent community waiting for the proper recognition. In the mid-1960s, according to Henry, "there were only two people who tried to make large sculpture in Chicago, Steve Urry and myself. Richard Hunt had never made a large piece at that point."[154] Within a few

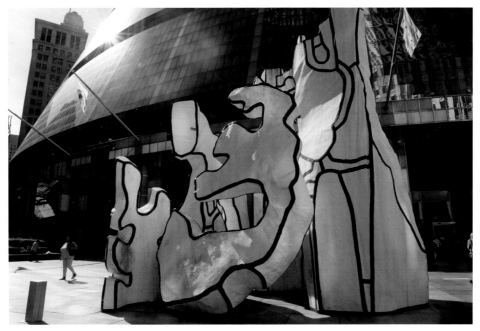

Jean Dubuffet (1901–1985), *Monument with Standing Beast*, **1984; fiberglass, 29 feet; James R. Thompson Center, Chicago;** **photograph by Karina Wang, PhotoScapes, Chicago; artwork © Artists Rights Society (ARS), New York**

years Mark DiSuvero, Jerry Peart, and Berry Tinsley—having decided to make Chicago their base instead of New York—received much encouragement and support from the Museum of Contemporary Art and several local contemporary galleries. The tide of interest in sculpture that followed the Picasso allowed all three of them to start a combined gallery, CONSTRUCT, not long after. According to Peart,

The Picasso and the Grand Rapids Calder really started the movement for public acceptance of large-scale sculpture. The Picasso had a very large effect; not just on artists, but on the people and on the plazas. It just wouldn't go away. The abstract quality of it was important — the first and daring kind of thing here. The piece really set some precedents. It was the first use of that material on that scale! And it showed that the artist did not need to be here; that sculpture could be executed by a third party and still be "a Picasso."[155]

Specifically, the Dearborn Street corridor that developed with the Calder stabile *Flamingo* at the Federal Center, the Chagall mosaic *Four Seasons* for former First National Bank, and the Miró *The Sun, the Moon and One Star* at the Brunswick Building across Washington Street from the Picasso, can all

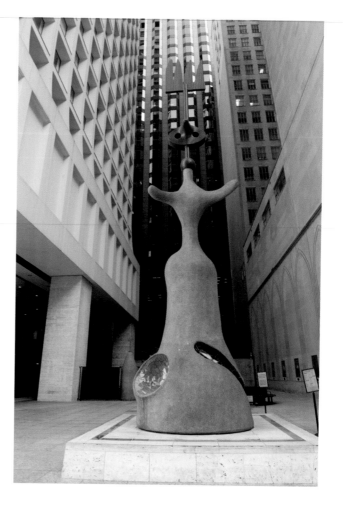

Joan Miró (1893–1983), *The Sun, the Moon and One Star*, now known as *Miro's Chicago*, 1981; mixed media, 39 feet; Brunswick Building, Chicago; photograph by Karina Wang, PhotoScapes, Chicago; artwork © Artists Rights Society (ARS), New York

trace their lineage to the now-named Daley Plaza sculpture. As early as 1976 Henry said "In the mid-1960s everybody said 'what is it?' And 'why is it here?' I don't think anybody now has any questions about the value of sculpture."[156]

T. J. Clark framed these values in a characteristically dualistic formulation. In *Picasso and Truth*, the eminent critic mused on the potential of monumental sculpture in general for making unique visual statements:

Monumentality in Picasso … is aloneness. It is being set apart. Sculpture is its necessary matrix, then, since what is sculpture but the act of stilling, isolating, making over the mobile and vulnerable into a material which allows it to persist — petrifying or metallizing it, giving it a suit of armor that is (so the statue persuades us) what the body is capable of being? Here is what sculpture does most deeply. It makes the human a singular upright, with us moving round it, keeping our distance instinctively, knowing that the point of the monolith is its apartness from the world of our wishes. And a version of this kind of distance, says Picasso, is all the monumentality

we are now capable of — in its odd way heroic, but not perfect or complete, and not putting the spectator in awe. Singleness is aloneness.[157]

Pivoting from the idea of the heroic and singular to that of the public and social, Clark expands on the theme, remarking that, "of course monumentality—sculpture—need not, and maybe should not, be like this. It should be accompaniment, familiar idealization, sewn into the texture of everyday life." In this formulation, the Chicago Picasso qualifies on both counts, especially since it has indeed been "sewn into the texture of everyday life." With the passage of time, the Picasso has become intertwined with the very identity of Chicago and to become a central part of the city's public life. In Hartmann's words, "Since the unveiling it has been the scene of many events.… It has gone from controversy itself to taking part in the controversy of the city. The statue adds dimension of humanity to things that go on around the urban core of the city."[158]

In this particular case, it did not take long for the Picasso to become a backdrop to turbulent contemporary history. In 1968, when Chicago and Mayor Daley hosted the National Democratic Convention, riots took place in the Civic Center Plaza. Chicago policemen with machine guns and National Guardsmen on tanks were prepared to carry out the mayor's famous "shoot to kill" order against the political demonstrators gathered around the Chicago Picasso. Radical Abbie Hoffman, Yippie (Youth International Party) leader of the "Chicago Eight," declared: "Everything in the city goes but that. Picasso's a Communist and it's great,"[159] before releasing the Yippie candidate for president—Pigasus the Pig—onto the plaza. The following year, during union demonstrations from a racially inspired union dispute, white workers scaled the sculpture and aired their views from the new podium. Boot marks left by construction workers who climbed the statue faded within a year, but it took longer for the words on the face of the monument that read "Blackstone Nation."[160] In 1971 the sculpture was the target of a Molotov cocktail hurled by a self-proclaimed art lover.

As the vitriolic days of the late 1960s passed, the sculpture became ubiquitous in more accessible and happier contexts. It was featured on the cover of countless magazines and guides to Chicago, as well as in numerous tourist-oriented and commercial publications (a 1977 *Daily News* survey found that the Picasso was the best-known Chicago landmark, with 50 percent of the residents of far-off Aieu, Hawaii correctly identifying the sculpture).[161] It has become the subject of amateur poetry, media cartoons, and songs—including the 2014 "Bulletproof Picasso," by the American rock band Train, in which the singer sings "We don't need a reason / for anything we feel / we don't need a reason / Picasso's at the wheel"; the album art featured a vintage Cadillac convertible with a license plate reading PICASSO.[162] The sculpture was featured in a 1980 exhibit titled "Glimpses of America" that was part of a cultural exchange with China intended to "give our Chinese friends a broad and honest view of America."[163] Maybe the

most idiosyncratic reaction took the form of a 20-page essay by Edwin R. Herrick, a hierophant, who tried to explain it in terms of his own bizarre religious context. Certainly Picasso, a self-proclaimed atheist, (as well as any clear thinking person) would have found incomprehensible "A Spiritual Interpretation of Chicago's Picasso, Michelangelo's Pieta, and the 23rd Psalm."[164]

A wrinkle of a decidedly more secular type came to light in 2016, when Philip Lanier, the filmmaker behind a WTTW television documentary about the provenance of the sculpture, revealed that chief design architect, Jacques Brownson, had told of him a previously little-known element of erotic visual play embedded in the late-career piece. According to Lanier,

Jacques Brownson told me in the 1960s that there was a dirty joke embedded in the sculpture, but you have to be at just the right angle to see it. All the architects were concerned about Picasso's sense of humor. Some of his later drawings and paintings were becoming more sensual. Bill (Hartmann) and all were concerned he would do something filthy. Jacques told me that from a certain floor in the Daley Center you could look down and see what was really there. I went up when I was doing the WTTW documentary and saw exactly what he said was true. The wings of hair are really a woman's hips bending over and the open space/hole seen from the rear is actually a woman's vagina — rather like some of Georgia O'Keefe suggestive works…This was a striking observation. I never knew how clever it was, but no one has ever talked publicly about it before now, nearly 50 years after the sculpture's installation.[165]

At the other end of the visual-allusion continuum, one that cemented the sculpture's familiarity most firmly in the collective national consciousness came during the filming of the celebrated 1980 comedy *The Blues Brothers*. As the titular protagonists, played by Dan Aykroyd and John Belushi (a Wheaton, Illinois native who got his start at Chicago's legendary "Second City"), go careening across the city in a car chase, speeding under the elevated trains and into the Loop, Aykroyd's character says, "We should be very close to the Honorable Daley Plaza," and Belushi's character responds, "That's where they've got that Picasso." The subsequent finale—a spectacularly staged mob scene with police cars, armored tanks, and hundreds of riot-equipped "police" climbing everywhere—made a memorable impression, although, characteristically, Jacques Brownson was concerned about damage done to the granite surface of the plaza. According to Northwestern University architectural historian David Van Zanten, "Once the plaza was chosen for the final scene of the movie, the space became iconic. The plaza and sculpture then entered the pop mindset."[166] Its place in pop history was only further enhanced by its appearance in *Ferris Bueller's Day Off* (1986), in which Matthew Broderick sings in a parade; *Switching Channels* (1988), with Kathleen Turner and Burt Reynolds; and *The*

Rear view of Chicago
Picasso, 2015; photograph by
Mike Schwartz Photography,
Chicago

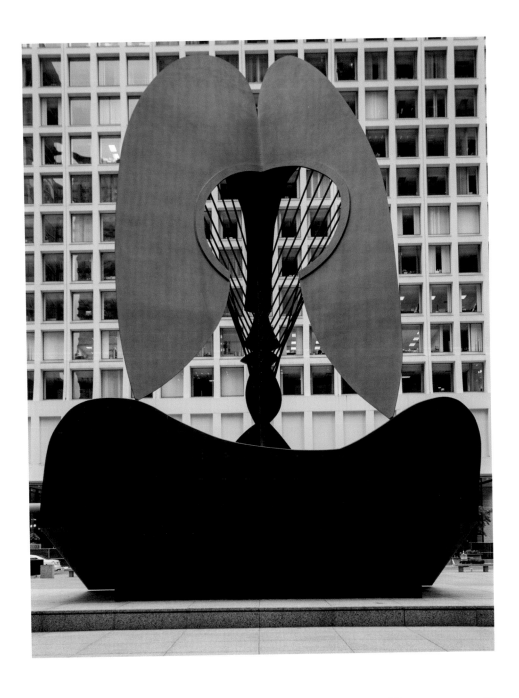

Top: Chicago Picasso wearing Chicago Cubs helmet during post-season National League Division Title win in 2008; the Cubs finally advanced to the World Series and won in 2016—108 years after their last World Series Championship; helmet executed and installed by Chicago Scenic Studios; photograph courtesy of Chicago Scenic Studios

Bottom: Police car at Daley Center from *Blues Brothers* movie, 1980; photograph courtesy of Universal Studios Licensing LLC, Atlanta, Georgia

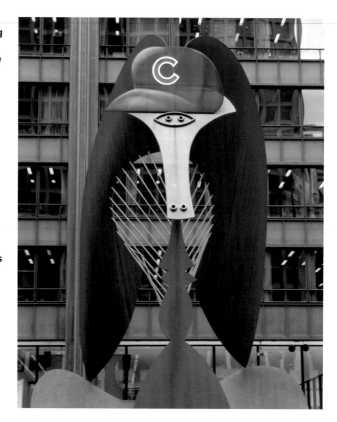

Fugitive (1993), which featured yet another police-chase scene, this time with Harrison Ford. The plaza even stood in for New York City during the 2007 filming of *Batman: The Black Knight.*[167] Over the May 21–22, 2016 weekend hundreds of movie fans gathered at the Daley Plaza to celebrate the 30th anniversary of the renowned Ferris Bueller film.

More to the point, the sculpture has been genuinely incorporated into the daily life and rituals of the city's citizens. Its popularity and importance stay in the hearts of Chicagoans. That was evidenced in 2016 when the sculpture became the primary image for the runners' medal of the famous Chicago Marathon. During the summer the city's Department of Cultural Affairs and Special Events plans musical performances, farmers' markets, and weekly events titled "Under the Picasso." As if to echo Hartmann's long-ago use of props, the sculpture assumes Cubs and White Sox insignia on Opening Day, as well as Blackhawks regalia following that team's Stanley Cup victories. The sculpture watches over the eternal flame for veterans lost in the Korean, Vietnam, and other recent wars. Every year the official Memorial Day parade ends there with placing of a floral wreath. Originally the flame was in front of the sculpture, but when the granite plaza was replaced in 1996, the flame was moved to her left on Dearborn Street, and unfortunately the pigeons followed. For nearly 50 years it played host to annual Christmas tree lighting ceremonies and German *Christkindlmarkets,* as well as the lighting of a large menorah. In December 2013 the Atheist and Agnostic Community put up an 8½-foot tall letter "A" that leaned to one side and was illuminated at night with red lights. It was placed between the Christian crèche and the towering menorah.

And in a brief reprise of the tumultuous days of the 1960s, citizens protesting Chicago's bid to host the 2016 Olympics attempted to disrupt city officials as they were placing a 2016 Olympic banner on the Picasso, with six protestors arrested on September 29, 2009.[168] And on July 9, 2016, Black Lives Matter Chicago protesters assembled at the Daley Plaza before heading to the popular "Taste of Chicago" in Grant Park and then north along Michigan Avenue, blocking traffic and shopping on the Mag Mile.[169]

Not surprisingly, most Chicagoans have come to recognize the sculpture as an attractive and integral part of the city landscape: as early as 1976, a poll taken by the scholar Margaret A. Robinette for her book on outdoor sculpture had 75 percent of Daley Center respondents saying explicitly that they liked the sculpture, with 80 percent answering that they would not consider replacing the work, and that they believe outdoor sculpture improves the quality of urban life.[170] To this day, even the most jaded Chicagoans do not sleepwalk through the Loop and ignore the work of art; someone on the plaza always is looking at and photographing the sculpture. It isn't just a tourist attraction, for Chicagoans have developed an intimate relationship with the sculpture as they eat lunch, sunbathe, rest, and play on its deep-rust surfaces. The citizens of the city identify

with the sculpture in a variety of personal ways; while some relate to the "I will" spirit of the sculpture, others find the ambiguity of the work a reflection of the uncertainty of the times. Regardless of what the people find for themselves in the sculpture, the majority has come to perceive it as a symbol of Chicago, noble and strong; and they are proud to have it enriching the heart of their city. The prophecy made by art critics Joshua Kind and D. Thompson in 1966—"Chicago cannot lose. It will have taken a definite visual step towards acclaiming for itself an artistic standing in the world"—has proved resoundingly true.[171] One thinks too of William E. Hartmann's response to the congratulations on the "coup" of landing Picasso from MoMA's director, Alfred Barr, who had been so understandably skeptical about the prospects for a Picasso for Chicago way back in 1962. With characteristic public-mindedness Hartmann responded, "It was no coup—in a coup someone wins and someone loses. No one has lost."[172]

The 2004 advent of Millennium Park and the public sculptures featured therein has paradoxically served to throw the Picasso into a flattering light, as the two complement each other beautifully. If the Chicago Picasso could lean her head forward and look a couple blocks east on Washington Street, she could see some of her new companions: *Cloud Gate*, better known as "The Bean," and the sculptural Frank Gehry bridge. Russell Bowman described the Millennium Park installations as

an evolution of what pubic sculpture is. *Cloud Gate* sculptor Anish Kapoor understood the nature of interacting with the public. Visitors become a part of the piece, seeing their own reflection and surrounding buildings. People contemplate at the Plensa fountain that is architectural in design, which reflects the city's architectural history. The 1,000 faces changing in the fountain present a cross-section of the diversity of people in the city.[173]

As popular as Millennium Park is, though, it lacks the gravitas and the formal integrity that the Picasso has, not least because of its placement in such a central governmental milieu. Those who would say that *Cloud Gate*, "for the social-media age of the Second City, has replaced the Picasso—for all its brilliance, a rusty, jarring ... presence—as the artistic talisman, and premiere symbol, of the capital of the Middle West," and that "the high-tech, culturally-engined Chicago of the 21st century prefers a cultural park"[174] are misunderstanding a central conception of civic design, which is not one of forced superannuation but of evolution and synthesis. Picasso's work of art has acquired a civic meaning, not from its content or prearranged purpose, but from its acquisition by the city and prominent installation in the great, open civic plaza. In the end the controversy over the sculpture's inspiration remains intriguing but essentially tangential, for all art—including monumental sculpture—can

Top: Anish Kapoor (1954–), *Cloud Gate* (aka "The Bean"), 2006; stainless steel, 33 x 42 x 66 feet; Millennium Park, Chicago; photograph by Karina Wang, PhotoScapes, Chicago; artwork © Artists Rights Society (ARS), New York

Bottom: Jaume Plensa (1955–), *Crown Fountain*, 2004; granite reflecting pool with dual LED screen and glass brick sculpture, 50 feet; Millennium Park, Chicago; photograph by Karina Wang, PhotoScapes, Chicago; artwork © Artists Rights Society (ARS), New York

be created and enjoyed simply on the basis of formal qualities: shape, line, material, color, texture, composition. Picasso understood this:

Everyone wants to understand art. Why not try to understand the songs of a bird? Why does one love the night, flowers, everything around one, without trying to understand them? But in the case of [art] people have to understand. If only they would realize above all that an artist works of necessity, that he himself is only a trifling bit of the world, and that no more importance should be attached to him than to plenty of other things which please us in the world, though we can't explain them.[175]

Indeed, the Chicago Picasso has fulfilled many of the traditional functions of public sculpture: to humanize the site or building, to provide focus, to procure prestige for the client, to decorate, and to enhance aesthetically the quality of life. Or as American Bridge engineer Anatol Rychalski—still soulful and reflective in his retirement—put it, "Art is something you feel, an invisible force that keeps us artistically aware."[176]

Finally, as laypersons and scholars look back over Picasso's career with ever-deeper perspective and clarity, the Chicago Picasso as his crowning achievement begins to take on a singular glow. This was the last sculpture he conceived; and in its realization at the Civic Center, Picasso finally achieved his dreams of monumentality. The recent 2015–16 retrospective of Picasso's sculpture at the Museum of Modern Art suggests that it was sculpture, not painting, where Picasso found the truest expression of his artistic vision—a piece of revisionist thinking that serves only to underline the magnitude of the achievement in Chicago, suggesting "a view of Picasso allied more closely to fact than to legend," MoMA curator, Ann Temkin, concludes. "Picasso's achievement has been largely framed in terms of the individualistic Romantic genius … the sculptural oeuvre reveals him as a lifelong collaborator, intensely and willingly reliant on fellow artists and artisans."[177] The sculpture is a manifestation of an artist who "was far from the stereotypes of individualism and self-expression that still largely define popular opinions of his art," wrote Michael Fitzgerald, in a similar vein. "Instead we find an artist intent on collaboration and seriously engaging issues of public art."[178] It fulfills the higher purpose of all public sculpture—it educates the vision, elevates the spirit, and delights the mind of society. The people and city of Chicago have gained in the acquisition of this monumental sculpture a reputation for having dared to pursue the most famous artist of the century. In the words of Robert Rosenblum,

It will be curious for archeologists to discover someday that most primitive and advanced of the twentieth century here together. For today you can say — there is "a Picasso," Picasso is here — as if he is the king of the century, a leader of

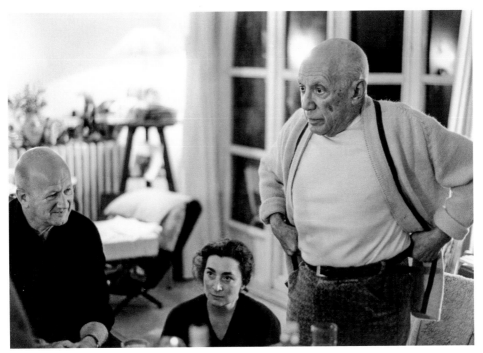

William E. Hartmann, Jacqueline, and Picasso in Mougins, 1968; photograph by Lucien Clergue, 15 x 11 **inches; collection of the author; photograph © Estate of Lucien Clergue**

mankind. It is a feat of vanity if not of art history. He is going to last for centuries, or at least as long as the skyscrapers of Chicago.[179]

That may indeed prove to be a long, long time; but for now, it is enough to celebrate a half century of living with this marvelous and captivating sculpture, and to appreciate its grandeur and its singular beauty. Picasso once said, "people don't buy my paintings, they buy my signature."[180] Certainly, it is worth keeping in mind that *Les Femmes d'Alger (Version "O")* sold at auction in 2015 for $179.4 million.[181] Thanks to Picasso, the city of Chicago has something far more valuable, even priceless. The architects wanted a premier signature artwork for their plaza; and the people of Chicago were the fortunate recipients of Picasso's genius, generosity, and grandiosity. From this point of departure, the journey has just begun.

Pablo Picasso, *Richard J. Daley Center Sculpture*, 1967; white chalk on plywood, 39³⁄₈ x 31⁵⁷⁄₆₄ inches; gift of Pablo Picasso, The Art Institute of Chicago; artwork © 2017 Estate of Pablo Picasso / Artists Rights Society (ARS), New York

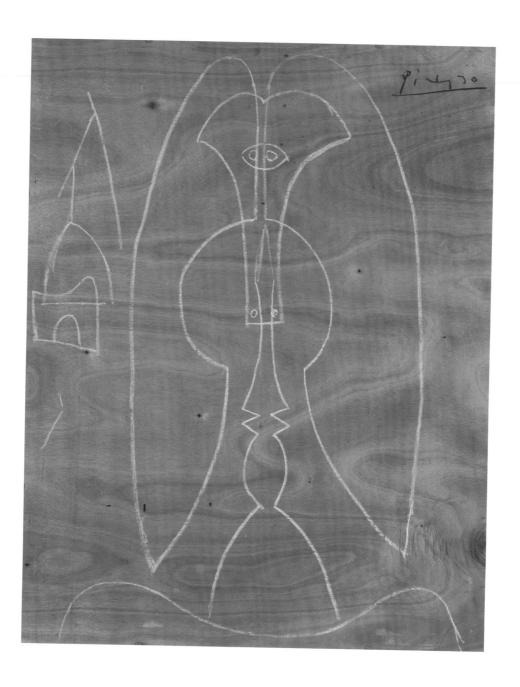

ACKNOWLEDGMENTS

The inspiration for this book came from my earlier Master of Arts thesis in art history at Northwestern University and the more recent realization that the Chicago Picasso sculpture would be having a 50th anniversary celebration in August 2017.

Much of my research consisted of interviews with the principal participants in the acquisition and construction of this first monumental modern sculpture in Chicago. I am thankful to all of the architects who worked on the Civic Center building and plaza and talked with me at great length about the project and the sculpture. Special thanks to William E. Hartmann and Norman Schlossman who met with me several times, sharing original notes about their visits with Picasso and allowing their conversations to be recorded. I am grateful for the conversations with Charles H. Murphy Sr., Charles H. Murphy Jr., Jacques Brownson, Carter Manny, and Fred Lo about the building, plaza, politics, and sculpture. Architect Richard Bennett even composed a poem for me about the Picasso.

It was a pleasure talking with Anatol Rychalski, chief engineer for American Bridge and Iron Division of U. S. Steel, which built the 50-foot high, 162-ton sculpture. He and his steelworkers realized they were working on a piece of art, not their more usual bridge or building.

All of these men, who were intimately involved in the diverse aspects of the Chicago Picasso, were extremely generous with their time and thoughts. All seemed to understand that they were part of something extraordinary for their city. They were passionate about their work on this unique civic and cultural endeavor. Richard J. Daley, mayor of Chicago during the years covered here, also played a key role.

During my early thesis research Charles E. Schroeder provided insight about the philanthropic funding for the sculpture and introduced me to others in Chicago who became so helpful. His imprimatur opened many doors to leaders in the city.

I am indebted to John W. McCarter Jr., who prepared such a lively and discerning foreword to this book. He understands the importance and uniqueness of civic sculpture in Chicago.

There are so many people who contributed to the research by agreeing to discussions and interviews about the Chicago Picasso, some of whom talked to me when the sculpture was relatively new and again in the past few years as this book became a reality. I am especially grateful to Richard Hunt, Dirk Lohan, Russell Bowman, Franz Schulze, and Paul Gray—all of whom provided perspectives about the Chicago Picasso as a real work of Art, with a capital A, beyond the original curiosities that absorbed the public and media in the early days and years.

I want to thank my friend and art dealer Eva Maria Worthington for her advice and encouragement about this book and life's challenges and opportunities.

This book takes the reader on a fascinating journey that began in 1967. Along the way, perplexing mysteries were unlocked. I thank filmmaker, Paul Laniere, for his recent disclosures.

I received great advice and assistance from the staff at the Art Institute of Chicago and single out Aimee Marshall in particular. Other museums that granted permissions for Picasso works in their collections include the Museum of Modern Art, Musée Picasso and Centre Pompidou in Paris, and the National Gallery of Iceland.

In New York, Hannah Rhadigan and Alan Baglia at Artist Rights Society and Robbi Siegal at Art Resources were so helpful in guiding me through the complicated procedures of acquiring the images and permissions to publish works of art by Picasso and Oldenburg. I am deeply grateful to the Picasso Estate for approving essential Picasso works for this book so that I could tell the story of the Chicago Picasso.

A very special thank you to Dr. David Van Zanten, professor of art and architectural history at Northwestern, who directed my thesis. Years later he kindly shared his expert and professional opinions about the sculpture and plaza for this book.

Telling the story of the Chicago Picasso has brought intellectual pleasure and stimulation. I was fortunate to spend a day in Arles, France with longtime Picasso personal friend and photographer, Lucien Clergue, who offered his insights and distinctive photographs that are included in this book. We became friends, too.

I am grateful to Mr. and Mrs. Richard Gray and to Mr. and Mrs. Morton L. Janklow for permissions to use photographs of Picasso works of art from their personal collections. Pace Gallery in New York graciously provided fine images of the Janklow sculpture.

I offer an extraordinary appreciation to Skidmore, Owings & Merrill for cooperation in locating, providing, and permitting use of the important photographs that document the development of the Chicago Picasso, from the maquette to the unveiling. Karen Widi, Manager of Library, Records & Information Services at SOM deserves singular recognition and appreciation. And, an exceptional thank you to SOM architect Fred Lo and his wife, Mary, for their assistance, conversation, and friendship.

Great Chicago photographers—Mike Schwartz and Karina Wang—took pictures over and over to capture just the right shot at the right time of day to express the ideas in this book. I so appreciate their long hours and efforts. And, to Chicago Scenic Studios who provided photographs of the sports hat decorations for the sculpture on celebratory occasions.

Mike Lindgren has masterfully assisted with many drafts of the manuscript and with social media, setting up Tumblr and the website for ChicagoPicasso

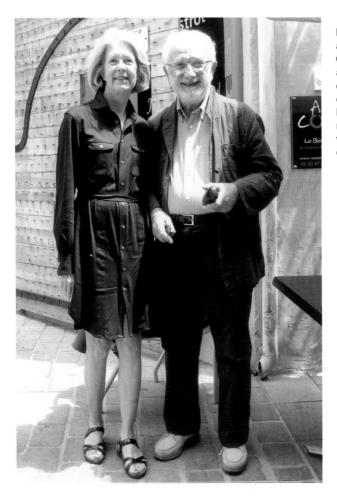

Photographer Lucien Clergue and author in Arles, 2011; Clergue was decorated as Chevalier de la Légion d'honneur in 2003 and elected to the Académie des Beaux-Arts in 2006 when a new section for photography was created, later serving as chairman in 2013.

.com. He even went to NYU to obtain the photo of Carl Nesjar's *Sylvette* sculpture. Mike has been invaluable in bringing this book into reality. Ampersand Inc. founder, publisher, and editor Suzie Isaacs and designer David Robson have been extraordinarily patient and reassuring with a first-time author. They have brought this beautiful book to print for all readers interested in this very unique Picasso gift and sculpture in Chicago.

Finally, I thank my family and friends who have supported me during the demanding process of writing this book. And, a specific thanks to Richard Maslow, without whose encouragement and endorsement I could not have published the story of the Chicago Picasso. It is a point of departure for all of us to consider.

Patricia Balton Stratton
February 2017

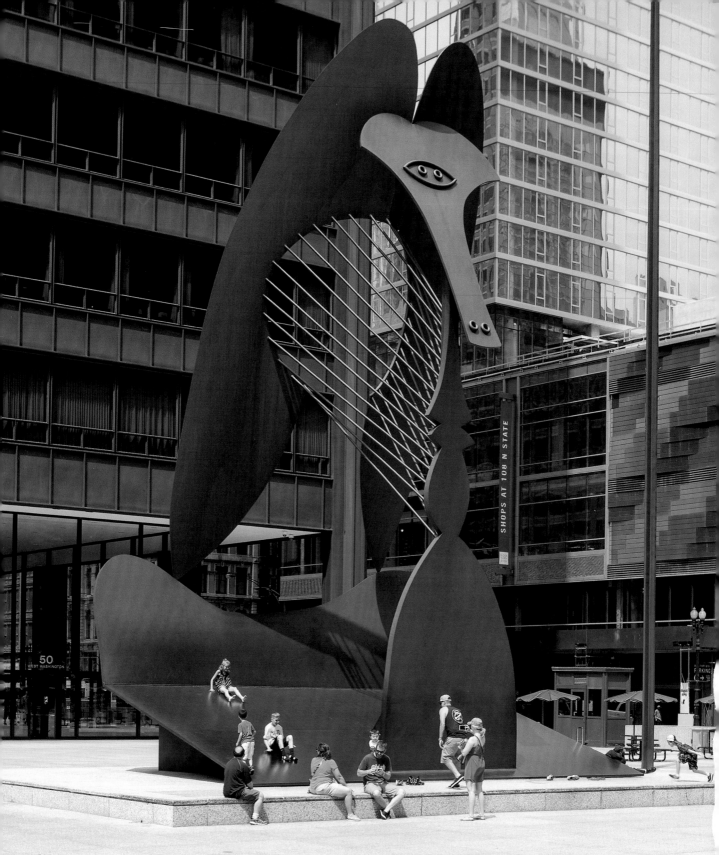

Chicago Picasso, 2015;
photograph by Mike
Schwartz Photography,
Chicago

The Chicago Picasso, 1986, written for the 20th anniversary in 1987

By Gwendolyn Brooks

Set,
seasoned,
sardonic still,
I continue royal among you.
I astonish you still.
You never knew what I am.
That did not matter and does not.
Mostly
you almost supposed I almost Belong; that I
have a Chicago beauty, that I
have a booming Beauty.

I tell you that although royal
I am a mongrel opera strange in the street.
I am radical, rhymeless —
 But warranted!

Surely I shall remain.[182]

August 15, 1986

APPENDIX B

Two poems by Richard M. Bennett, partner,
Loebl, Schlossman, Bennett & Dart

Prose poem written to Picasso to urge the artist
to design a sculpture for the City of Chicago

In the middle of Chicago is a flat place one hundred meters by fifty meters
on its north will be the law courts building
 tallest of its kind
west is the city and county building
 with the mayor's office
 the representatives
 the tax collectors
 the records of births and marriages and deaths
south are two tall office skyscrapers
 one has its pinnacle the chapel of the protestants
 over a way is the central basilica of the Catholics
 further south the important city synagogue
 mixed about are banks and the bourse the brokers
 businessmen and lawyers
eastward the great shopping street
 high buildings for doctors and dentists
 theatres garages hotels and the great Art Institute
 with Miró Toulouse Lautrec Goya El Greco
 Matisse and early and late Picassos
beyond is the harbor on a freshwater lake connected by other lakes and
 rivers and canals to the salt oceans and
 all the lands and islands
outward the city coils in rings of warehouses mills and stores
 airports factories houses and hospitals parks and suburbs
 millions of women and children and men
in the middle is the empty plaza where those millions and other
 millions will visit to feel the heart of this mighty
 city made by machines
It is a place waiting for a spirit
 the spirit in a sculpture
 will you do it?

1963

Poem written for the author, P. A. Stratton

The Steel Person

The steel lady — or man — or lady-man

Sits quietly as citizens flow by.

Does any other plaza have another "IT"?

A shape without a name?

Other plazas have something with names.

Chicago's Plaza has only IT.

A shape without a name.

Every Person — woman, child and man — has a name.

Is Picasso's "IT," only an "IT"?

September 23, 1981

APPENDIX C

Cor-Ten Steel: Properties and History

Cor-Ten is the material that clads the exterior structure of the 648-foot now-renamed Daley Center building and is the visible material of the 50-foot Chicago Picasso sculpture—4,500 tons and 162 tons respectively.

Cor-Ten is the trademark name for corrosive resistant and high tensile steel made by United States Steel. This steel is often referred to as self-weathering steel, a special low-alloy steel that develops a protective and permanent russet-colored oxide coating. This protective coating allows the surface to remain unpainted.

Bethlehem Steel was the only other American steel corporation that produced weathering steel at that time, using the trademark name Mayari-R. Bethlehem submitted the only other bid for the original Civic Center building, but was only awarded the contract for the 2,352 windows.

Weathering steel is about 40 percent stronger than conventional structural steel, and if left unprotected it forms a dense, tightly adhering oxide coating that is self-sealing. This means that the steel does not need to be painted or repainted over its lifetime. It is also about 50 percent more economical than mild carbon steel. Although stiffer than mild carbon steel, Cor-Ten lends itself well to fabrication.

These attributes contributed to the Chicago architects' choice of Cor-Ten steel for the Chicago Picasso, in addition to the aesthetic decision to complement the new building material.

The Daley Center was only the second office building erected of Cor-Ten steel. Two years earlier Deere & Company World Headquarters, designed by Eero Saarinen, was built in Moline, Illinois. Both were bold design advances by the architects and the clients. Previously, weathering steel had been used for railroad cars, bridges, guardrails, and other industrial equipment.

The low, horizontal Deere & Company World Headquarters was placed in a bucolic 1,400-acre wooded setting and received international acclaim for the ingenious design and beauty. On the other hand, the very tall Civic Center was located in just a 2.8-acre granite-covered block in downtown Chicago. Yet, both buildings were hugely successful in vastly different surroundings; and Cor-Ten continues to be used in architectural applications for public and commercial structures worldwide.

All the above advantages and natural finish led artists to design and construct sculptures of this unique material that became a new medium for art. After the Picasso was unveiled, other prominent artists in the 1960s who used Cor-Ten were Richard Serra, Louise Nevelson, Barnett Newman, and Chicago's own Richard Hunt.

Deere & Company World Headquarters on 1400 wooded acres, 2003; designed by Eero Saarinen 1958, begun 1961, opened 1964; Cor-Ten steel; photograph courtesy of John Deere, Moline, Illinois

APPENDIX D

Table of weights and thicknesses
for the Chicago Picasso

	Weight in Tons	Thickness in Inches
Base	69	2.5
Back Plate (Bow-tie)	20	3
Right Wing	7	1
Left Wing	5	1
Vertical Front Plate	30	6
29 Ribs (rods)	2.5	2 (rib behind is 4 in.)
Face	3.2	2
TOTAL Cor-Ten Sculpture	136*	
Grillage (below grade)	26	
TOTAL	**162**	

Cor-Ten cut away and returned to foundry as scrap	144	

TOTAL FINISHED STEEL USED	**306**	

Other materials used in construction:

Falseworks (erecting material)	12	
Tracking and Skidding materials	7	
GRAND TOTAL STEEL USED	**393**	

* Total figure discrepancy due to rounding off the large parts to the nearest ton.

APPENDIX E

Pablo Picasso 1881–1973
Family Tree

Olga Khokhlova
1891–1955
Met 1917
Married 1918
Separated 1935

**Paul, known
as Paulo**
1921–1975
Married Émilienne
Lotte 1950
Divorced 1953

Pablito 1949–1973
Marina 1950

Married Christine
Pauplin 1962

Bernard 1959

**Marie-Thérèse
Walter**
1909–1977
Met 1927
Separated 1943

Maya 1935
Married Pierre
Widmaier 1960

Olivier 1961
Richard 1964
Diana 1971

Françoise Gilot
1921
Met 1943
Separated 1953

Claude 1947
Married Sydney
Russel 1979
Separated 1999

Jasmin 1981

Jacqueline Roque
1926–1986
Met 1954
Married 1961

Paloma 1949
Married Rafael
López Sánchez
1978
Divorced 1998

Married
Éric Thévenet 1999

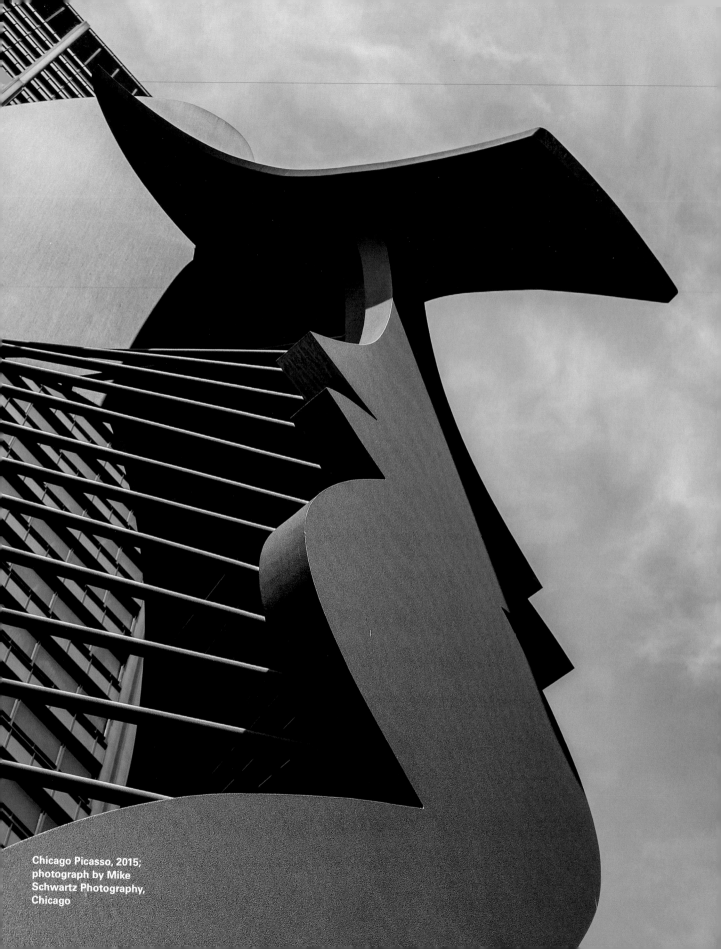

Chicago Picasso, 2015;
photograph by Mike
Schwartz Photography,
Chicago

NOTES

Introduction

1. Edward Barry, "Crowds See Unveiling of Picasso Work: Sculpture Hailed as New Image," *Chicago Tribune*, August 16, 1967.
2. Ibid.
3. Ibid.
4. For more information about Cor-Ten steel, see Appendix C.
5. Sheila Wolfe, "Colossus or Whatsis: All Come for a Look," *Chicago Tribune*, August 16, 1967.
6. M. W. Newman, "Regarding Picasso's Civic Center Sculpture," *Chicago Daily News*, July 15, 1967.
7. Ann Temkin and Ann Umland, *Picasso: Sculpture* (New York: Museum of Modern Art, 2015), 28.
8. *Paintings and Drawings of Picasso*, by Jaime Sabartés (New York: Tudor Publishing Co., 1946), 146; quoted in *Picasso On Art: A Selection of Views*, edited by Dore Ashton (Boston: Da Capo, 1988), 16.

Chapter 1

9. Peter Carter, "Mies van der Rohe, Ludwig," in *The Grove Encyclopedia of American Art* (Oxford University Press, 2011). http://www.oxfordreference.com.w.ezproxy.nypl.org/view/10.1093.
10. Peter Carter, *Mies van der Rohe at Work* (London and New York: Phaidon Press, 1999 reprint of 1974 original), 156.
11. Franz Schulze (professor of art history, Lake Forest College, art critic), in discussion with the author, Chicago, June 23, 1981.
12. Jacques Brownson (chief design architect, C. F. Murphy Associates), telephone interview with the author, Denver, October 14, 1981.
13. Dirk Lohan (architect, grandson of Mies van der Rohe), in discussion with the author, Chicago, January 28, 2015.
14. Franz Schulze, *Mies van der Rohe* (Chicago: University of Chicago Press, 2014), 412.
15. Joe Mathewson, *Up Against Daley* (LaSalle, Illinois: Open Court Publishing Co., 1974), 80.
16. John D. Cordwell (architect and city planner), telephone interview with the author, Chicago, October 4, 1981.
17. Brownson, in discussion with the author, October 14, 1981.
18. Paul Gapp, "Old Rustyside: A Monumental Success Story," *Chicago Tribune*, February 2, 1975.
19. Edward Schreibner, "Picasso Work Rubs Reilly in Wrong Places," *Chicago Tribune*, June 14, 1967.

20. Brownson, telephone interview with the author, Denver, November 10, 1981.

21. Schulze, in discussion with the author, Chicago, June 23, 1981.

Chapter 2

22. Lawrence B. Perkins (architect, senior partner, Perkins & Will), telephone interview with the author, Chicago, October 7, 1981.

23. Schulze, in discussion with the author, Chicago, June 23, 1981.

24. M. B. Reilly, "UC Exhibit Reveals Downtown Cincinnati's Historic Terrace Plaza Hotel," *UC News* (Cincinnati: University of Cincinnati, September 24, 2011).

25. Copyright judgment, Letter Edged in Black Press, Inc. v. the Public Building Commission of Chicago, Civil Action No. 69C 353 (U.S. District Court, N. D. Illinois E. D., 1970), affidavits and depositions attached thereto; William E. Hartmann speech to Mayor Daley and members of the Public Building Commission, June 1965, Hartmann Deposition, exhibit 21.

26. Ibid.

27. Ibid.

28. Norman Schlossman (architect, senior partner, Loebl, Schlossman, Bennett & Dart), in discussion with the author, Chicago, September 25, 1981.

29. For Bennett's poem, see Appendix A.

30. Copyright judgment, William E. Hartmann speech.

31. Press release, Public Buildings Commission of Chicago, September 20, 1966.

32. Norman Schlossman, in discussion with the author, September 25, 1981, transcript. Schlossman read his notes recording the initial visit with Picasso, May 21, 1963.

33. Sir Roland F. Penrose, *Picasso: His Life and Work* (Berkeley and Los Angeles: University of California Press, 1981), 443.

34. Sir Roland F. Penrose and Edward Quinn, *Scrapbook 1900–1981* (New York: Rizzoli, 1981), 244.

35. Schlossman, in discussion with the author, September 25, 1981.

36. Letter to William E. Hartmann, June 11, 1963, Hartmann Deposition, exhibit 6.

37. Letter to William E. Hartmann, January 12, 1964, Hartmann Deposition, exhibit 6.

38. William E. Hartmann (architect, partner, Skidmore, Owings & Merrill), in discussion with the author, Chicago, August 11, 1981.

39. Copyright judgment, William E. Hartmann speech.

40. Penrose, *Picasso: His Life and Work*, 444.

41. Copyright judgment, William E. Hartmann speech.

42. Lucien Clergue (photographer), "*Picasso Mon Ami,*" lecture, Art Institute of Chicago, October 20, 1981.

43. Event program, "Dedication of the Chicago Picasso," City of Chicago, August 15, 1967.

44. Hartmann, in discussion with the author, Chicago, August 11, 1981.

45. Clergue, in discussion with the author, Chicago, October 20, 1981.

Chapter 3

46. Roberta Smith, "Picasso Completely Himself in Three Dimensions," *New York Times*, September 10, 2015.

47. Peter Schjeldahl, "Another Dimension," *New Yorker*, September 21, 2015, 108.

48. Barry Schwabsky, "Secret Accords," *Nation*, November 9, 2015, 32.

49. Sir Roland Penrose, *Picasso: Sculpture-Ceramics-Graphic Work: at the Tate Gallery* (London: Arts Council of Great Britain, 1967), 20.

50. Matthew Kangas, *Seattle Art Guide* (Seattle: Tipton Publishing Co., 2011).

51. Ibid.

52. Françoise Gilot and Carlton Lake, *Life With Picasso* (New York: McGraw-Hill, 1964), 313.

53. Schjeldahl, 109.

54. Sir Roland Penrose, *The Sculpture of Picasso* (New York: Museum of Modern Art, 1967), 23.

55. Ibid., 18.

56. Lionel Prejger, "Picasso découpe le fer," *L'ŒIL* 82 (October 1981), 28.

57. Carl Nesjar, "Letter from the Airport," *Living Arts* 1, Spring 1963, 53. Published by the Institute of Contemporary Art, London.

58. Barbara Rose, "Blowup—The Problem of Scale in Sculpture," *Art in America* 56 (July/August 1968), 87.

59. Harriet Senie, "Urban Sculpture: Cultural Tokens or Ornaments to Life?" *Art News* 78 (September 1979), 112.

60. Alan Bowness, "Picasso's Sculpture," from *Picasso 1881–1973*, edited by Sir Roland Penrose and John Golding (London: Paul Elek, Ltd., 1973), 154.

61. Verpoorten, Frank, catalogue for *Naples Collects* (Naples, Florida: Artis/Baker Museum, 2015), 164.

62. Schulze, in discussion with the author, Chicago, June 23, 1981.

63. Hartmann, telephone interview with the author, Chicago, November 20, 1977.

64. Harold Joachim (curator, prints and drawings, Art Institute of Chicago), in discussion with the author, Chicago, February 11, 1982.

Chapter 4

65. Carter H. Manny Jr. (senior partner, C. F. Murphy Associates), telephone interview, San Raphael, California, January 25, 2016.

66. Fred Lo (architect, Skidmore, Owings & Merrill), in discussion with the author, Winnetka, Illinois, October 24, 1981. For more information on the dimensions of the structure, see Appendix D.

67. Donald Schwartz, "Our Own Picasso—A Progress Report," *Chicago Sun-Times Midwest Magazine*, May 14, 1967.

68. Joseph P. Colaco (structural engineer, Skidmore, Owings & Merrill), telephone interview, Houston, November 3, 1981.

69. Hartmann, in discussion with the author, November 23, 1981.

70. Colaco, telephone interview, Houston, November 3, 1981.

71. Newman, "Regarding Picasso's Civic Center Sculpture."

72. Carter H. Manny Jr. (senior partner, C. F. Murphy Associates), telephone interviews, Chicago, September 18, 1981, and October 20, 1981.

73. Roberto Otero, *Forever Picasso* (New York: Harry N. Abrams, Inc., 1974), 46.

74. Ibid., 52.

75. John Adam Moreau, "Picasso Designs a Statue for the Civic Center," *Chicago Sun-Times*, September 14, 1966.

76. Copyright Judgment, Christiansen to Blair, December 23, 1963, Hartmann Deposition, exhibit 13.

77. Correspondence from the office of the secretary, Art Institute of Chicago, January 25, 1982.

78. Copyright Judgment, Hartmann to Penrose, May 17, 1966.

79. Charles E. Schroeder, in discussion with the author, Chicago, October 5, 1981.

80. Public Building Commission of Chicago, October 24, 1967, Minutes of the Commission Meeting, 1115.

81. Anatol Rychalski (senior design engineer, U. S. Steel American Bridge Division), telephone interview, Pittsburgh, January 11, 1982.

82. Ibid.

83. Ibid.

84. Lo, in discussion with the author, October 24, 1981.

85. Public Building Commission of Chicago, July 27, 1966, Minutes of the Commission Meeting, 905–6.

86. Hartmann, in discussion with the author, August 11, 1981.

87. Public Building Commission of Chicago and William E. Hartmann, "Deed of Gift," signed by Picasso August 9, 1966.

88. Copyright Judgment, Robert Christiansen, affidavit, May 5, 1969, 40–41.

Chapter 5

89. Barry, "Crowds See Unveiling of Picasso Work; Sculpture Hailed as New Image."

90. Hugh Hough, "Picasso's Gift to Chicago Unveiled," *Chicago Sun-Times*, August 16, 1967.

91. "The Picasso Square," editorial, *St. Louis Post-Dispatch*; reprinted in the *Chicago Sun-Times*, September 30, 1967.

92. Jerilyn Watson, "Other Cities Like Our Picasso," *Chicago American*, July 23, 1967.

93. "Percy Applauds Picasso," *Chicago American*, August 20, 1967.

94. City of Chicago press release, 25th anniversary celebration, Chicago Picasso, August 1992.

95. "Picasso Stirs Praise from Legislature," *Chicago Tribune*, September 20, 1967.

96. Adam Gopnik, preface to *Picasso and Chicago: 100 Years, 100 Works* (Chicago: Art Institute of Chicago, 2013), by Stephanie D'Alessandro, 13.

97. Gert Schiff, *Picasso's Last Years: 1963–1973* (New York: New York University/Braziller, 1983), cover.

98. Norman Ross, "Let's Not Knock It Till We've Tried It," *Chicago Daily News*, August 16, 1967.

99. Russell Bowman (former president, Milwaukee Museum of Art, Museum of Contemporary Art, Chicago; consultant, dealer), in discussion with the author, Chicago, June 9, 2015.

100. Donald Zochert, "Pride of Plaza, Our Picasso is One Year Old," *Chicago Daily News*, August 15, 1968.

101. Bill Kurtis, "Miró's Monument," *Chicago Sun-Times*, "Show" section, April 19, 1981.

102. Richard Hunt (sculptor), in discussion with the author, Chicago, December 7, 2014.

103. Franz Schulze, "But, Of Course, It's a Woman," *Chicago Daily News*, August 23, 1969.

104. Franz Schulze, foreword to *A Guide to Chicago's Public Sculpture*, by Ira J. Bach and Mary Lackritz Gray (Chicago: University of Chicago Press, 1983), pp xi-xviii.

105. Schulze, telephone interview with the author, Lake Forest, Illinois, June 23, 1982.

106. Don Powell (SOM architect), telephone interview with the author, Naples, Florida, March 15, 2015.

107. John Canaday, "Picasso in the Wilderness," *New York Times*, August 27, 1967.

108. Hartmann, telephone interview, Chicago, November 30, 1981.

109. Lloyd Green, "Picasso Model Hailed at Dedication Ceremony," *Chicago Sun-Times*, September 21, 1966.
110. David Douglas Duncan, "Letter from Saigon," *Chicago Tribune Magazine*, December 17, 1967, 14–16.
111. "Early Snow," staff photo, *Chicago Tribune*, October 6, 1967.
112. Roberta Smith, "Review: Picasso's Weeping Women, United," *New York Times*, June 10, 1994.
113. Andrew Hermann, "The Woman Who Inspired City's Picasso," *Chicago Sun-Times*, November 11, 2004.
114. Stephanie D'Alessandro (curator of modern art, Art Institute of Chicago); in discussion with the author, Chicago, July 1, 2015.
115. Hélène Parmelin, *Picasso Says* (London: George Allen and Unwin, Ltd., 1969), 68.
116. Hélène Parmelin, *Picasso: Women, Cannes and Mougins* (New York: Harry N. Abrams, Inc., 1964), 142.
117. John Berger, *Toward Reality* (New York: Alfred A. Knopf, 1962), 130.
118. William B. Chappell, "The Chicago Picasso Reviewed a Decade Later," *Art International* 21 (October-November 1977), 61–63.
119. Sir John Richardson, *Picasso: An American Tribute* (New York: Public Education Association/Chanticleer Press, 1962).
120. Mary Mathews Gedo, *Picasso: Art as Autobiography* (Chicago and London: University of Chicago Press, 1980), 245–46.
121. Mary Mathews Gedo (author, psychologist), in discussion with the author, Wilmette, Illinois, November 18, 1981.
122. Parmelin, *Picasso: Women, Cannes and Mougins*, 123.
123. Milton S. Fox, Introduction to Parmelin, *Picasso: Women, Cannes and Mougins*, xiv.
124. Sir John Richardson, *Picasso: An American Tribute*.
125. Klaus Gallwitz, *Picasso: The Heroic Years* (New York: Abbeville Press, 1985), 100, 90.
126. David Douglas Duncan, *The Private World of Pablo Picasso* (New York: Ridge Press, 1958), 157.
127. David Douglas Duncan, *Photo Nomad* (New York: W. W. Norton and Co., 2003), 298.
128. Prejger, 32–33.
129. Sir Roland F. Penrose, *The Eye of Picasso* (New York: The New American Library, in arrangement with UNESCO, 1967), 25.
130. Lucien Clergue (photographer, Picasso friend), in discussion with the author, Arles, France, June 9, 2011.
131. Lo, in discussion with the author, Winnetka, Illinois, January 28, 2015.
132. Simone Gauthier, "Picasso, the Ninth Decade," *Look* 31 (November 1967), 88.

133. Carol Kion, "Jacqueline: Picasso's Wife, Love, and Muse," *Wall Street Journal*, September 30, 2014.

134. Manuel Gasser, "*Femme au Chapeau*, Genesis of a Sculpture," *Graphis* 26 (1970–71), 204–8.

135. Milton Esterow, "The Battle for Picasso's Multi-Billion Dollar Empire," *Vanity Fair*, March 7, 2016.

Chapter 6

136. Gauthier, "Picasso, the Ninth Decade."

137. "Picasso's Sculpture May Go Commercial," *Chicago Sun-Times*, November 12, 1967.

138. Scott Hodes (attorney; son of attorney Barnet Hodes), in discussion with the author, Chicago, October 19, 1981.

139. Newman, "Suit Attacks City's Picasso Copyright," *Chicago Daily News*, May 27, 1970.

140. Michael Fitzgerald, *Picasso and American Art* (New York: Whitney Museum of American Art, in association with Yale University Press, 2006), 258.

141. Copyright judgment, District Judge Alexander Napoli, "Memorandum Opinion and Order," December 22, 1970, as reproduced in Franklin Feldman and Stephen E. Weil, *Legal and Business Problems of Artists, Art Galleries, and Museums* (New York: Practicing Law Institute, 1973), 321–22.

142. Robert Rosenblum (art historian), narrator, *Picasso: The Legacy of a Genius,* film, directed by Michael Blackwood (New York: Blackwood Films, 1980).

143. Claes Oldenburg to Barnet Hodes, December 25, 1970. Files of Scott Hodes, attorney, Chicago.

144. Brownson, in discussion with the author, Chicago, October 14, 1981.

145. Morton G. Neumann (collector), telephone interview, Chicago, December 14, 1981.

146. Gedo, in discussion with the author, Wilmette, Illinois, November 18 1981.

147. Franz Schulze, "How Picasso Lady Looks to Art Critic…," *Chicago Daily News*, August 16, 1967.

148. Schulze, telephone interview, Lake Forest, Illinois, January 24, 2016.

149. Robert Hughes, "Art and Architecture: A Failed Marriage," lecture, "Bright New Chicago" series, sponsored by the University of Chicago, April 27, 1981.

150. Dennis Adrian (critic, lecturer, Illinois Institute of Art, Art Institute of Chicago), in discussion with the author, Chicago, November 23, 1981.

151. Linda Witt, "Picasso Booms Business," *Chicago American*, August 8, 1967.

152. Ed Hotaling, "Rally Round the Picasso, Boys!" *Art News* 68 (January 1970), 73.

153. Hunt, in discussion with the author, Chicago, December 7, 2014.

154. Jane Allen and Derek Guthrie, "Interview with Three Chicago Sculptors," *New Art Examiner* (November 1976), 4.

155. Jerry Peart (sculptor), telephone interview, Chicago, November 2, 1981.

156. Jane Allen and Derek Guthrie.

157. T. J. Clark, *Picasso and Truth: From Cubism to Guernica* (Princeton: Princeton University Press, in conjunction with the National Gallery of Art, Washington DC, 2013), 227–28.

158. David Reed, "The Picasso's Birthday," *Chicago Sun-Times*, August 15, 1970.

159. Hotaling, 27.

160. Newman, "Scarface, Climbers Wound Picasso Sculpture," *Chicago Daily News*, September 27, 1969.

161. "Our Best-known Landmark?" *Chicago Daily News*, January 25, 1977.

162. Jason Tanamor, interview with Train front man Pat Monahan, July 18, 2014, "Zoiks! Online," http://www.zoiksonline.com/2014/07/exclusive-interview -train-front-man-pat.html.

163. "China Gets a Fresh Look at the U.S.," *Chicago Tribune*, June 12, 1980.

164. Edwin A. Herrick, *A Spiritual Interpretation of Chicago's Picasso, Michelangelo's Pieta, and the 23rd Psalm* (New York: Vantage Press, 1968).

165. Philip Lanier (filmmaker), telephone interview with the author, Monroe, Georgia, February 5, 2016.

166. David Van Zanten (professor of art and architectural history, Northwestern University), in discussion with the author, Wilmette, Illinois, January 28, 2015.

167. Lorene Yue, *Crain's Chicago Business*, July 7, 2010.

168. Fernando Diaz, "No Games Chicago Olympics protest ends in arrests," *Chicago Now*, News & Opinion of *Chicago Tribune,* September 29, 2009.

169. *Chicago Tribune*, "Protestors Take In Taste of Chicago," July 10, 2016, 9.

170. Margaret A. Robinette, *Outdoor Sculpture* (New York: Guptill Publications, 1976), 93, 172.

171. D. Thompson and Joshua Kind, "Chicago Picasso," *Chicago Midwest Art* 2 (November 1966), 7.

172. M. W. Newman, "A Sandwich by Picasso," *Chicago Daily News*, September 21, 1966.

173. Bowman, in discussion with the author, Chicago, June 9, 2015.

174. Chris Jones, "Nice Move, O Tannenbaum," *Chicago Tribune*, October 22, 2015.

175. Alfred H. Barr Jr., *Picasso: Fifty Years of His Art* (New York: Museum of Modern Art, 1946), 274.

176. Rychalski, telephone interview with the author, Chicago, January 23, 2016.

177. Anne Temkin and Anne Umland, 29.

178. Michael Fitzgerald, "A Master's Genius in 3-D," *Wall Street Journal*, September 14, 2015.
179. Rosenblum, *Picasso: The Legacy of a Genius.*
180. Pierre Dufour, *Picasso 1950–1968* (Cleveland: The World Publishing Co., 1969), 12.
181. Neil Irwin, "The $179 Million Picasso that Explains Global Inequality," *New York Times*, May 13, 2015.
182 "Gwendolyn Brooks at 70," *Chicago Tribune*, July 12, 1987.

SOURCES

Periodicals

Allen, Jane, and Derek Guthrie. "Interview with Three Chicago Sculptors," *New Art Examiner* (November 1976).

Barry, Edward. "Crowds See Unveiling of Picasso Work: Sculpture Hailed as New Image," *Chicago Tribune*, August 16, 1967.

Calloway, Earl. "Picasso's Sculptured Creation Is Unveiled: Chicago Given Increased Architectural Significance," *Chicago Daily Defender*, August 16, 1967.

Canaday, John. "Picasso in the Wilderness," *New York Times*, August 27, 1967.

Chappell, William B. "The Chicago Picasso Reviewed a Decade Later," *Art International* 21 (October-November 1977).

Chicago American, "Percy Applauds Picasso," August 20, 1967.

Chicago Daily News, "Our Best-Known Landmark?" January 25, 1977.

Chicago Sun-Times, "Picasso's Sculpture May Go Commercial," November 12, 1967.

Chicago Tribune, "China Gets a Fresh Look at the U.S.," June 12, 1980.

———— "Early Snow," October 6, 1967.

———— "Gwendolyn Brooks at 70," July 12, 1987.

———— "Picasso Stirs Praise from Legislature." September 20, 1967.

———— "Protestors Take In Taste of Chicago," July 10, 2016.

Diaz, Fernando. *Chicago Now*, News and Opinion of *Chicago Tribune*, September 2009.

Duncan, David Douglas. "Letter from Saigon," *Chicago Tribune Magazine*, December 17, 1967.

Esterow, Milton. "The Battle for Picasso's Multi-Billion Dollar Empire," *Vanity Fair*, March 7, 2016.

Fitzgerald, Michael. "A Master's Genius in 3-D," *Wall Street Journal*, September 14, 2015.

Gapp, Paul. "Old Rustyside: A Monumental Success Story," *Chicago Tribune*, February 2, 1975.

Gasser, Manuel. "*Femme au Chapeau*, Genesis of a Sculpture," *Graphis* 26 (1970–71).

Gauthier, Simone. "Picasso, the Ninth Decade," *Look* 31 (November 1967).

Green, Lloyd. "Picasso Model Hailed at Dedication Ceremony," *Chicago Sun-Times*, September 21, 1966.

Hermann, Andrew. "The Woman Who Inspired City's Picasso," *Chicago Sun-Times*, November 11, 2004.

Hotaling, Ed. "Rally Round the Picasso, Boys!" *Art News* 68 (January 1970).

Hough, Hugh. "Picasso's Gift to Chicago Unveiled," *Chicago Sun-Times*, August 16, 1967.

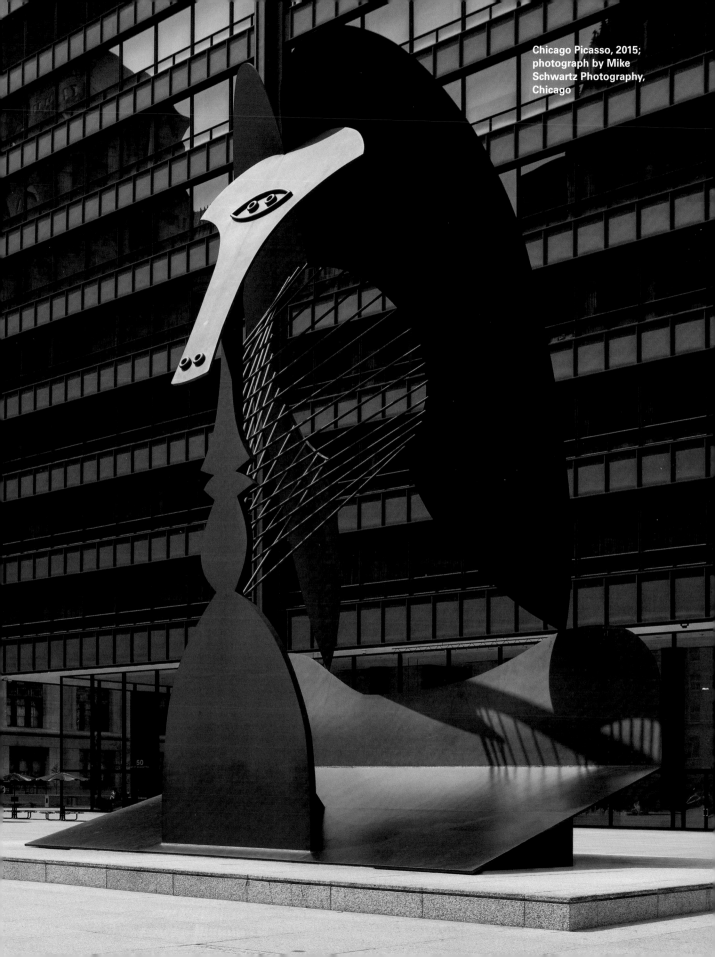

Irwin, Neil. "The $179 Million Picasso that Explains Global Inequality," *New York Times*, May 13, 2015.

Jones, Chris. "Nice Move, O Tannenbaum," *Chicago Tribune*, October 22, 2015.

Kino, Carol. "Jacqueline: Picasso's Wife, Love, and Muse," *Wall Street Journal*, September 30, 2014.

Kurtis, Bill. "Miró's Monument," *Chicago Sun-Times*, "Show" section, April 19, 1981.

Moreau, John Adam. "Picasso Designs a Statue for the Civic Center," *Chicago Sun-Times*, September 14, 1966.

Nesjar, Carl. "Letter from the Airport," *Living Arts* 1, Spring 1963. Published by the Institute for Contemporary Art, London.

Newman, M. W. "A Sandwich by Picasso," *Chicago Daily News*, September 21, 1966.

——— . "Regarding Picasso's Civic Center Sculpture," *Chicago Daily News*, July 15, 1967.

——— . "Scarface, Climbers Wound Picasso Sculpture," *Chicago Daily News*, September 27, 1969.

——— . "Suit Attacks City's Picasso Copyright," *Chicago Daily News*, May 27, 1970.

Prejger, Lionel. "Picasso découpe le fer," *L'ŒIL* 82 (October 1981).

Reed, David. "The Picasso's Birthday," *Chicago Sun-Times*, August 15, 1970.

Rose, Barbara. "Blowup—The Problem of Scale in Sculpture," *Art in America* 56 (July/August 1968).

Ross, Norman. "Let's Not Knock It Till We've Tried It," *Chicago Daily News*, August 16, 1967.

Schjeldahl, Peter. "Another Dimension." *New Yorker*, September 21, 2015.

Schreiber, Edward. "Picasso Work Rubs Reilly in Wrong Places," *Chicago Tribune*, June 14, 1967.

Schulze, Franz. "But, Of Course, It's a Woman," *Chicago Daily News*, August 23, 1969.

——— . "How Picasso Lady Looks to Art Critic...," *Chicago Daily News*, August 16, 1967.

Schwabsky, Barry. "Secret Accords," *Nation*, November 9, 2015.

Schwartz, Donald. "Our Own Picasso—A Progress Report," *Chicago Sun-Times Midwest Magazine*, May 14, 1967.

Senie, Harriet. "Urban Sculpture: Cultural Tokens or Ornaments to Life?" *Art News* 78 (September 1979).

Smith, Roberta. "Review: Picasso's Weeping Women, United." *New York Times*, September 10, 1994.

——— . "Picasso, Completely Himself in Three Dimensions." *New York Times*, September 10, 2015.

St. Louis Post-Dispatch, "The Picasso Square." Reprinted in the *Chicago Sun-Times*, September 30, 1967.

Thompson, D., and Joshua Kind. "Chicago Picasso," *Chicago Midwest Art* 2 (November 1966).

Watson, Jerilyn. "Other Cities Like Our Picasso," *Chicago American*, July 23, 1967.

Witt, Linda. "Picasso Booms Business," *Chicago American*, August 8, 1967.

Wolfe, Sheila. "Colossus or Whatsis: All Come for a Look," *Chicago Tribune*, August 16, 1967.

Yue, Lorene. *Crain's Chicago Business,* June 8, 2007.

Zochert, Donald. "Pride of Plaza, Our Picasso is One Year Old," *Chicago Daily News*, August 15, 1968.

Books

Ashton, Dore (editor). *Picasso On Art: A Selection of Views* (Boston: Da Capo, 1988).

Barr, Alfred H., Jr. *Picasso: Fifty Years of His Art* (New York: Museum of Modern Art, 1946).

Berger, John. *Toward Reality* (New York: Alfred A. Knopf, 1962).

Bernier, Rosamond. *Matisse, Picasso, Miró As I Knew Them* (New York: Alfred A. Knopf, 1991).

Bowness, Alan. "Picasso's Sculpture," from *Picasso 1881–1973*, edited by Sir Roland Penrose and John Golding (London: Paul Elek, Ltd., 1973).

Carter, Peter. *Mies van der Rohe at Work* (London and New York: Phaidon Press, 1999 reprint of 1974 original).

———— . "Mies van der Rohe, Ludwig." *The Grove Encyclopedia of American Art* (New York and Oxford: Oxford University Press, 2011).

Clark, T. J. *Picasso and Truth: From Cubism to Guernica* (Princeton: Princeton University Press, in conjunction with the National Gallery of Art, Washington, DC, 2013).

Clergue, Lucien, *Picasso Mon Ami* (Paris: Editions Plume, 1993).

D'Alessandro, Stephanie. *Picasso and Chicago: 100 Years, 100 Works* (Chicago: Art Institute of Chicago, 2013).

Dufour, Pierre. *Picasso 1950–1968* (Cleveland: The World Publishing Co., 1969).

Duncan, David Douglas. *Photo Nomad* (New York: W. W. Norton and Co., 2003).

———— . *Picasso & Lump: A Daschund's Odyssey* (London: Thames & Hudson, Ltd, 2006).

———— . *The Private World of Pablo Picasso* (New York: Ridge Press, 1958).

Fairweather, Sally. *Picasso's Concrete Sculpture* (New York: Hudson Hills Press, 1982).

Feldman, Franklin, and Stephen E. Weil. *Legal and Business Problems of Artists, Art Galleries, and Museums* (New York: Practicing Law Institute, 1973).

Fitzgerald, Michael. *Picasso and American Art* (New York: Whitney Museum of American Art, in association with Yale University Press, 2006).

Gallwitz, Klaus, *Picasso: The Heroic Years* (New York: Abbeville Press, 1985).

Gedo, Mary Mathews. *Picasso: Art as Autobiography* (Chicago and London: University of Chicago Press, 1980).

Gopnik, Adam. Preface to *Picasso and Chicago: 100 Years, 100 Works* (Chicago: Art Institute of Chicago, 2013), by Stephanie D'Alessandro.

Herrick, Edward. *A Spiritual Interpretation of Chicago's Picasso, Michelangelo's Pieta, and the 23rd Psalm* (New York: Vantage Press, 1968).

Kangas, Matthew. *Seattle Art Guide* (Seattle: Tipton Publishing Co., 2011).

Mathewson, Joe. *Up Against Daley* (LaSalle, Illinois: Open Court Publishing Co., 1974).

Otero, Roberto. *Forever Picasso* (New York: Harry N. Abrams, Inc., 1974).

Parmelin, Hélène. *Picasso Says* (London: George Allen and Unwin, Ltd., 1969).

———— . *Picasso: Women, Cannes and Mougins* (New York: Harry N. Abrams, Inc., 1964). Introduction by Harry N. Abrams editor-in-chief Milton S. Fox.

Penrose, Roland F. *Picasso: His Life and Work* (Berkeley and Los Angeles: University of California Press, 1981).

———— . *Picasso: Sculpture-Ceramics-Graphic Work: at the Tate Gallery* (London: Arts Council of Great Britain, 1967).

———— . *The Eye of Picasso* (New York: The New American Library, in arrangement with UNESCO, 1967).

Penrose, Roland F., and Edward Quinn. *Scrapbook 1900–1981* (New York: Rizzoli, 1981).

Richardson, John. *Picasso: An American Tribute* (New York: Public Education Association/Chanticleer Press, 1962).

———— . *PICASSO Mosqueteros: The Late Works 1962–1973*; (New York: Gagosian Gallery, 2009).

Robinette, Margaret A. *Outdoor Sculpture* (New York: Guptill Publications, 1976).

Rosenblum, Robert. *The Sculpture of Picasso* (New York: Pace Gallery, 1982).

Sabartés, Jaime. *Paintings and Drawings of Picasso* (New York: Tudor Publishing Co., 1946), contributor in *Picasso On Art: A Selection of Views*, edited by Dore Ashton (Boston: Da Capo, 1988).

Schiff, Gert. *Picasso: The Last Years, 1963–1973* (New York: George Braziller in association with Grey Art Gallery & Study Center, New York University, 1988).

Schulze, Franz. Foreword to *A Guide to Chicago's Public Sculpture*, by Ira J. Bach and Mary Lackritz Gray (Chicago: University of Chicago Press, 1983).

Schulze, Franz and Edward Windhorst. *Mies van der Rohe* (Chicago: University of Chicago Press, 2014).

Temkin, Anne, and Anne Umland. *Picasso: Sculpture* (New York: Museum of Modern Art, 2015).

Verpoorten, Frank. Catalogue for *Naples Collects* (Naples, Florida: Artis/Baker Museum, 2015).

Interviews

Adrian, Dennis. Interview with the author, November 23, 1981.

Bowman, Russell. Interview with the author, June 9, 2015.

Brownson, Jacques. Interview with the author, October 14, 1981.

———— . Interview with the author, November 10, 1981.

Clergue, Lucien. Interview with the author, October 20, 1981.

———— . Interview with the author, June 9, 2011.

Colaco, Joseph P. Interview with the author, November 3, 1981.

Copley, William N. Interview with the author, November 1, 1981.

Cordwell, John D. Interview with the author, October 4, 1981.

Gedo, Mary Mathews. Interview with the author, November 18, 1981

Gray, Paul. Interview with the author, December 8, 2014.

Hartmann, William. Interview with the author, November 20, 1977.

———— . Interview with the author, August 11, 1981.

———— . Interview with the author, November 30, 1981.

Hodes, Scott. Interview with the author, October 19, 1981.

Hunt, Richard. Interview with the author, December 7, 2014.

Joachim, Harold. Interview with the author, February 11, 1982.

Lanier, Philip. Interview with the author, February 5, 2016.

Lo, Fred C. T. Interview with the author, October 24, 1981.

———— . Interview with the author, January 28, 2015.

———— . Interview with the author, October 19, 2015.

———— . Interview with the author, September 19, 2016.

Lohan, Dirk. Interview with the author, January 20, 2015.

Manny, Carter H., Jr. Interview with the author, September 18, 1981.

———— . Interview with the author, October 20, 1981.

———— . Interview with the author, January 26, 2016.

Neumann, Morton G. Interview with the author, December 14, 1981.

Peart, Jerry. Interview with the author, November 2, 1981.

Perkins, Lawrence B. Interview with the author, October 7, 1981.

Powell, Don. Interview with the author, March 15, 2015.

Rychalski, Anatol. Interview with the author, January 11, 1982.

———— . Interview with the author, January 16, 2016.

Schlossman, Norman. Interview with the author, September 25, 1981.

Schroeder, Charles E. Interview with the author, October 5, 1981.

Schulze, Franz. Interview with the author, June 23, 1982.

———— . Interview with the author, January 24, 2016.

Van Zanten, David. Interview with the author, January 28, 2015.

Manuscripts, Lectures, Public Documents, Films

Art Institute of Chicago. Correspondence from the office of the secretary, January 25, 1982.

"Chicago Picasso: Greatness in the Making," WNET, 1967, directed by Mallory Slate.

City of Chicago. Event program, "Dedication of the Chicago Picasso." August 15, 1967.

Clergue, Lucien. *"Picasso Mon Ami,"* lecture, Art Institute of Chicago, October 20, 1981.

Copyright judgment, Letter Edged in Black Press, Inc. v. the Public Building Commission of Chicago, Civil Action No. 69C 353 (U.S. District Court, N. D. Illinois E. D., 1970), affidavits and depositions attached thereto; William E. Hartmann speech to Major Daley and members of the Public Building Commission, June 1965, Hartmann Deposition, exhibit 21.

Hughes, Robert. "Art and Architecture: A Failed Marriage," lecture, "Bright New Chicago" series, sponsored by the University of Chicago, April 27, 1981.

Lanier, Philip and John Callaway. "Picasso: Pablo and The Boss: The Amazing Story of Chicago's Picasso," WTTW Film with the Chicago Historical Society.

Oldenburg, Claes, Letter to Barnet Hodes, December 25, 1970, courtesy of Scott Hodes.

Public Buildings Commission of Chicago, press release, September 20, 1966.
———— Minutes of the Commission Meeting, July 27, 1966.
———— Minutes of the Commission Meeting, October 24, 1967.

Rosenblum, Robert. *Picasso: The Legacy of Genius*, film, directed by Michael Blackwood. 1980.

Tanamor, Jason. Interview with Train front man Pat Monahan, July 18, 2014, "Zoiks! Online."

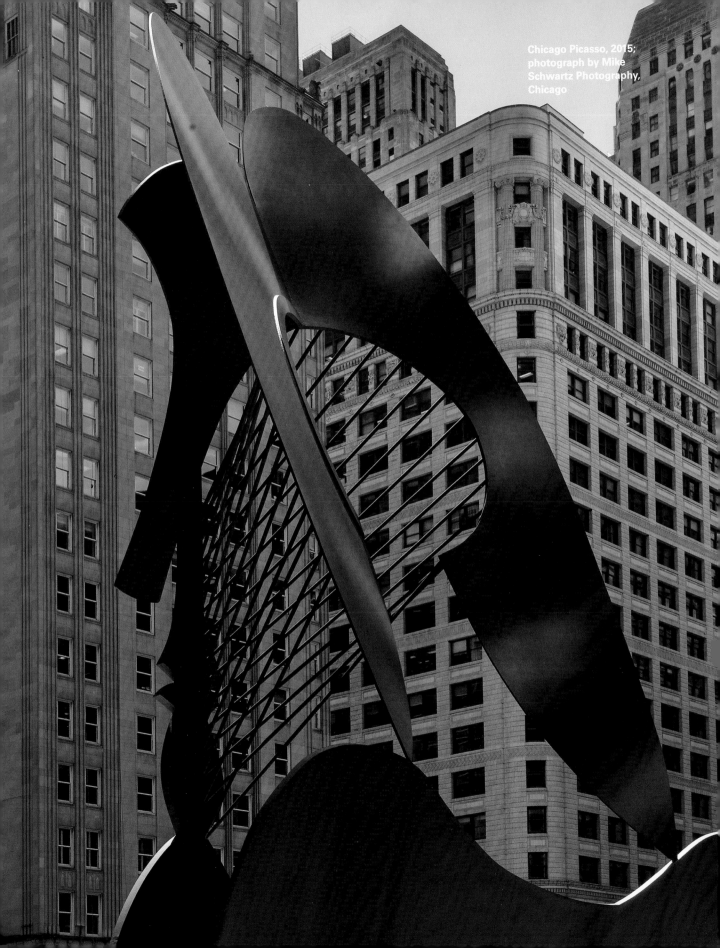

Chicago Picasso, 2015;
photograph by Mike
Schwartz Photography,
Chicago

LIST OF ILLUSTRATIONS

Hardcover

Drawing of Picasso maquette, front view, 1966; © SOM

Jacket Cover

Chicago Picasso profile, 2016; photograph by Karina Wang, PhotoScapes, Chicago

Frontispiece

Pablo Picasso (1881–1973), in Mougins, France, 1967, with one of his studies for Civic Center Sculpture, white chalk on plywood, 39⅜ x 31⁵⁷⁄₆₄ inches, gift of the artist to the Art Institute of Chicago; photograph © SOM, artwork © 2017 Estate of Pablo Picasso / Artists Rights Society (ARS), New York

Foreword

Introduction

Chapter 1

sculpture at lower left; watercolor and gouache on board, 42 x 84 inches; gift of Helmut Jahn, 1982.1083, The Art Institute of Chicago

Chapter 2

23. William E. Hartmann (1916–2003); photograph © SOM
24. Chicago Picasso and visitors in the plaza, 2015; photograph by Mike Schwartz Photography, Chicago
29. Picasso with Sioux Indian bonnet, 1964, gift of William E. Hartmann at left; unidentified friend at right; photograph © SOM
31. Aluminum model designed by Fred Lo, 41¼ inches, held by J. D. Rollins, president of U. S. Steel American Bridge Division, William E. Hartmann of SOM, and Robert W. Christensen, executive director of Chicago Public Building Commission; executed by Richard Rush Studio, Chicago, 1966; photograph by Hube Henry © Hedrich Blessing, courtesy of SOM
33. Pablo Picasso signed Deed of Gift, August 21, 1966; photograph © SOM

Chapter 3

34. Pablo Picasso, *Maquette for Richard J. Daley Center Sculpture*, 1964; simulated and oxidized welded steel, 41¼ x 27½ x 19 inches; gift of Pablo Picasso, 1966.379, The Art Institute of Chicago; artwork © 2017 Estate of Pablo Picasso / Artists Rights Society (ARS), New York.
37. Pablo Picasso, *Les Demoiselles d'Avignon*, 1907; oil on canvas, 96 x 92 inches; acquired through the Lillie P. Bliss Bequest; photograph courtesy of MoMA; artwork © 2017 Estate of Pablo Picasso / Artists Rights Society (ARS), New York; photograph © The Museum of Modern Art / licensed by SCALA / Art Resource, New York
39. Pablo Picasso, *Figure* (*Project for a Monument for Apollinaire*), 1928; iron sculpture, 39 inches high; gift of the artist's estate; courtesy of Musée Picasso, Paris; artwork © 2017 Estate of Pablo Picasso / Artists Rights Society (ARS), New York; photograph by Béatrice Hatala © RMN-Grand Palais / Art Resource, New York
41. Pablo Picasso, *Abstraction: Background with Blue Cloudy Sky*, January 4, 1930; oil on panel, 26 x 19⅜ inches; gift of Florene May Schoenborn and Samuel A Marx, Wilson L. Mead Fund, 1955.748, The Art Institute of Chicago; artwork © 2017 Estate of Pablo Picasso / Artists Rights Society (ARS), New York
42. Pablo Picasso, *Tete de femme*, 1962; sheet metal cut-out and folded, 20 x 10⅞ x 7 inches; collection of Mr. and Mrs. Morton L. Janklow, New York, New York; photograph by Kerry Ryan McFate, courtesy Pace Gallery; artwork © 2017 Estate of Pablo Picasso / Artists Rights Society (ARS), New York
43. Pablo Picasso, *Tete de femme*, 1962; sheet metal cut-out and folded, 20 x 10⅞ x 7 inches; three-quarter profile view; collection of Mr. and

Mrs. Morton L. Janklow, New York, New York; photograph by Kerry Ryan McFate, courtesy Pace Gallery; artwork © 2017 Estate of Pablo Picasso / Artists Rights Society (ARS), New York

44. Carl Nesjar, *Sylvette,* 1968; approved enlargement from earlier Picasso metal sculpture, white cement and crushed granite, 34 feet 10 inches; East Building, Silver Towers, New York University, New York, New York, concrete, glass, and reinforced steel; construction completed 1967; architecture by I. M. Pei; director, James Ingo Freed; engineering by Farkas and Barron; designated as a NYC Landmark by the Landmarks Commission of New York City, 2008; photograph by Michael Lindgren, New York

45. Carl Nesjar, *The Bather,* 1975; approved enlargement from earlier Picasso metal sculpture, white cement and crushed granite, 28 feet; commission for Gould Inc., Rolling Meadows, Illinois; (maquette gift by Gould CEO William Yllvisaker to Harper College, Palatine, Illinois); photograph by R. Scott Stratton

47. Pablo Picasso, *Six Busts of Women,* 1962; graphite on ivory wove paper, 16½ x 10⅝ inches; restricted gift of William E. Hartmann, 1967.539, The Art Institute of Chicago; artwork © 2017 Estate of Pablo Picasso / Artists Rights Society (ARS), New York

Chapter 4

48. Civic Center Plaza, 1963; photograph by Bill Engdahl © Hedrich Blessing, courtesy of SOM

51. Drawings of Picasso maquette, top, front, and rear views, 1966; © SOM

53. Wind tunnel test, up to 185 mph, executed by SOM engineers; photograph © Paul Weidlinger, courtesy of SOM

55. Aluminum model by SOM, 1966; 41¼ inches; executed at Richard Rush Studio, Chicago, signed by Picasso "*Bon à tirer;*" photograph by Hube Henry © Hedrich Blessing, courtesy of SOM

56. Wooden model of Chicago Picasso, 1966; 12½ feet, designed by Fred Lo, standing second from right, and Joseph Colaco of SOM at American Bridge Division of U. S. Steel, Gary, Indiana; photograph © SOM

59. Aluminum model, 1966; 12½ feet, (Fred Lo at right) at American Bridge Division of U. S. Steel, Gary, Indiana; photograph © Hedrich Blessing, courtesy of SOM

60. Chicago Picasso under construction at American Bridge Division of U. S. Steel, Gary, Indiana, 1966–67; photograph © Williams & Meyer, courtesy of SOM

62. Railroad track skidding material in place on Civic Center Plaza for installing Picasso sculpture in sections before welding, 1967; photograph © SOM

63. U. S. Steel American Bridge worker welding together front face plate at Civic Center, 1967; courtesy of SOM

65. U. S. Steel American Bridge workers hoisting 30-ton front face plate into position at the Civic Center, 1967; photograph © SOM

Chapter 5

66. Chicago Picasso, 2015; photograph by Mike Schwartz Photography, Chicago
71. Poster for Picasso exhibition at Galerie H. Matarasso, Nice, 1956–57; 26½ x 19 inches; vintage original poster dated December 4, 1956; purchased from the collection of Chicago architect Robert Kleinschmidt by the author; artwork © 2017 Estate of Pablo Picasso / Artists Rights Society (ARS), New York
72. Pablo Picasso, *Portrait of Sylvette David*, 1954; oil on canvas, 51⁷⁄₁₆ x 38¹⁄₁₆ inches; gift of Mary and Leigh Block, 1955.821, The Art Institute of Chicago; artwork © 2017 Estate of Pablo Picasso / Artists Rights Society (ARS), New York
75. Pablo Picasso, *Portrait of Jacqueline*, December 28, 1962; graphite with smudging and black ballpoint pen on paper, 13¾ x 9⅞ inches; courtesy of Richard and Mary L. Gray and the Gray Collection Trust; artwork © 2017 Estate of Pablo Picasso / Artists Rights Society (ARS), New York
76. Pablo Picasso, *Jacqueline with a Yellow Ribbon*, 1962; sheet metal, cut-out, bent, and painted, 19⅝ inches; courtesy of the National Gallery of Iceland, Reykjavik; gift of Jacqueline Roque Picasso; artwork © 2017 Estate of Pablo Picasso / Artists Rights Society (ARS), New York

Chapter 6

80. Picasso in Mougins studio with sculptures, c. 1966; photograph by Lucien Clergue, 14½ x 14½ inches; collection of the author; photograph © Estate of Lucien Clergue; artwork © 2017 Estate of Pablo Picasso / Artists Rights Society (ARS), New York
83. Claes Oldenburg (1929–), *Soft Version of the Maquette for a Monument Donated to Chicago by Pablo Picasso,* 1968; canvas and rope painted with acrylic, 38 x 28¾ x 21 inches; courtesy of Musée National d'Art Moderne, Centre Georges Pompidou, Paris; reproduced with permission of the Oldenburg van Bruggen Studio, New York; photograph by Philippe Migeat © CNAC / MNAM / Dist. RMN-Grand Palais / Art Resource, New York; artwork © Claes Oldenburg / Artists Rights Society (ARS), New York
84. Chicago Picasso, 2015; Mike Schwartz Photography, Chicago
86. Richard Hunt (1935–), *Freeform*, 1993; welded stainless steel, 26 x 35 x 2 feet; State of Illinois Building, 160 North LaSalle Street, Chicago; photograph by Karina Wang, PhotoScapes, Chicago

86. Alexander Calder (1898–1976), *Flamingo,* 1974; painted steel stabile, 53 feet; Federal Center, Chicago; photograph by Karina Wang, PhotoScapes, Chicago; artwork © Artists Rights Society (ARS), New York

88. Marc Chagall (1887–1985), *The Four Seasons,* 1972; mosaic, 70 x 14 x 10 feet; Chase Tower Plaza, Chicago; photograph by Karina Wang, PhotoScapes, Chicago; artwork © Artists Rights Society (ARS), New York

89. Jean Dubuffet (1901–1985), *Monument with Standing Beast,* 1984; fiberglass, 29 feet; James R. Thompson Center, Chicago; photograph by Karina Wang, PhotoScapes, Chicago; artwork © Artists Rights Society (ARS), New York

90. Joan Miró (1893–1983), *The Sun, the Moon and One Star,* now known as *Miro's Chicago,* 1981; mixed media, 39 feet; Brunswick Building, Chicago; photograph by Karina Wang, PhotoScapes, Chicago; artwork © Artists Rights Society (ARS), New York

93. Rear view of Chicago Picasso, 2015; photograph by Mike Schwartz Photography, Chicago

94. Chicago Picasso wearing Chicago Cubs helmet during post-season National League Division Title win in 2008; the Cubs finally advanced to the World Series and won in 2016 — 108 years after their last World Series Championship; helmet executed and installed by Chicago Scenic Studios; photograph courtesy of Chicago Scenic Studios

94. Police car at Daley Center from *Blues Brothers* movie, 1980; photograph courtesy of Universal Studios Licensing LLC, Atlanta, Georgia

97. Anish Kapoor (1954–), *Cloud Gate* (aka "The Bean"), 2006; stainless steel, 33 x 42 x 66 feet; Millennium Park, Chicago; photograph by Karina Wang, PhotoScapes, Chicago; artwork © Artists Rights Society (ARS), New York

97. Jaume Plensa (1955–), *Crown Fountain,* 2004; granite reflecting pool with dual LED screen and glass brick sculpture, 50 feet; Millennium Park, Chicago; photograph by Karina Wang, PhotoScapes, Chicago; artwork © Artists Rights Society (ARS), New York

99. William E. Hartmann, Jacqueline, and Picasso in Mougins, 1968; photograph by Lucien Clergue, 15 x 11 inches; collection of the author; photograph © Estate of Lucien Clergue

Acknowledgements

100. Pablo Picasso, *Richard J. Daley Center Sculpture,* 1967; white chalk on plywood, $39\frac{3}{8}$ x $31\frac{57}{64}$ inches; gift of Pablo Picasso, 1967.538, The Art Institute of Chicago; artwork © 2017 Estate of Pablo Picasso / Artists Rights Society (ARS), New York

103. Photographer Lucien Clergue and author in Arles, 2011

Appendices

104. Chicago Picasso, 2015; Mike Schwartz Photography, Chicago
109. Deere & Company World Headquarters on 1400 wooded acres, 2003; designed by Eero Saarinen 1958, begun 1961, opened 1964; Cor-Ten steel; photograph courtesy of John Deere, Moline, Illinois

Notes

112. Chicago Picasso, 2015; Mike Schwartz Photography, Chicago

Sources

123. Chicago Picasso, 2015; Mike Schwartz Photography, Chicago
129. Chicago Picasso, 2015; Mike Schwartz Photography, Chicago

Jacket Rear Cover

Picasso and Jacqueline in profile, c. 1960; 14½ x 18 inches, photograph by Lucien Clergue; collection of the author; photograph © Estate of Lucien Clergue; © 2017 Estate of Pablo Picasso / Artists Rights Society (ARS), New York

ABOUT THE AUTHOR

Patricia Balton Stratton was born in Cincinnati and received both her undergraduate and graduate education at Northwestern University, where her masters thesis in art history concentrated on the acquisition, construction, and iconography of the Chicago Picasso. She served as a docent and guide for a number of regional art museums, as well as a volunteer and board member of the Chicago Public School Art Society (later known as Art Resources in Teaching) that was an affiliate of the School of the Art Institute. She divides her time between Chicago and Naples, Florida. Her daughter and four grandchildren live in Arlington Heights, Illinois.

Contraindications/Indications: massage can reduce anxiety related to the condition and reduce swelling of the nerve; use caution on the cervical vertebrae.

Benign tumor — a tumor that does not metastasize and does not destroy normal tissue.

Contraindications/Indications: avoid massage of immediate area; pressure may break the capsule.

Bone fracture — a break in a bone.

Contraindications/Indications: work proximal and distal to the site of injury, but not on the fracture until there is complete union (usually 6 to 8 weeks); check with client's doctor before starting therapy; energy work promotes healing during the acute phase of healing; exercise and stretch atrophied muscles when bone has healed appropriately.

Bronchitis (chronic) — inflammation of the mucous membranes of the bronchial tubes.

Contraindications/Indications: can be infectious, so check with client's doctor before starting therapy; massage can reduce thoracic muscular spasms; avoid massage if there is a fever.

Burns

Contraindications/Indications: check with client's doctor before starting therapy; avoid affected area if painful; energy work is effective; deeper massage can reduce scarring if completely healed.

Bursitis — inflammation of the bursae; commonly occurs in the shoulder or knee.

Contraindications/Indications: avoid deep work on affected areas; massage can increase inflammation in acute cases; caution must be used because it can be a painful condition; check the bicipital groove of the humerus for tendon dislocation.

Cancer — a tumor or form of new tissue cells that lack a controlled growth pattern; can invade and destroy normal tissues and spread.

Contraindications/Indications: always obtain approval from client's doctor before starting therapy because massage may promote metastasis; energy work can reduce stress and anxiety.

Carcinoma (basal cell, squamous cell) — a new growth or malignant tumor in the epithelial tissue; can metastasize and affect almost any tissue that it reaches through the blood or lymph channels.

Contraindications/Indications: always obtain approval from client's doctor before starting therapy because massage can promote metastasis; energy work can relieve stress and associated anxiety.

Carpal tunnel syndrome — pain or numbness affecting some part of the median nerve distribution in the hands.

Contraindications/Indications: massage of the cervical muscles, pectoralis minor muscle, and arms can relax involved muscles and improve circulation and nerve innervation.

Cerebral palsy — a nonprogressive motor disorder or paralysis caused by prenatal damage to the brain.

Contraindications/Indications: check with client's doctor before starting therapy; massage may improve motor control and reduce related anxiety; no deep tissue work.

Chronic fatigue syndrome — a disorder marked by abnormal, severe, chronic fatigue and exhaustion.

Contraindications/Indications: massage may reduce associated stress and anxiety and allow the body to relax; avoid deep tissue work because it may overwork the immune system.

Circulatory system disorders — disorders involving the circulatory system, such as hypertension (high blood pressure), cardiac decompensation (heart weakness), and arrhythmia (irregular heartbeat).

> **Contraindications/Indications:** research thoroughly and check with client's doctor before starting therapy; any massage should be light and soothing.

Cirrhosis of the liver — a disease that damages the liver and impairs the normal functions of the liver.

> **Contraindications/Indications:** obtain approval from the client's doctor before starting therapy because there may be liver damage; avoid abdominal massage; massage for fluid movement may stress the liver; massage of lower extremities may reduce related edema.

Compromised immune system [acquired immunodeficiency syndrome (AIDS)] — decreased ability to fight off disease due to a depressed or inactive immune system.

> **Contraindications/Indications:** always obtain approval and advice from the client's doctor before starting therapy; follow universal precautions and hygiene requirements for your benefit and the client's benefit.

Constipation — problems in passing stools.

> **Contraindications/Indications:** always massage the abdomen in the direction of normal peristaltic action (clockwise); use caution during pregnancy.

Contracture — abnormal shortening of muscle tissue that makes it highly resistant to stretching; typically caused by abnormal formation of fibrous or scar tissue supporting the muscles or joints.

> **Contraindications/Indications:** massage can reduce or prevent contraction and adhesions.

Contusion — a nonacute bruise that causes hemorrhage below intact skin.

> **Contraindications/Indications:** watch for bleeding and avoid the area of the bruise; energy work promotes healing; do not massage directly on the bruise until clotting has been reabsorbed and the color of the bruise changes.

Cystic fibrosis — an inherited disease of the exocrine glands characterized by thick mucus that clogs the ducts; results in the attraction of bacteria and slow or impeded functioning of the pancreas, respiratory system, and apocrine glands and organs.

> **Contraindications/Indications:** obtain approval from client's doctor before starting therapy; avoid the area of the pancreas, if inflamed; tapotement is most effective in relieving blockage in the lungs.

Decubitus ulcer — a sore that forms as a result of prolonged pressure while lying down or in a wheelchair; most commonly forms over bony prominences where there is tissue death due to a lack of blood supply.

> **Contraindications/Indications:** do not massage affected area; massage as a preventive measure is most effective in improving circulation and alleviating pressure.

Degenerative disk disease — see *osteoarthritis,* under *arthritis.*

Dermatitis — inflammation of the skin resulting in itching, redness, and lesions.

> **Contraindications/Indications:** condition is not contagious; avoid massage if affected areas are painful, itching, or weeping.

Diabetes mellitus — a chronic disorder of carbohydrate metabolism due to abnormal insulin production; usually characterized by excessive urination.

> **Contraindications/Indications:** obtain approval and advice from client's doctor before starting therapy; caution must be used, especially in advanced cases; progression may include neuropathy, atherosclerosis, and kidney problems.

Digestive problems — abdominal stress due to illness, medical treatment, emotions, or trauma.

> **Contraindications/Indications:** use caution during pregnancy, especially during the first trimester; massage can facilitate peristalsis if done in a clockwise pattern on the abdomen.

Dislocation — bone or joint misalignment.

Contraindications/Indications: obtain advice from client's doctor before starting therapy; do not try to "set" a dislocation; no stretching or massage should be done until pain and inflammation subside; energy work is appropriate.

Dysmenorrhea — painful menstruation caused by some type of pelvic pathology.

Contraindications/Indications: massage can reduce circulatory congestion and associated pain; energy work is most effective.

Ecchymosis — see *subcutaneous bleeding.*

Edema — a condition in which there is an excessive amount of interstitial fluid contained in body tissues.

Contraindications/Indications: obtain approval from client's doctor before starting therapy; massage is contraindicated for edema due to heart decompensation, infections, and kidney diseases; massage for general edema can improve movement of blood and lymph and reduce swelling; watch for edema in pregnancy, which could be a symptom of toxemia.

Elderly clients

Contraindications/Indications: watch for diseases common in the elderly, such as osteoporosis (in pelvis, lumbar vertebrae, and cervical vertebrae), atherosclerosis, and parchment skin; client may bruise easily; avoid deep work and extreme neck range of movement, especially in the area of the carotid artery; massage should be shorter but more frequent than usual.

Emphysema — a chronic pathologic condition in which the terminal bronchioles and alveoli become destroyed; primarily due to exposure to cigarette smoke.

Contraindications/Indications: check with client's doctor before starting therapy; massage can relax muscles involved with breathing and reduce associated anxiety.

Endometriosis — excessive growth of the inner lining of the uterus (i.e., the endometrium).

Contraindications/Indications: avoid localized massage on the lower abdomen; energy work can be effective.

Extreme fatigue

Contraindications/Indications: may be a serious condition such as acquired immunodeficiency syndrome (AIDS), cancer, chronic infection, or hepatitis; use caution and check with client's doctor before starting therapy.

Fever — usually defined as a core temperature of 99.6°F or higher.

Contraindications/Indications: massage is contraindicated; even energy work will reduce the fever, which will inhibit the immune system at work (fever is an immune system response to infection); there is the possibility of a contagious condition.

Fibromyalgia (fibrositis, fibromyositis) — various inflammatory conditions involving fibrous or muscle tissue and resulting in lack of range of movement, increased sensitivity, and pain.

Contraindications/Indications: caution is important due to possible extreme sensitivity to touch; kneading, pétrissage, and friction can break up adhesions and prevent further formations, but perform only as client's tolerance allows.

Headache (tension or cluster) — pain in various parts of the head.

Contraindications/Indications: massage can reduce tension and relax tense muscles, primarily in the neck and shoulders, that typically cause these types of headaches.

Hematoma — see *subcutaneous bleeding.*

Hernia — protrusion or partial protrusion of an organ through the wall of the cavity that contains it.

Contraindications/Indications: avoid massage of affected area.

Herniated disk — rupture or protrusion of the nucleus pulposus in the intervertebral disk; usually occurs in the lumbar region.

> **Contraindications/Indications:** in acute phase, obtain advice from client's doctor before starting therapy and avoid the area; energy work is okay.

Hypertension — high blood pressure.

> **Contraindications/Indications:** check with client's doctor before starting therapy; massage is contraindicated in extreme cases due to possible thrombus (clot) formation; avoid deep tissue work or painful massage in all cases; soothing massage may reduce high blood pressure and associated stress.

Infants

> **Contraindications/Indications:** tissue is very pliable, sensitive, and in extreme growth, so avoid deep or painful work; ideas of touch develop at an early age, so massage should be short and sweet.

Infectious diseases — diseases include the common cold, the flu, Reye's syndrome, and tuberculosis.

> **Contraindications/Indications:** these are typically contagious; massage is contraindicated if a fever is present and during the acute phase; energy work should be avoided; massage can aggravate the condition and spread infection.

Infectious skin conditions — skin conditions that are infectious include impetigo, warts, scabies, ringworm, and any bacterial, viral, fungal, or parasitic problems.

> **Contraindications/Indications:** all are contagious, so **do not touch** the client; refer client to a physician.

Inflammation (acute) — general area of redness, pain, heat, and swelling; any condition with the suffix "-itis" (e.g., tendonitis, pancreatitis) involves inflammation.

> **Contraindications/Indications:** obtain approval from client's doctor for general massage; avoid areas of inflammation; energy work can reduce inflammation.

Injured limb (nonacute) — injury or trauma to a limb, typically not requiring medical treatment.

> **Contraindications/Indications:** massage according to the client's condition; working proximal to the injury can increase circulation and assist in healing.

Insomnia — inability to sleep for extended periods of time.

> **Contraindications/Indications:** massage should be soothing and relaxing; effleurage from the occiput to the coccyx can sedate the energy in the governing vessel meridian.

Laminectomy — excision of the vertebral posterior arch; usually done to relieve herniated disks; often finished with fusion of the affected vertebrae.

> **Contraindications/Indications:** in acute phase, check with client's doctor before starting therapy; usually necessary to avoid the area; energy work could be effective.

Lipoma (or sebaceous cyst) — a fatty, nonmetastatic tumor of a sebaceous gland.

> **Contraindications/Indications:** if the client has not seen a doctor, refer the client; avoid direct deep work; massage is generally okay.

Loss of tissue integrity — a condition that can result from recent surgery and associated scar tissue as well as chronic joint subluxations and other conditions.

> **Contraindications/Indications:** research the condition; if necessary, obtain advice from client's doctor; massage is generally indicated.

Malignant melanoma — an abnormal, cancerous growth of skin cells that can metastasize.

> **Contraindications/Indications:** obtain approval from client's doctor before any massage; if the client has not seen a doctor, diplomatically refer immediately; avoid immediate area.

Medications — includes over-the-counter medications and prescription medications.

Contraindications/Indications: research the reason for medication; when in doubt as to the course of action, check with client's doctor.

Mental conditions — conditions that may be encountered include psychosis and bipolar disorder, among others.

Contraindications/Indications: research the condition; check for medications, which can affect pain sensitivity; massage can aggravate some conditions; avoid deep work in stressful cases; when in doubt, obtain advice from client's doctor.

Migraine headache — usually a severe, unilateral headache with accompanying visual and gastrointestinal disturbances.

Contraindications/Indications: use caution during an episode; check with client's doctor, if necessary; massage of the neck and shoulders and pressure point therapies can be most effective.

Multiple sclerosis — an inflammatory disease of the central nervous system in which the immune system degrades the myelin sheath of the nerves.

Contraindications/Indications: use caution because of impaired neurologic sensitivity; massage can reduce muscle spasm and associated anxiety.

Muscle cramps — spontaneous and involuntary muscle contractions.

Contraindications/Indications: short effleurage from tendons to muscle belly can reset proprioceptors; compression, strain–counterstrain, proprioceptive neuromuscular facilitation, and reciprocal inhibition stretching can be effective.

Neuralgia — severe, sharp pain along the course of a nerve (e.g., sciatica).

Contraindications/Indications: first check origin of nerve root; massage can release tension, soothe pain, and release endorphins (natural pain killers).

Nonunion fracture — a broken bone that has not yet fused back together.

Contraindications/Indications: avoid immediate area until sufficiently healed; energy work is best until healed.

Open sores (and lacerations)

Contraindications/Indications: avoid immediate area; refer client for medical care.

Osteitis deformans (Paget's disease) — a chronic condition characterized by lengthening of the long bones and deformity of the flat bones.

Contraindications/Indications: massage is contraindicated due to fragile bones.

Osteitis fibrosa cystica — a condition with symptoms similar to rickets (see *osteomalacia*) but with abnormal blood calcium and phosphorous levels and accompanying cysts and tumors.

Contraindications/Indications: massage is contraindicated due to fragile bones.

Osteoarthritis — see *arthritis.*

Osteomalacia (rickets) — softening of bone tissue causing brittleness and deformities.

Contraindications/Indications: massage is contraindicated due to fragile bones.

Osteoporosis — a condition in which bone integrity is reduced due to a lack of calcium absorption; most common in postmenopausal women; bones of the pelvis and the lumbar and cervical vertebrae are most often affected, but all bones may be brittle.

Contraindications/Indications: check with client's doctor before starting therapy; any bodywork should be light.

Parkinson's disease — a chronic nervous disease characterized by slow-spreading muscular tremors, muscle weakness and rigidity, and a peculiar gait.

Contraindications/Indications: check with client's doctor before massage; massage may reduce muscle spasm and associated stress and anxiety.

Peripheral neuritis — inflammation of nerves outside of the central nervous system.

Contraindications/Indications: light massage, vibration, and soothing techniques are best; deeper tissue techniques may be contraindicated because they can cause further inflammation.

Phlebitis — inflammation of a vein, usually in a lower limb.

Contraindications/Indications: avoid affected area; energy work is beneficial.

Poliomyelitis — inflammation of the gray matter of the spinal cord caused by an acute viral disease; symptoms include fever, sore throat, headache, vomiting, stiff neck and back, and eventually atrophy and deformity of muscle groups.

Contraindications/Indications: in postacute phase, massage can increase circulation to affected areas, reduce associated anxiety, and promote muscle tonus.

Postural deviations — postural distortion such as scoliosis, kyphosis, and lordosis.

Contraindications/Indications: massage can reduce stress on postural muscles.

Pregnancy — includes entire pregnancy (first, second, and third trimesters).

Contraindications/Indications: use caution on the abdomen, especially during the first trimester; deep or stressful techniques and abdominal kneading are contraindicated; use cushions for comfort and to reduce physical stress on the spine and baby; watch for edema.

Psoriasis — a chronic, noncontagious skin disease (dermatitis) marked by red patches covered by scales; usually located on the scalp, knees, elbows, umbilicus, and genitals.

Contraindications/Indications: avoid affected areas if painful, itching, or weeping; massage can reduce stress, which can aggravate the condition.

Raynaud's disease — a peripheral vascular disorder of abnormal vasoconstriction, usually to the digits; most common in women; attacks are triggered primarily by physical and emotional stress or by cold; symptoms include extreme cold, numbness, and pain of the digits.

Contraindications/Indications: massage may increase circulation, reduce associated stress, and relax affected muscles; application of warmth works best.

Rheumatoid arthritis — see *arthritis*.

Scar tissue — tissue that has healed after it has been damaged.

Contraindications/Indications: avoid massage for 6 to 8 weeks after surgery or injury; energy work is effective during the acute phase; after 6 to 8 weeks, cross-fiber work breaks up adhesions and stretching polarizes fibers of the scar.

Sciatica — severe pain along the course of the sciatic nerve (i.e., down the back of the thigh and lower leg) [see also *neuralgia*].

Contraindications/Indications: massage may reduce stress on the lumbar area and legs and reduce pain and associated anxiety.

Severe muscle injury — tissue injury due to trauma.

Contraindications/Indications: avoid massage for the first 5 to 7 days; use the "RICE" (rest, ice, compression, elevation) concept; energy work is effective during the acute phase.

Sprains and strains — tearing or damage to ligaments or tendons.

Contraindications/Indications: use ice and energy work during the first 48 to 72 hours; massage proximal to the injury may improve circulation and healing.

Subcutaneous bleeding (ecchymosis, hematoma) — areas where blood is released into tissue (e.g., bruise, black eye, contusion); some clotting may be involved, but the body will eventually reabsorb it.

Contraindications/Indications: avoid the affected area.

Subluxation — partial or incomplete dislocation; term most commonly used by chiropractors relating to a facilitated segment of the spinal vertebrae.

Contraindications/Indications: check with client's doctor, if necessary; use caution; massage can reduce spasm and stress of musculature involved; energy work can be effective.

Substance abuse — inappropriate or unlawful use of drugs or alcohol.

Contraindications/Indications: do not treat any client who is under the influence of drugs or alcohol; explain why and reschedule; massage can stress the liver and kidneys; the client may be unpredictable while under the influence.

Temporomandibular joint dysfunction (TMJ, TMD) — pain in and around the temporomandibular joint with accompanying clicking and malocclusion.
 Contraindications/Indications: condition can change position of jaw, causing natural teeth, dentures, and bridges to fit together improperly; massage can relax muscles and relieve symptoms; work with dentist or physician, if necessary.

Tendonitis and tenosynovitis — aggravation, injury, or inflammation of the tendons or tendon sheaths.
 Contraindications/Indications: ice is often the treatment of choice; deep friction is the preferred massage treatment because it breaks up adhesions and promotes temporary pain relief; compression of surrounding tissues releases tension.

Thoracic outlet syndrome — a condition in which nerves or vessels are compressed in the neck or axilla; characterized by pain in the arms and numbness and weakness in the hands and fingers.
 Contraindications/Indications: use caution working on the brachial plexus; massage of cervical muscles, shoulder girdle, and pectoralis minor muscle could relieve compression and stress on the plexus.

Trigeminal neuralgia (tic douloureux) — degeneration or compression of the trigeminal nerve with associated pain along the course of the nerve.
 Contraindications/Indications: massage of nerve root area may reduce spasms and associated pain.

Torticollis (wryneck) — deformity of the neck causing tilting to one side; involves spasm of the sternocleidomastoid muscle.
 Contraindications/Indications: massage may relieve stress of affected muscles and associated anxiety.

Tuberculosis — infectious, inflammatory, chronic, reportable disease; most commonly affects the lungs, although it can affect almost any part of the body.
 Contraindications/Indications: highly infectious; obtain approval and advice from client's doctor before starting massage.

Unexplained pain — any pain with an unknown cause.
 Contraindications/Indications: question and determine cause before proceeding; reschedule and refer to an appropriate health care professional, if necessary.

Varicose veins — enlarged, protruding, twisted superficial veins, usually in the lower extremities; caused by impaired circulation and loss of vascular integrity.
 Contraindications/Indications: do not massage directly on or distal to the affected area; work done proximal to the area can be beneficial.

Whiplash (postacute) — hyperflexion or hyperextension, primarily of the cervical vertebrae.
 Contraindications/Indications: massage may relax affected muscles and relieve associated anxiety.

Chapter Forty

Application: Positioning

Client Preparation, Draping, and Support

Client Comfort

Temperature, lighting, music, aromas, and decorations can all be used to create an atmosphere that is comfortable for the client.

> The client's comfort is the therapist's number one concern.

Temperature. A temperature **between 72°F and 78°F** is usually comfortable for the client, although it may not be comfortable for the therapist. Always keep a fan or heater available.

Lighting. Low lights induce a more relaxed atmosphere.

Music. Usually, music with no beat and no vocals is best for relaxation. Quietness can provide a sense of privacy as well.

Aroma therapy. Although responses to aromas can vary with the client, many aromas can promote a soothing experience. Aromas can be used as an additive to your oils.

> If you use music with a beat, remember the following rule of thumb: a beat faster than the heart rate is stimulating and a beat slower than the heart rate is relaxing.

Environment. Use plants, colors, decorations, and pieces of furniture that promote a professional but not sterile image.

Professionalism. Attitude and congeniality are just as important as anything you do in the massage. Act in a way that expresses your philosophy and attitudes.

Equipment and Products

Lubricants

Use **lotions** or **oils** for lubrication of body surfaces to reduce friction and promote smooth, flowing massage strokes. If properly used, lotions and oils can dramatically enhance the overall massage. When deciding which lubricant to use, consider the advantages and disadvantages of each (Table 40–1).

> Allow the client a choice of lubricants. Some people have allergies to certain products and chemicals.

Sheets and towels

Always use proper draping to promote professionalism and privacy. The client's privacy is the ultimate consideration and is necessary to ensure respect and trust. When using sheets and towels, remember to:

Table 40-1. *The Advantages and Disadvantages of Lotions and Oils*

Lubricant	Advantages	Disadvantages
Oils*	Do not need to be reapplied often during a massage	More likely to stain
		More likely to become rancid
	Less is used during a massage	More expensive
Lotions	Less likely to stain	Need to be reapplied often during a massage
	Less likely to become rancid	
	Less expensive	More is used during a massage
	Usually more compatible with the skin	

*Use only cold-pressed oils. Avoid mineral oils and cheap oils.

- Change the sheets after each client.
- Launder the sheets the same day they are used.
- Use hot water and bleach to disinfect.
- Use unscented detergents (clients may have allergies to scented detergents).
- Keep clean sheets separate from soiled sheets.
- Discard sheets when they become worn or rancid.

Pillows and bolsters

Use pillows and bolsters for maximum comfort when positioning the client on the table.

- Cover pillows and bolsters with towels or pillowcases that can be laundered.
- Have several pillows available for use in various conditions (e.g., pregnancy) or problems (e.g., low back and lumbar problems, chest and neck problems).

In **pregnancy,** positioning is crucial, especially after the first trimester. Guidelines for proper pillow placement vary according to the position of the client (Table 40–2).

For **low back and lumbar problems,** cushions must be placed to reduce the angle of the muscles that support the low back, which relieves associated stress and strain. Guidelines for pillow placement vary according to the position of the client (see Table 40–2).

For clients with **chest and neck problems,** cushions should be placed to reduce undo positional stress. Guidelines for pillow placement vary according to the position of the client (see Table 40–2).

Basic Principles of Posture and Client Kinesthetic Awareness

Therapist Posture and Body Mechanics

Purpose of good posture and body mechanics

Good posture and body mechanics will reduce the possibility of fatigue and muscle strain and promote efficient movement, which:

- Increases strength and power
- Increases pressure
- Decreases the possibility of injury
- Enhances the quality and effectiveness of massage
- Promotes energy (or chi)
- Increases career life span

Table 40-2. *Guidelines for Pillow Placement*

Client Condition	Prone Position	Supine Position	Side-Lying Position
Pregnancy	• Do not place the client face down after the first trimester without body cushions or proper cushions that support the entire torso with special concern for the baby • Use specialized tables that have a cut-out portion in the center • Use a cushion under the ankles	• Place a small cushion under the right hip to shift weight of the baby off of the spine and to reduce pressure on the inferior vena cava • Place a pillow under the knees and the neck for comfort and to reduce strain on the lumbar spine	• Place a cushion under the belly to support the baby • Place cushions between the legs and knees to elevate the knee on top so it is level with the hip • Place a pillow under the head
Low back and lumbar problems	• Place cushions under the ankles and under the pelvis to decrease the pelvic angle	• Place cushion under the knees and head to decrease the pelvic angle	• Have the client bend his knees and stagger them • Place cushions between the knees and under the head
Chest and neck problems	• Place a pillow under the chest to reduce the stress-associated problems (e.g., large breasts, dowager's hump, kyphosis, scoliosis)	• Place cushions under the knees and the neck	• Allow the client to "hug" a pillow • Place a pillow under the head and between the knees

Problems Associated With Poor Posture and Body Mechanics

Wrists. Overuse of the wrists can lead to problems such as carpal tunnel syndrome and osteoarthritis.

Back. Poor posture and excessive leaning over lead to neck and shoulder problems as well as muscle spasms and problems of the back and spine.

Arms. Overuse of the arms can lead to nerve entrapments as well as fatigue in the arms and shoulders.

> The problems that result from poor body mechanics are the number one reason why therapists quit massage therapy.

Postural Recommendations

Remember that the main source of strength comes from the lower body, not the arms and shoulders.

Balance on both feet, with the knees bent.

Keep the back straight and head up.

Use the pelvis and torso to provide the leverage and strength needed to apply pressure.

Keep the elbows and hands close to the body.

Keep the shoulders and wrists relaxed.

> Tai Chi provides excellent methods for maintaining correct posture and body balance while performing massage.

Use substitutes (e.g., elbows, forearms, fists) when more pressure or relief is needed.
Keep the wrists and hands in alignment with the movement.
Avoid small, repetitive movements.
If an injury or excessive stress occurs, rest until it heals.
Adjust the table height to allow for proper posture in relationship to client size.
Remember that massage therapists need bodywork on a regular basis too!

> Do not work when you have an injury or illness; not just for your benefit, but for the client's benefit too.

Client Posture and Body Mechanics

Evaluation of client posture

Correct posture is best described using a **plumb line** as a reference. A plumb line is a cord suspended from a fixed point with a plumb bob or other weight attached at the bottom. As the client stands by the plumb line, distortions and faulty alignments are easily seen. From an anterior view, all structures front and back should be symmetrical about the plumb line. When using a lateral view, certain bony landmarks can be compared to the reference line to assess proper alignment. In the case of proper standing alignment and posture from a lateral view, the reference line (plumb line) will be positioned as follows:

- Slightly anterior to the lateral malleolus
- Slightly anterior to the midline of the knee joint
- Approximately through the greater trochanter (posterior to the axis of the hip joint)
- Midline of the trunk (through the bodies of the lumbar vertebrae)
- Through the shoulder joint
- Through the bodies of the cervical vertebrae
- Through the lobe of the ear (external auditory meatus)

Client education

Physical distortion can dramatically affect overall health in many ways. Many medical and massage disciplines (e.g., chiropractic medicine, Hellerwork, Rolfing, osteopathic medicine) specifically deal with correcting distortion in the body. As massage therapists and bodyworkers, it is not only necessary to counteract the effects of distortion with massage, but we must also teach our clients about proper body posture and body mechanics to help them avoid and even correct distortion themselves. Following is a list of suggestions to give clients regarding their posture in common daily activities:

Standing
- Avoid standing for too long.
- Avoid carrying items (e.g., purse, book bag, small child) on one side of the body only.
- Try to balance the weight evenly over both feet.

Sitting
- Avoid slouching in a chair. (Chairs typically do not promote good posture.)
- While sitting or driving, elevate the knees above the level of the hips.

Sleeping
- The side-lying position is usually optimum, the back-lying position is second, and face down is third.
- When in the side-lying position, place a cushion between the knees.
- When in the supine position, place a cushion under the knees.
- When in the prone position, place cushions under the pelvis and under the ankles.

Lifting
- Avoid leaning over with the trunk when lifting or shoveling.
- Bend at the hips and keep the back straight.
- Stagger the feet and keep the head up.
- Lift evenly with the legs, not the back.

Practitioner Self-Awareness

In any bodywork session, the practitioner's effectiveness can be increased by taking care of his own condition before, during, and after a session. The bodyworker who is in tune with herself will be able to adjust to the client as needed and be more focused on the client's well-being. Also, self-awareness not only enhances personal safety but also promotes longevity as a bodyworker.

To be the most effective in any bodywork session, you must:

1. Be prepared by maintaining and promoting your own physical, mental, emotional, and spiritual health and balance.
2. Separate the practitioner's needs and the client's needs through the use of appropriate physical, emotional, and energetic boundaries during a session.
3. Be aware of the individual conditions for each client as you are working so you can be sensitive to the individual client's needs.
4. Clear away your own personal thoughts and focus on the client.
5. Use good body mechanics, including good physical posture and movement patterns.
6. Be aware of energy flow, set energetic boundaries, and stay grounded so that you can properly use chi and be sensitive to energy flows or imbalances for your client.

Chapter Forty-One

Application: Technique

Effects of Touch

Physiologic Effects of Massage

Some of the effects of touch therapy on the body systems come from the actual mechanical touch of the bodyworker. Other effects are related to the changes that take place during treatment (e.g., fluid movement).

General physiologic effects

- Breaks down adhesions or scarring
- Increases flexibility and mobility
- Increases joint range of motion
- Balances pH levels
- Reduces chemically induced pain and inflammation
- Increases cellular metabolism
- Increases skin temperature and blood flow
- Promotes hormonal release with systemic effects
- Removes toxins and metabolic wastes
- Chemically induces vasodilation
- Improves overall blood and lymph circulation
- Hastens healing

Effects on the circulatory system

- Delivers oxygen and nutrients to cells
- Removes toxins and metabolic wastes
- Promotes vascular health and flexibility
- Affects heart rate and blood pressure

Effects on the lymphatic system

- Augments the circulatory system by returning interstitial fluid (lymph) to the blood (lymph moves primarily by muscle contraction)
- Opens lymph channels for better flow
- Reduces edema
- Increases urine volume and excretion

> Increasing the blood and lymph circulation is the most widely recognized physiologic effect of massage.

Effects on the integumentary system

- Increases blood flow to the skin, which improves its condition
- Causes a rise in skin temperature and perspiration
- Facilitates sebaceous secretions

Effects on the muscular system

- Stretches muscles
- Promotes muscle relaxation
- Improves muscle tonus
- Relieves muscle spasms, cramps, and pain
- Improves athletic performance
- Promotes healing

Effects on the nervous system

- Alleviates pain directly, chemically, and via the nervous response
- Promotes homeostasis in the parasympathetic and sympathetic systems
- Promotes natural release of pain killers (i.e., endorphins)

Effects on the respiratory system

- Reduces stress and anxiety associated with respiratory problems
- Relaxes muscles required for the breathing process
- Promotes fluid removal from the lungs (certain percussion techniques)

Effects on the immune system

- Increases T cytotoxic cells (killer cells) [correlated with decreased anxiety and increased relaxation]
- Reduces stress, which has a direct effect on the immune system and the parasympathetic nervous system

Emotional Effects of Massage

Positive feelings

Positive feelings are the body's way of expressing emotions physically. Massage has been known to cause a client to "feel" better both physically and mentally. Although the "feelings" are subjective and based on perception, there is no underestimating the power of the mind and its effect on the body.

Emotional reactions

The benefits of touch and its effect on emotions are generally physiologic in nature. Some of the effects of massage on hormones, neurotransmitters, and various systems (e.g., nervous, circulatory, and immune systems) can result in physical as well as mental and emotional changes. The connection between the physical and emotional can also be seen in the "fight or flight" mechanism of the sympathetic and parasympathetic nervous systems, which is based on an emotional reaction and causes emotional as well as physical responses.

Psychologic benefits

In addition to a general positive feeling, massage has many specific psychologic benefits, some of which are listed below:

- Reduces stress
- Encourages better nutrition, exercise, and health practices
- Reduces pain, both physical and emotional
- Reduces fatigue, both physical and emotional
- Increases productivity
- Promotes a sense of confidence and control
- Promotes deep relaxation
- Promotes feelings of being healthier, more relaxed, invigorated, energetic, peaceful, and even more youthful
- Helps rebuild a more positive self-image and sense of self-worth

Manual Contact and Manipulation

Qualities of Touch

According to Gertrude Beard, massage and bodywork can be broken down into components or "qualities of touch." These qualities can affect the treatment and its benefits quite dramatically, depending on how the practitioner chooses to use them.

Direction of movement

 Centrifugal — movement away from the heart, following arterial flow.

 Centripetal — movement toward the heart, following venous flow.

 Cross-fiber — working perpendicular to natural fiber directions.

Pressure — the amount of pressure or depth (either deep, medium, light, or nontouch) and drag or pull; further broken up into rate (speed) and rhythm (intervals) of movement.

Lubricants or instruments — includes the necessary lubricants or instruments (e.g., oils, lotions, massage tools, stones, hot and cold packs).

Frequency and duration — frequency and the time spent during the treatments.

Physical positioning — positioning of both the client and the practitioner.

Swedish Massage

General guidelines

In Swedish massage, there are **five basic massage strokes,** each with a distinctive and therapeutic benefit. Although there are many variations to these strokes, there are a few general guidelines that apply to all variations and should be followed to achieve the best results. As a general rule, Americans and Europeans tend to work in a centripetal direction (i.e., toward the heart), while the Chinese and South Americans tend to work in a centrifugal direction (i.e., away from the heart). Swedish massage is European in origin, so the direction of the strokes is meant to aid the circulatory and lymphatic systems. (Because the effects on the circulatory and lymphatic systems are the most widely recognized therapeutic effects in Swedish massage, they will be discussed in greater detail later in this chapter.)

Each stroke should be applied with the client in mind. Pressure should begin light. With each successive stroke, the pressure can be increased according to the client's tolerance or to achieve the desired results of the stroke. A therapist's touch must be able to adjust to every condition and body part. Sensitivity to the client comes through verbal and tactile communication.

In each stroke in massage, an important rule of thumb to follow is: **movements faster than the heart rate cause stimulation, movements slower than the heart rate cause relaxation.** With this in mind, each technique used can be adjusted to the appropriate situation and to the client's needs.

These general guidelines can be applied to the five basic strokes of Swedish massage: **effleurage, friction, pétrissage, tapotement,** and **vibration.**

Effleurage (gliding)

Effleurage is the first and **most widely used** stroke. It is performed with long, gliding strokes toward the heart without trying to move deeper tissues. Effleurage can be applied with broad surfaces, such as the palms, the pads of the fingertips, or the pads of the thumbs. Each stroke is used to evaluate the client (e.g., condition, tissue tension, texture, temperature, pain tolerance). Effleurage is best applied with relaxed hands that conform and cover as much of the body surface as possible. Pressure should be uniform and the stroke flowing and rhythmic. Effleurage is a great way to begin and end each segment of the body being worked. Types of effleurage strokes include **nerve strokes** and **feathering** (a very light stroke), both of which can maintain the client's relaxed state.

The main purposes and benefits of effleurage are to relax, stimulate, stretch, and broaden tissue; promote blood and lymph movement; reduce edema; and improve circulation.

Pétrissage (kneading)

Pétrissage is a technique that manipulates the fleshy areas of the body. Using the fingers and hand, together or separately, the stroke is applied with various movements such as grasping, lifting, compressing, rolling, and kneading. Other pétrissage versions include chucking and rolling. **Chucking** involves grasping flesh with one hand and moving the hand up and down along the bone while the other holds the limb steady. **Rolling** involves using both hands to compress the muscle to the bone and then rolling it back and forth. Pressure in all forms of pétrissage is firm and directed toward the center of the body. The shoulders and arms should be relaxed and held close to the body.

The main purposes and benefits of pétrissage are to assist removal of metabolic wastes, break up adhesions, promote fluid movement in deeper tissues, stretch and broaden muscle tissue and fascia, revitalize dry skin by promoting blood and lymph circulation, and rehabilitate weak muscles.

Friction

Friction is a technique that uses direct pressure on the skin, with or without gliding, and a vigorous rhythmic movement using the fingers and palms. There are many styles of the technique, each with its own benefits, but only a few are described as having good therapeutic value. **The bony areas of the body receive the greatest benefit from friction.** These areas (i.e., joints, bony attachments for ligaments and tendons) receive less blood flow and are most prone to injury and adhesions. Friction warms, stimulates fluid movement, promotes flexibility, and breaks down adhesions. The most widely used forms of friction are circular friction, deep cross-fiber friction, parallel stroke, and pumping.

Circular friction. A superficial stimulation of tissue underlying the skin by using small, circular movements to promote circulation and to stimulate nerves and muscle tissue.

Deep cross-fiber friction (or **transverse friction**). As described in Cyriax's works, transverse friction is applied perpendicularly to muscle fibers in an effort to break up scars, adhesions, and fibrous tissue.

Parallel stroke. According to Harold Storm, a parallel stroke benefits the client by stimulating underlying tissue and reducing adhesions.

Pumping (or **compression**). Uses pumping and compression movements to benefit the fleshier parts of the body.

The main purposes and benefits of friction are to increase circulation, break down deposits in fascia, promote circulation, and promote joint flexibility.

Tapotement (percussion)

Tapotement is a technique that uses striking movements (e.g., pounding, tapping, beating, slapping, hacking, cupping, pinching). These techniques are generally rapid and alternating, using minimal force with the therapist's hands relaxed. Tapotement can be highly stimulating by promoting muscle tonus through a repetitive muscle contraction and relaxation response. This technique is used primarily over fleshy areas, but good judgment should be used. **Tapotement should not to be used over injuries, tightly contracted muscles, lymph areas, the upper lumbar region where the kidneys are located, or any area considered sensitive by the client.** However, tapotement promotes circulation in the stump of amputated limbs, and is the treatment of choice used by respiratory therapists to break up lung congestion.

Although it is widely accepted that there are five basic strokes in Swedish massage, there are massage therapists who separate these strokes into eight basic strokes. "Rocking" (from pétrissage), "shaking" (from vibration), and "compression" (from friction) have been separated from the original five and included as basic strokes. But no matter how they are organized, the techniques for each stroke are the same.

The general purposes and benefits of tapotement are to stimulate tissue repair; promote muscle tonus; increase circulation; and loosen phlegm and increase expectoration in respiratory tract conditions.

Vibration

Vibration is a technique characterized by highly rhythmic shaking or trembling manipulation of surface tissues of the body. It is applied with rigid hands, and the movement comes primarily from the forearms or wrists.

The general purposes and benefits of vibration are to reduce the intensity of deep tissue work, to soothe and relax when applied lightly, or to stimulate when applied vigorously.

Joint Mobilization Techniques

Muscle Energy Technique

Muscle energy technique is a group of neuromuscular techniques that involve voluntary contraction of a specific muscle or muscle group while positioned in a specific direction. Contractions can vary in intensity and for varied lengths of time. These are client-active techniques to achieve a corrective outcome.

Positional Release Techniques

Positional release techniques involve specific body parts positioned to isolate a muscle, tendon, ligament, or joint to achieve a release. This can be done through an **isometric contraction** (i.e., contraction without joint movement), an **isotonic contraction** (i.e., contraction with joint movement), or an **isokinetic contraction** (i.e., movement at a constant speed through a range of motion with mild resistance).

Strain–Counterstrain

Strain–counterstrain is a technique that uses the palpation of tender points (or trigger points) to guide the positioning of the body to reduce the tenderness, therefore promoting the muscle tension to release on its own.

Stretching

Stretching involves exercises or movements that promote lengthening or extension of a muscle or muscles. It also involves movement of the joint involved as well as movement of muscles through a full range of motion.

Purposes for stretching

- To increase and maintain a more complete range of motion
- To relieve muscle and joint soreness
- To improve mobility and flexibility
- To lengthen fascia and improve elasticity
- To prevent reinjury and strengthen tissue
- To increase tissue temperature by stimulating metabolism
- To promote blood flow to bring nutrients to tissues and remove metabolic wastes

Proper stretching technique

- Move slowly and rhythmically.
- Breathe slowly and rhythmically.
- Exhale on the stretch, inhale when relaxed.
- Stretch until a mild tension is felt.
- Do not overstretch; it is counterproductive.

Types of stretching

There are various types of stretching techniques:

Static stretching (assisted). The therapist gently assists the client in stretching until resistance is met, and holds until release is felt (about 10 to 20 seconds).

Static stretching (unassisted). The client stretches into resistance and applies light contraction. Yoga is a good example of unassisted static stretching.

Proprioceptive neuromuscular facilitation. An assisted stretching technique in which a muscle is stretched into resistance and held for 10 seconds. Then the client contracts the muscle involved isometrically (no joint movement) for 5 seconds. The process is repeated three to four times.

Ballistic stretching. Involves bobbing or bouncing during the stretch using body weight. Ballistic stretching is **not recommended** due to the possibility of muscle strain and small muscle tears.

Passive stretching. Slow, steady, gentle movement to lengthen muscles when natural resistance is minimal.

Reciprocal inhibition stretching. Involves contracting the antagonist muscle to the one being stretched (e.g., contracting the tricep to release the bicep). This tells the body to relax the muscle being stretched. This technique is very useful for **reducing muscle cramping.**

Terms Related to Quality of Movement

Types of Movements

Movements can be classified as either conscious or reflexive. **Conscious movements** are voluntary movements performed under the conscious control of the brain (e.g., kicking, throwing a ball). **Reflexive movements** are involuntary movements due to activation of

the proprioceptors (e.g., muscle spindle activation in a stretch reflex). (See Chapter 18 for more information about proprioceptors.)

Joint Movements

A complete list of joint movements is provided in Chapter 6. In general, joint movements can be classified as passive, active, and assistive. In **passive** joint movement, the therapist stretches and moves the body part while the client relaxes the involved muscles. In **active** joint movement, the client participates by contracting and moving the involved muscles of the joint. In **active assistive** joint movement, the client performs the motion with the assistance of the therapist.

Range of Motion

Range of motion refers to the amount of natural movement within a joint. **Active** range of motion is the amount of available active joint movement. **Passive** range of motion is the amount of available passive joint movement.

Chapter Forty-Two

Application: Communication

Response to Emotional Needs

Intimacy is the sharing of one's deepest nature; it is personal, private, and marked by close association. Intimacy should not be confused with sexual closeness, although that is one way of sharing intimacy. Intimacy is an element of massage therapy that is difficult to find in other professions. In the nurturing environment of a massage session, it is easy for clients to "open up" at a deeper level than normal, saying things or sharing emotional feelings they normally avoid, even in their closest relationships. It is the responsibility of the therapist not to cross the client–therapist boundary and to stay within the scope of practice, not venturing into the field of psychology. However, as "emotional release" work (sometimes known as somatoemotional release) becomes more common, it will be important to know how to deal with situations in which emotions arise.

For clients to gain the greatest benefit from touch therapy, it is important for them to feel safe. Following is a list of ideas on how to preserve intimacy with your clients and create a safe environment for them to experience touch.

1. **Listen.** The best way to respond to emotions is to just listen. People sometimes need to vent, and listening is a large part of building trust.
2. **Touch.** Nurturing through touch during a bodywork session can be one of the safest ways to communicate.
3. **Empathize.** Understand the client's feelings, but do not take them on as your own.
4. **Do not judge.** True empathy is a lack of personal judgment. The client who does not feel judged by the therapist will be more likely to trust the therapist and to benefit from the touch.
5. **Ask questions.** When appropriate, guide the client toward finding his own answers, but do not play psychologist.
6. **Refer.** If the client needs more than bodywork, refer her to the appropriate psychologic professional. Unless the therapist holds a credential, it is best to avoid counseling the client.
7. **Concern.** Show genuine concern for the client. This is part of caring and empathy.

The more skilled the therapist becomes in caring for the client, the more valuable the outcome can be for the client. This may be the only opportunity for some clients to be nurtured, to feel accepted, and above all, to be touched.

Verbal and Nonverbal Communication

Communication can be an art when it comes to dealing with a client. To be truly effective in treatment, it is important to establish trust and understanding. Following is a list of some of the more important factors in good verbal and nonverbal communication.

1. **Establish rapport.** Show courtesy, respect, and professionalism.
2. **Assess.** Observe, interview, and palpate the client (see Chapter 38).
3. **Interview.** Ask open-ended questions to lead the client to hidden answers.
4. **Read between the lines.** Use intuition and experience to see what is not obvious.
5. **Speak clearly.** Do not talk "over the client's head."
6. **Listen.** Seek to understand before you are understood.

Planning Single and Multiple Sessions

First and foremost, the client is responsible for his or her own healing. Your job is to satisfy the needs of the client by creating a successful treatment plan with the client. During the initial interview, a plan can be developed; however, it is only after the first treatment that you can begin to apply the plan. It is difficult to evaluate the client's condition until you get your hands on the client, and you may find things that contribute to the client's condition of which the client is unaware.

The plan you set up with your client should be based on several factors:

1. **Current condition.** Why is the client here?
2. **Goals.** What does the client want to achieve with bodywork?
3. **Effort.** How much is the client willing to put into carrying out the plan?
4. **Frequency.** How often should you see the client and how often can the client come?
5. **Contraindications.** What can or cannot be done with the client?
6. **Modalities.** What modalities fit the client's needs and desires?
7. **Referrals.** Does the client need a referral to another health care professional?

With these factors in mind, develop a treatment plan with realistic short-term and long-term goals. Monitor the goals, using session notes as an important tool to measure progress. Periodically reevaluate the situation and look for improvements, sharing your findings with the client. This not only lets the client know of his or her progress, but also allows you to alter the treatment plan to better meet your mutual goals.

Chapter Forty-Three

Application: Hydrotherapy

Introduction

Hydrotherapy is used universally in numerous applications, including stress relief, reduction of edema, pain relief, and first aid. It is simply the use of water as a medium for changing the body chemically, physiologically, and mechanically. There are numerous benefits to using water in therapy:

- It can be used in a solid, liquid, or gaseous state.
- It is compatible with body tissues.
- It can be used externally and internally.
- It can be used in numerous ways (e.g., fomentation packs, showers, whirlpools, ice bags, colonic irrigation).
- It is inexpensive and easy to acquire.
- It is a solvent for many substances.

Definitions

General Body Temperatures

Core temperature — normal is 98.6°F (37°C) [+ or − 1°].
Skin temperature — normal is 92°F (33.3°C).

Temperature Descriptions

Dangerously hot — 110°F or above.
Very hot — 105°F to 110°F.
Hot — 100°F to 104°F.
Warm — 97°F to 100°F.
Neutral — 94°F to 97°F.
Tepid — 80°F to 92°F.
Cool — 70°F to 80°F.
Cold — 55°F to 70°F.
Very cold — 32°F to 55°F.

> Remember that water freezes at 32°F (0°C) and boils at 212°F (100°C). Temperatures between 112°F and 104°F and 68°F and 55°F are considered therapeutic.

Energy Transfer

Conduction — when a variable temperature is transferred from one object or substance to another through **direct contact; the primary way hydrotherapy is used.**

Convection — when temperatures are transferred via **moving liquids or gasses** (e.g., convection oven, car radiator).

Conversion — when energy is **transformed** from one type to another; for example, electricity in a light bulb is transformed into heat and light.

Effects of Hydrotherapy

Thermal Effects

Thermal effects result when using temperatures above or below normal body temperatures. The greater the variance, the more dramatic the effect. Initial contact with varied temperatures creates marked changes according to the degree of difference from body temperature. Longer-lasting effects are generally the desired effects of hydrotherapy. Thermal effects are the **most important effects in the use of hydrotherapy.**

Chemical Effects

Chemical effects result when using fluids to change pH balance or to irrigate body cavities internally (e.g., enemas, douches).

> Moist heat requires a lower temperature than dry heat to accomplish the same effect. Fluids dissipate temperature much more slowly than dry objects.

Mechanical Effects

Mechanical effects result when using fluids to impact body surfaces (e.g., whirlpools, showers, enemas, douches, sprays, friction rubs).

Hydrostatic Effects

Hydrostatic effects result when using temperatures that vary from normal body temperature over a large area, causing blood to migrate or shift from one area of the body to another. This is the **number one effect that is being induced by hydrotherapy.** Circulation shifts to the area of temperature change or away from that area depending on the length of time heat or cold is applied.

General Effects of Heat and Cold (Table 43–1)

Effects of Contrast Baths

A contrast bath uses **alternating hot and cold** water. Treatment is most effective when using applications of heat and cold of equal lengths of time (usually around 3 minutes of heat and 3 minutes of cold) for a total of 30 minutes. Neither temperature range should be used beyond patient tolerance. In general, contrast baths:

- Promote dramatic stimulation of circulation
- Reflexively stimulate related tissues and organs via the dermatomes
- Reduce stress, both mentally and physically

Table 43-1. *The Use of Heat and Cold in Therapy*

	Heat	Cold
General uses	Promote circulation of blood and lymph Relieve cramps and muscle spasms Relieve stress, both mental and physical	Reduce inflammation and secondary injury Relieve pain Relieve muscle spasms Promote healing
Local effects	Surface vasodilation and redness Increase in leukocyte migration through cell walls Muscle relaxation Increase in local sweating Local analgesia Increased cellular metabolism	Initial vasoconstriction Decrease in circulation Decrease in leukocyte migration through cells walls Decrease in cell metabolism Muscle contraction A numbing, analgesic effect
Systemic effects	Increase in heart rate Increase in nervous system stimulation, then sedation Increase in digestive process Decrease in cellular metabolism internally	Increase in nervous system stimulation, then sedation Initial increase in heart rate, then decrease Increase in cellular metabolism
Contraindications	Inflammation Circulatory and heart conditions Pregnancy Geriatric Infant Cancer Impaired neurologic sensitivity	Circulatory and heart conditions Pregnancy Geriatric Infant Cancer Impaired neurologic sensitivity

Reflexive Effects of Hydrotherapy

Reflexive effects of prolonged heat

- Heat to one extremity reflexively vasodilates the opposite extremity.
- Heat to the pericardium lowers blood pressure but increases heart rate.
- Heat to the chest increases expectoration and relaxes respiration.
- Heat to the trunk relieves stress on the kidneys, ureters, and gallbladder and promotes production of urine.
- Heat to the abdomen decreases intestinal blood flow, intestinal motility, and acid secretion in the stomach.
- Heat to the pelvis increases menstrual flow and relaxes pelvic muscles.

Reflexive effects of prolonged cold

- Cold to the nose and the back of the neck causes contraction of the blood vessels of the nasal mucosa.
- Cold to the scalp and hands causes vasoconstriction of the blood vessels to the brain.
- Cold to the pericardium decreases heart rate but increases stroke volume.
- Cold to the thyroid decreases its function.
- Cold to any arterial trunk causes vasoconstriction of the artery and its branches.
- Cold to the abdomen increases intestinal blood flow, intestinal motility, and acid secretion in the stomach.
- Cold to the pelvis increases organ functions.

Applications of Hydrotherapy

Fomentation — local application of moist heat.

Hydrocollator — a device, much like a crock pot in concept, that preheats silica gel packs to between 150°F and 160°F. The gel packs are then applied for thermal use.

Foot bath — immersion of the foot using temperatures between 100°F and 115°F.

Sitz bath — partial immersion bath for the pelvic region.

Whirlpool bath — partial immersion bath that uses agitation of water and air to promote stimulation locally.

Ice packs — localized application of cold; can be a chemical pack, ice bag, or frozen device.

Compress — local use of moist cold.

Salt glow — massage using wet salt to stimulate.

Alcohol rub — application of rubbing alcohol to lower the body temperature through rapid evaporation.

Russian bath — steam cabinet in which the client's head protrudes out of the top.

Chapter Forty-Four

Application: First Aid and Cardiopulmonary Resuscitation

This outline of general first aid and cardiopulmonary resuscitation (CPR) is based on the American Red Cross standards. This chapter is designed to provide only a basic outline and is not intended to train the reader. For more complete and detailed information or training contact the American Red Cross or American Heart Association.

Basic First Aid Principles

Definition

First aid is the immediate care given to injured or suddenly ill individuals until proper medical care can be administered. Proper first aid training can assist in saving a person's life, reduce complications of an injury or illness, and may promote quicker recovery.

Responsibilities

Typically, only a trained individual should administer first aid. When first aid is started, it is required that the first aid provider continue until another qualified provider or proper medical care arrives. If the injured individual is conscious, it is important to obtain consent from the individual or from the individual's parent or guardian before giving any care; it is the right of the individual to refuse treatment. If the injured individual is unconscious, first aid should be administered within the standards and limits of the first aid provider's training under the concept of **implied consent. Good Samaritan laws** can protect a first aid provider in liability cases if the care given has been in good faith and within the scope of the caregiver's training.

Universal Precautions

Universal precautions are procedures used in situations requiring contact with any body fluid, including blood, urine, sweat, tears, saliva, and semen. These procedures partially consist of proper gloving, masking, and eye protection to protect the caregiver and the patient from contractible diseases.

Assessment

Before administration of any first aid procedures, it is important to assess the victim's condition and obtain consent, if possible. If the situation appears to be a medical problem, obtain assistance as soon as possible.

Primary assessment

Initial assessment of the immediate condition involves the **"ABCs of first aid."** The ABCs (airway, breathing, and circulation) are a memory device for the recommended actions in life-threatening conditions.

Airway
- Check to see if the mouth and throat are clear of any object that would inhibit intake of air.
- If blocked, turn the head to the side and clear the oral cavity with your finger (finger sweep).

Breathing
- Check to see if the victim is breathing by feeling for breath and watching for thoracic expansion.
- If breath is absent, start artificial respiration.

Circulation
- Check the radial or carotid pulse.
- If a pulse is absent, start CPR.
- Check for signs of hemorrhaging.
- If bleeding is present, follow the procedure for wounds and bleeding.

Airway, breathing, and circulation must be addressed and priorities set before moving to the next steps. It is important to take control of the situation; do not panic. It is also very important to take care of yourself in any situation that might be life threatening, because you will not be of any assistance if you become injured.

Secondary assessment

A head-to-toe evaluation must be done to determine any specific conditions that might alter the type of first aid required. Following is a partial list of abnormal conditions that should be evaluated during the secondary assessment:

- Swelling
- Stains or burns around the mouth (possible poisoning)
- Localized pain or tenderness
- Structural abnormalities
- Discoloration (e.g., tissues, nails, lips)
- Full or partial paralysis
- Evidence of convulsion (tongue is bitten)
- Level of consciousness
- Vital signs (pulse and respiration)
- Temperature variance
- Medical Alert Tag (used for medical information)

Environment

Assess the immediate area for signs of life-threatening conditions, such as fire or a dangerous location. Also look for signs that might indicate the cause of the injury or illness.

Conditions and Techniques

Airway Obstruction—Abdominal Thrust Maneuver

Over 3000 deaths per year are a direct result of choking due to an object lodged in the airway. The abdominal thrust maneuver (formerly called the **Heimlich maneuver**) should be performed if the person is unable to speak, cough, or breathe. Continue to go through the steps of the maneuver until the victim coughs up the object, regains consciousness, or emergency medical service (EMS) arrives.

If the victim is **conscious**:

- Stand behind the victim.
- Clasp your hands into a fist.
- Wrap your arms around the victim, placing the "fist" below the rib cage on the midline.
- Perform up to five abdominal thrusts up and in.
- Check the victim.
- Repeat the sequence until the person coughs up the object, loses consciousness, or you are relieved by another trained individual.

In the case of an **unconscious** victim, the abdominal thrust maneuver is performed on the ground as follows:

- Place the victim in a supine position (face up).
- Straddle the victim's body.
- Clear the airway with a finger sweep, if necessary.
- Give two rescue breaths, if possible.
- Perform five abdominal thrusts with the palms of the hands.
- Check the victim.
- Repeat the sequence until the victim coughs up the object, regains consciousness, you are relieved by another trained individual, or EMS arrives.

If the victim is a **conscious infant**:

- Perform five blows to the back.
- Then perform five chest thrusts.

If the victim is an **unconscious infant**:

- Go through the steps required for a conscious infant.
- Follow each cycle with two gentle breaths.

Burns

Burns are tissue injuries that occur as a result of excessive heat, chemicals, or radiation. Burns are categorized according to severity, depth, and size of the damaged area. Burns are the leading cause of accidental death in the United States, with approximately 8000 lives lost annually in fires. Half of these casualties are children under 14 or adults over 64.

Extent of burns

Depending on size and location, the calculation of the extent of a burn can be difficult, but it is necessary to determine the correct course of action. In adults, burns over 15% of the body surface require hospitalization. In children, burns over 10% of the body surface require hospitalization. Burns of the extremities do not require hospitalization but do re-

quire prompt medical attention. Victims with third-degree burns on 50% or more of the body surface have an extremely high mortality rate.

First aid for burns

First-degree burns
- Apply cold water.
- Apply a dry, sterile dressing.

Second-degree burns
- Immerse the burn in cold water.
- Apply a dry, sterile dressing.
- Treat the victim for shock and seek medical attention.
- **Do not break blisters or apply ointments or antiseptics.**

Third-degree burns
- Cover the burn with a dry, sterile dressing.
- Do not remove adhered clothing.
- Elevate affected extremities.
- Treat the victim for shock and seek immediate medical attention.

Chemical burns
- Irrigate the burn with water for 5 minutes or follow label instructions, if available.

Heat-Related Injuries

Heat injuries occur with prolonged exposure to abnormally high temperatures. The effects can be dramatically accelerated according to **humidity, wind, length of exposure,** and **degree of temperature variance.** The effects can also be aggravated by the victim's current condition of **fatigue, emotional stress, presence of other injuries, alcohol in the system, smoking,** or **types of clothing.**

Heat cramps

Heat cramps are muscular pains and spasms due to loss of salt in sweating without replacement of salt. Cramps become more severe when the victim drinks large amounts of fluids while in a **salt deficiency.** Heat cramps can develop into mental confusion and convulsions.

First aid for heat cramps is as follows:

- Give the victim sips of salt water, half a glass every 15 minutes for 1 hour.
- Massage the cramps to relieve spasm.

Heat exhaustion

Heat exhaustion is due to **extreme sweating** from heat without proper fluid replacement. It is characterized by fatigue, weakness, cramps, and collapse.

First aid for heat exhaustion is as follows:

- Give the victim sips of salt water, half a glass every 15 minutes for 1 hour.
- Have the victim lie down and elevate the legs.
- Loosen clothing.
- Cool the victim with cold compresses, fans, or air conditioning.
- If the victim vomits, discontinue the fluids and seek medical assistance as soon as possible.
- Advise the victim to rest and stay out of warm environments for the next few days.

Heat stroke

Heat stroke is a response to heat characterized by an extremely high body temperature (106°F or higher) and **lack of sweating.** The victim is hot, red, and dry. The pulse is rapid and strong, and the victim may be unconscious. Heat stroke is the **most life-threatening** heat-related condition.

First aid for heat stroke is as follows:

- Undress the victim, but maintain modesty.
- Bathe or sponge bathe the victim with cold water or rubbing alcohol until the victim's temperature reaches 102°F, then dry the victim.
- Use fans or air conditioners to promote cooling.
- Monitor the victim's temperature.
- Do not give stimulants.
- Obtain medical assistance as soon as possible.

Cold-Related Injuries

Cold injuries are the direct result of prolonged exposure to abnormally low temperatures. The effects can be dramatically accelerated according to **humidity, wind, length of exposure,** and **degree of temperature variance.** Injuries can also be aggravated by the victim's current condition of **fatigue, emotional stress, presence of other injuries, alcohol in the system, smoking,** or **wet clothing.**

Overall symptoms include shivering, numbness, low body temperature, drowsiness, muscular weakness, confusion, impaired judgment, unconsciousness, staggering, loss of vision, or euphoria.

Hypothermia

Hypothermia is a condition related to prolonged exposure to low temperatures. It is categorized according to current body temperature. **Mild** hypothermia is a body temperature **above 90°F** and **profound** hypothermia is a body temperature **below 90°F.**

First aid for hypothermia is as follows:

- Perform artificial respiration, if necessary.
- Move the victim to a warm room or environment.
- Remove any wet, frozen, or constrictive clothing.
- Rewarm the victim rapidly with warm blankets or by placing the victim in a warm bath.
- If conscious, give the victim warm liquids (no alcohol).
- Dry the victim thoroughly.
- Follow the first aid standards for frostbite.

Frostbite

Frostbite is a condition in which crystals form in the fluids and soft tissues of the body. It generally affects the fingers, toes, nose, cheeks, and ears. Symptoms include **pale, glossy skin** that appears **white or gray. Blistering** is also common as tissue damage increases. Eventually, **gangrene** may set in as circulation decreases.

First aid for frostbite is as follows:

- Cover the frozen part.
- Provide extra blankets and clothing.
- Move the victim indoors or to a warm environment.

- Give the victim a warm drink (no alcohol).
- Rewarm the frozen part quickly by immersing it in warm water or gently wrapping it in a warm blanket.
- Handle the area gently; **no massage.** Swelling will be rapid when thawed out.
- Once the part is rewarmed, have the victim exercise it.
- Gently wash the area with soap and water, then pat it dry.
- Do not break any blisters.
- Place gauze between the digits, if affected.
- Do not apply any other dressings unless absolutely necessary.
- Elevate affected area.
- If the feet are involved, do not let the victim walk.
- Do not apply heat.
- Obtain medical assistance as soon as possible.
- Give fluids as needed if conscious and not vomiting.

Fractures

Fractures are the result of a break or crack in a bone. They are usually classified as **simple** (closed) or **compound** (open), based on whether or not the skin is broken. Symptoms and signs include deformity, swelling, pain and tenderness, loss of limb function, discoloration, and possible bleeding.

First aid for fractures is as follows:

- Give immediate first aid for breathing, bleeding, shock, or other emergencies as needed.
- Protect the victim from further injury.
- Obtain medical assistance based on severity of condition.
- Immobilize the break and its proximal and distal joints.
- Elevate the injury, only if it is possible to do so without disturbing the injury.
- Apply splints, if possible.

Head Injuries

Head injuries are injuries that involve skull fractures, a concussion, or a contusion. A **skull fracture** is a break or crack in the skull. Symptoms include pain and tenderness, deformity of the skull, bleeding from the nose or ears, discoloration under the eyes, unilateral dilation of the pupils, and wounds and bleeding on the skull. A **concussion** is a condition resulting from a blow to the head, usually causing loss of consciousness. It is characterized as mild, moderate, or severe based on the time spent unconscious. Symptoms include unconsciousness, severe headache, amnesia, dizziness, and visual anomalies (e.g., "stars," double vision). A **contusion** is a condition resulting from a blow to the head, usually causing loss of consciousness. It is much more severe than a concussion due to swelling and bruising of the brain. Symptoms include unconsciousness, nausea and vomiting, unequal pupil size, blurred vision, headache, paralysis, and amnesia.

First aid for head injuries is as follows:

- Evaluate the victim with the "ABCs" of assessment.
- Check for neck or spinal injury.
- Treat for immediate conditions (e.g., bleeding, shock).
- Elevate the head and shoulders if conscious and no spinal injury is suspected.
- If unconscious, lay the victim on the side.
- Obtain medical assistance as soon as possible.
- Monitor symptoms until help arrives.

Muscle Injuries

Muscle injuries are injuries related to trauma or extreme overuse of the musculoskeletal structures.

First aid for musculoskeletal injuries is as follows:

- **R.I.C.E.** (**r**est, **i**ce, **c**ompression, and **e**levation) of the injury during the first 48 to 72 hours after the injury.
- Obtain medical care as soon as possible.

Poisoning

Injury or death can result from contact, internally or externally, with a toxic foreign substance. Poisoning can occur through **ingestion, inhalation,** or by **direct contact** with a toxic substance (e.g., chemicals, berries, drugs, gasses, poison ivy).

First aid for **ingested** poisons is as follows:

- Determine the source of the poisonous substance.
- Contact the local poison control center or a physician.
- Dilute the poison, if the victim is conscious, with a glass of water or milk as soon as possible.
- Induce vomiting if advised. Use **syrup of ipecac** to induce vomiting, **activated charcoal** to deactivate the poison, and **epsom salts** as a laxative.

If unable to reach medical help in the case of ingested poison:

- Do not give victim vinegar, lemon juice, or olive oil.
- Induce vomiting only in cases of drug overdose, when there is certainty that the substance is not strongly acidic or alkaline, or when petroleum products are involved.
- Treat the victim for shock.
- Obtain medical assistance as soon as possible.

First aid for **inhaled** poisons or fumes (e.g., carbon monoxide, chlorine, solvents, gasses) is as follows:

- Remove the victim from the source of the poison, if possible.
- Contact EMS.
- If the victim is not breathing, attempt artificial respiration.
- Treat for poisons by removing contaminated clothing and washing exposed areas of the body.

First aid for **contact** poisons (e.g., chemicals, solvents, acids, caustic fluids) is as follows:

- Remove contaminated clothing.
- Flush the affected areas with water or special neutralizing agents, if available, while removing clothing.
- Continue washing the affected area for 5 minutes with soap and water.
- If the poison is corrosive or a pesticide, call EMS.
- If the victim is conscious, promote ingestion of fluids.

Shock

Shock is a result of a depressed state of many vital body functions that could become life threatening even though the actual injuries might not be. First aid for shock

should improve circulation, promote oxygen supply, and maintain normal body temperature.

After initial evaluation of the patient and immediate first aid to reduce life-threatening conditions, proceed as follows:

- Keep the victim lying down in a position that improves circulation (legs elevated, possibly on the side if unconscious).
- Cover the victim only to maintain body heat.
- Obtain medical help.
- Do not give the victim fluids when abdominal injuries or head injuries are suspected.

Wounds and Bleeding

Wounds are internal or external disruptions of body tissues that can be classified as "open" or "closed."

Open wounds

An open wound is a break in the skin or a mucous membrane such as an abrasion (scrape), incision (cut), laceration (tear), puncture, or avulsion (torn off).

First aid for **simple open wounds** is as follows:

- Dress and bandage the wound.

First aid for **severe open wounds** is as follows:

- Apply direct pressure on the bleeding wound.
- Elevate the injured area of the body above the heart.
- Apply pressure on the supplying artery.
- Apply a tourniquet (only in life-threatening cases).
- Treat the victim for shock.
- Seek medical assistance.

Closed wounds

A closed wound is a wound that involves underlying tissues without a break in the skin or mucous membrane. Symptoms of serious internal bleeding include pain and tenderness; cold, pale, clammy skin; weak, rapid pulse; rapid breathing; dizziness; vomiting and coughing blood; restlessness; excessive thirst; and possibly abdominal distention.

First aid for closed wounds is as follows:

- Examine the victim for fractures or other injuries to the head, neck, chest, abdomen, limbs, back, or spine.
- In minor cases, apply an ice bag to reduce swelling and slow bleeding.
- Treat the victim for shock.
- Seek medical attention.
- Do not give fluids when internal injuries are suspected.

Artificial Respiration

Over 3000 deaths annually are attributed to asphyxia, two thirds of which are children under 4 years of age. Asphyxia can be caused by conditions such as obstruction of the airway by objects or liquids, swelling tissues in the airway, injury to the airway, disease, poisoning, and chest compression. The following **procedure** should be followed for artificial respiration after all initial assessments have been completed (i.e., ABCs, secondary as-

sessment, environment assessment). **Artificial respiration alone is ineffective if the heart has stopped;** CPR will need to be done. Following is the basic process for artificial respiration.

Determine consciousness
- Tap the victim on the shoulder.
- Ask loudly, "Are you okay?"
- If there is no response, assume the victim to be unconscious.

Shout for help

Clear any airway obstruction
- With the victim in a supine position, turn the head to the side and, if necessary, clear the airway with a finger sweep.
- Check for breathing.
- If this does not clear the obstruction, turn the victim on the side and administer four rapid, sharp blows between the shoulder blades.
- For an infant, turn the infant upside down and give four sharp blows between the shoulder blades.
- Perform the abdominal thrust maneuver.
- Recheck for airway obstruction, perform finger sweep to clear any objects, and perform CPR, if necessary.

> Special equipment is available that covers the mouth and nose of the victim during artificial respiration to protect the person administering artificial respiration from vomit and body fluids. These tools are available through most medical supply companies or from the local American Red Cross chapter.

Look, listen, and feel
- Position the head anteriorly, tilt the head back, and press the jaw or neck forward to open the airway and cause the tongue to move out of the way. (Do not attempt to tilt the head if the victim may have a head or neck injury. Instead, just press the jaw forward.)
- Place your ear close to the nose and mouth to listen and feel for respiration, and watch the chest for movement for 3 to 5 seconds.
- If the victim is breathing, contact medical assistance.
- If the victim is not breathing, continue with artificial respiration.

Breathe for the victim
- With the airway open, tilt the victim's head back and protract the jaw.
- Begin giving the victim breaths using the most appropriate of the following methods:

Mouth-to-mouth respiration (most commonly used for adults)
- Pinch the victim's nose.
- Open your mouth wide and tightly place it over the victim's mouth.
- Blow into the victim's mouth.
- Give four quick, full breaths.
- Turn your head and look, listen, and feel again for breathing.
- Check for a pulse at the carotid artery.
 - If there is no pulse, begin CPR.
 - If a pulse is present, but the victim still is not breathing, resume rescue breathing by giving one full breath every 5 seconds and checking once per minute until the victim resumes breathing independently, the pulse is absent (start CPR), or trained help arrives.

Mouth-to-nose respiration (most commonly used for small children and infants)—perform artificial respiration in the same manner as mouth-to-mouth respiration with the following differences:
- Do not tilt the head back as far as an adult.
- Use smaller breaths for children.

- Use small "puffs" instead of breaths for infants.
- Administer a breath **every 3 seconds for infants** and **every 4 seconds for children** (versus every 5 seconds for adults).

Cardiopulmonary Resuscitation (CPR)

CPR is performed when a victim's heart has stopped. It is a technique that combines artificial respiration and artificial circulation to provide immediate life support until EMS arrives. Typical conditions that require CPR include heart attack, suffocation, drowning, electrocution, and drug overdose.

CPR is not outlined in this text because of the nature of the training required to perform the technique. It is extremely important that before performing CPR you receive proper training through a credible organization that certifies individuals in CPR (e.g., American Red Cross, American Heart Association).

Precautions

Following is a list of conditions for which CPR is contraindicated:

- There is a "Do Not Resuscitate" order.
- The victim has been in cardiac arrest for more than 30 minutes (except in cold water drowning victims).
- The victim is in a dangerous environment.

Procedure

Perform an initial evaluation of the situation as you approach the person, which can be summarized as RAP (responsiveness, activate, position) and ABC (airway, breathing, circulation).

CPR may induce vomiting and cause sternal and rib fractures. Smooth performance of the technique may reduce the chances of these complications.

RAP
- Check the **responsiveness** of the victim to determine the level of consciousness.
- **Activate** the EMS system by calling for help or having someone else call
- **Position** the victim in the supine position.

ABC
- Check the **airway** for possible obstructions.
- Check for **breathing,** then give two breaths.
- Check for **circulation** by palpation of the carotid pulse.
- If the victim shows no sign of breathing or pulse, continue with CPR.

Chapter Forty-Five

Touch Therapy Modalities

This chapter is designed to give bodyworkers a general knowledge of some of the most predominant massage and bodywork modalities being used in the massage profession. Each of these techniques has been considered for its uniqueness and specialized application and purpose. Bodyworkers each have an individualized approach to treating clients, and an integration of modalities is often used to achieve holistic balance.

Acupressure

Acupressure is derived from early Chinese medical practices (see Chapter 20) in which the body is mapped out as a series of **energy meridians.** Energy flowing in these meridians can be stimulated or sedated to achieve desired changes through the manipulation of over 2000 acupressure points. In Chinese medicine, these points are primarily stimulated through the use of needles in a technique known as acupuncture. Acupressure is the technique that uses digital pressure to accomplish similar effects.

Alexander Technique

The Alexander technique was created by F.M. Alexander. It is based on conscious awareness and movement of one's posture in an effort to lengthen the spine. As in the animal kingdom, posture and movement are associated with efficient use of the body. For example, if a person slouches, he has a limited ability to breathe. With a distorted posture, normal movement is hindered and altered and distortion sets in through repetition of that movement. The Alexander technique retrains the client's movement patterns to be more efficient and less painful.

Amma (Anma)

Amma (also called Anma) has been practiced for over 4000 years in China. Amma (meaning "massage" in Chinese) eventually made its way to Japan about 1500 years ago. The Japanese refined Amma into an early version of what is now known as Shiatsu. Massage, pressure-point therapy, and energy meridian concepts are all integral parts of this age-old healing practice. (Also see *Shiatsu* in this chapter.)

Aromatherapy

Aromatherapy is used by itself or as an addition to other types of therapies to promote specific physical and emotional changes and effects. Essential oils are extracted from wood, flowers, fruits, leaves, stems, and roots of plants. Each type of oil has distinct properties that affect the body or emotions in specific ways. Therefore, oils are very versatile for use in massage oils, in aromatic diffusers, directly on the body, or as ingredients in lotions, shampoos, and other cosmetic products.

Aston Patterning

Aston patterning was created by Judith Aston and is based on the work of Ida Rolf (see *Rolfing*), whose concepts of postural balance relate to body symmetry. Judith Aston's work taught her that each body has an individual asymmetry. After her injuries in two auto accidents, she discovered that changes could occur at a deep level using a noninvasive technique. In Aston patterning, one hand massages in the direction of the grain of the muscle while the other hand uses a spiraling motion that follows where the tissues direct or lead.

Bindegewebsmassage

Bindegewebsmassage was developed by Elizabeth Dicke (German) in the 1940s. This technique is a type of connective tissue massage that follows the patterns of dermatomes. By use of massage in certain patterns and movements, there is a vascular and visceral reflexive effect on many pathologic conditions that can promote healing through improving circulation.

Craniosacral Therapy

John Upledger, DO, researched and systematized this therapy based on the osteopathic techniques of Dr. William Sutherland and Dr. DeJarnet. Craniosacral therapy is based on the cranial rhythm (i.e., the movement of cranial and sacral fluids) within the craniosacral cavity and how it is affected by imbalances in the body. The emphasis is on promoting, through light touch and energy work, a balanced cranial rhythm to promote overall health.

Esalen Massage

Located just outside Big Sur, California, the Esalen Institute uses an integration of multiple massage techniques. Using everything from Swedish massage to Rolfing, the practitioner focuses on blending body, mind, and spirit in each massage. The location of the institute on the cliffs overlooking the Pacific Ocean is an environment that acts as a catalyst for this blending to occur.

Feldenkrais Method

The Feldenkrais method was created by Dr. Moshe Feldenkrais, an Israeli nuclear physicist. This technique is concerned with integrating the body and mind through reeducating learned movements of the body. It is based on the belief that our bodies and our movements are a direct expression of our lifestyles and emotional makeup. By reintroducing different styles of movement through repetition we can bring into awareness old habits and create new ones, leading to new ways of being.

Hellerwork

Hellerwork was created by Joseph Heller, an aerospace engineer turned bodyworker. This modality is based on Rolfing, but includes a somatoemotional element. Heller found through research that the body has an emotional makeup that coincides with certain anatomic areas of the body. Because Heller trained at the Rolf Institute, his background included the concept that the body is plastic in nature and that it works better when it is kept in balance with gravity. Through the use of relatively deep and strenuous tissue manipulation and dialogue, the client can regain postural balance and emotional release from tissue memory that may be the cause of the imbalance.

Jin Shin Do

Developed by Iona Teeguarden, this modality is a blend of Shiatsu, acupressure, breath work, psychology, and Taoist philosophy. This technique incorporates bodywork, dialogue, breath exercises, and pressure-point work during which pressure points are held for up to 5 minutes. Balance of the body, mind, and spirit is the effect that is being promoted.

Kinesiology, Applied

In the early 1960s, a chiropractor by the name of Dr. George Goodheart developed the concept that specific muscles and their functions are related to specific body systems and can be used to evaluate and treat specific imbalances. With the use of "muscle response testing" (MRT), weaknesses in specific body systems can be evaluated by noting weak response to resistance applied to a specific muscle. The focus is more on evaluation rather than treatment. Applied kinesiology was later developed into simpler versions, such as touch for health.

Lomi Lomi

Native to the Hawaiian Islands, this ancient massage technique was handed down from generation to generation. It is a blend of Swedish massage, sports massage, chiropractic medicine, prayer, and meditation. Spirituality is the key as Kahunas (or "keepers of the secret") chant and almost dance as they integrate the massage.

Manual Lymph Drainage

This systematic approach to opening and clearing the lymph system was developed by Dr. Emil Vodder, PhD. Primarily, this technique is used for facilitation of lymph movement, especially when there is damage to the lymph channels as a result of surgery, injury, congenital defects, or various invasive therapies. This modality uses a number of techniques, including pumping and stroking to open capillaries and lymph nodes to promote an increased release of toxins and greater absorption capabilities.

Myofascial Release

As the name indicates, this is a therapy or group of similar therapies developed with the intent to "release" muscle fascia. Myofascial release is based on the concept that all body structures are surrounded by different types of fascia and that this tissue has the ability to be

stressed and become hardened or to be relaxed and become more fluid. Because of trauma or overuse, tissue can develop adhesions and harden, which decreases mobility and flexibility. Therefore, the myofascial release techniques are used to promote a more fluid state for the fascia. Using specific pressure in specific directions, the fascia warms and "melts," allowing for deeper work to be done.

Neuromuscular Therapy

Based on early concepts of pain relief techniques, this modality has been developed and promoted by Paul St. John, LMT. Along with various tissue manipulation techniques, this therapy is based on trigger-point therapy, which uses the neuromuscular system to balance and normalize muscle function and reduce the pain response.

Polarity

Developed by Dr. Randolph Stone, this modality describes energy bodywork in a scientific format in which the entire body is animated through a matrix of energy in and around the human form. Each part of the body has positive, negative, or neutral energy. By working with these energies, a current can be established to promote a flow of energy to improve overall health.

Postural Integration

Postural integration is a generic term used in many techniques. This concept primarily focuses on promoting postural balance through integration of body and mind techniques. The most well-known version of this modality was developed by Jack Painter who used concepts in bodywork, breath work, acupressure, energy work, and dialogue to achieve the desired effect.

Proprioceptive Neuromuscular Facilitation

This stretching technique has been documented to achieve up to 15% more flexibility than conventional static stretching. It is accomplished by stretching just into resistance, isometrically contracting the muscle group for a count of five, relaxing, and then repeating the cycle up to three times. Variations of this technique are abundant. Proprioceptive neuromuscular facilitation is most commonly used in sports massage.

Qi Gong (Chi Kung)

This Chinese technique includes two ways of approaching the movement of chi energy to promote or maintain health. The first is Qi Gong exercise, which is meditative in nature but energizes the body through movement, much as Tai Chi does. The second is Qi Gong massage, also an energy movement technique that resembles Reiki in concept. Both require the student to find the center (or dan tien) and work to balance the body's energies from that point.

Reflexology

Originally called zone therapy, reflexology was developed by Dr. William Fitzgerald. It involves segments of the body called reflex zones. Any stimulation within a zone reflexively

stimulates everything within that zone. Eunice Ingham, a student of Fitzgerald, systematized the work to focus on the feet and hands as the most effective areas. The entire body is mapped out on the feet, and stimulation of each mapped area has a reflex response on the related body part or area.

Reiki

This energy technique is a recreation of an ancient Tibetan Buddhist concept of opening and moving energy within the chakras for greater spiritual enlightenment. Dr. Mikao Usui supposedly received this enlightenment during a highly meditative search for higher meaning. Reiki practitioners receive a series of attunements in which their chakras are open to receive chi and then themselves become conduits of that chi. Reiki is performed first as a self-help treatment or cleansing, then as an energy healing technique for others, and eventually in a way that sends the healing energies to others in another time and space. Upon reaching the master level, the practitioner gains the ability to perform the attunements.

Rolfing

Created by Dr. Ida P. Rolf, this technique is based on the plastic nature of the body's connective tissue (fascia). The fundamental concept is that the fascia can become stressed and hardened when the body is habitually out of alignment with gravity. Rolfing is a 10-session program focused on specific areas of the body. Deep connective tissue manipulation helps to remold the fascia into pliable body tissue, allowing the body to balance and realign itself with gravity.

Shiatsu

In the early 1900s, Tamai Tempaka combined the traditional Chinese medicinal practice of acupressure with Western concepts of medicine to create an improved healing technique. The Chinese mapped over 2000 acupuncture points on the human body. The Japanese developed a version that uses only the most important 660 points, or tsubos. Shiatsu (meaning "finger pressure" in Japanese) uses about 80% pressure-point therapy and 20% massage. Both a diagnostic tool and a treatment method, Shiatsu is primarily focused on moving chi within the energy meridians of the body to achieve flow and balance so the body can heal.

Soma (Hanna Somatic)

Created by Thomas Hanna, this modality was designed for individuals with neuromuscular disorders. Soma is based on techniques from the Feldenkrais method, the work of Hans Selye (known for his research on stress and its effect on disease), and biofeedback principles. Hanna developed this bodywork and exercise process to integrate the mind and body to teach voluntary control of the neuromuscular system.

Spinal Touch

Created by Lamar Rosequist, DC, and based on early concepts of Aquarian age healing (Dr. Hurley) and polarity (Dr. Randolph Stone), spinal touch is a systematized version of light-touch postural integration in which posture is promoted as the key to health. This

technique establishes the L5–S1 joint as the center of gravity and the basis for posture and health. Using a plumb line evaluation to determine postural imbalance and distortion, energy concepts and light-touch tissue manipulation are used to reeducate postural balance by influencing the position of the sacrum.

Sports Massage

Sports massage is a concept rather than an actual technique because any massage technique can be used. The main focus of sports massage is to improve the performance of the athlete within specific time frames relative to an event. It is important to note that there are numerous variations of these techniques that must be based on the individual and the event. The following are basic guidelines for sports massage.

Pre-event Massage

Pre-event massage is most effective when performed just prior to or as part of the athlete's warm-up. The focus is to stimulate metabolism, encourage positive mental focus, and draw needed blood and oxygen to the area of the body that is to perform first. No deep or relaxing techniques are used. Pre-event massage usually lasts no more than 10 to 15 minutes.

Postevent Massage

Postevent massage is most effective when performed after rehydration and within the first 2 hours after the event. The focus is to relax and relieve stress for the purpose of promoting the healing process, removing metabolic waste, and increasing circulation. This alone can cut the downtime for the athlete in half. Care is taken to avoid deep tissue work so as not to overwork the muscles.

Training Massage

Training massage is the most important aspect of sports massage. The focus of training massage is to reduce the chance of injury by increasing range of motion and flexibility in the areas most prone to performance problems. Training massage is the ideal time to work as long as is appropriate, using any and all techniques available to accomplish the focus. This allows the athlete to perform with more intensity and frequency. Bodywork is done 24 hours or more before or after the actual event.

> Only if the athlete is accustomed to receiving bodywork would training massage be appropriate 24 hours before or after an event.

Intraevent Massage

Intraevent massage is performed during the event as allowed by time and opportunity. Generally, the focus is to maintain a relaxed but stimulated state for the athlete, much like a boxer receiving a rubdown between rounds. Intraevent massage allows the athlete to continue in a performance condition and does not allow the athlete to relax, which can hinder immediate performance. Bodywork is short, stimulating, and sweet. No deep, relaxing, or long-term work is done.

Rehabilitation Massage

Rehabilitation massage is used in injury management, for both current and chronic conditions. It is usually appropriate during the off-season or downtime to achieve maximum

rehabilitation. Focus is on the immediate area of injury with awareness of pain levels and tissue response. Light, proximal work or energy work is usually most appropriate. In the case of chronic injuries, deep tissue and stretching techniques help to break up scar tissue and repolarize the protein fibers to regain mobility and flexibility.

Tellington Touch

Created by Linda Tellington-Jones and otherwise known as equine massage, the Tellington touch modality was developed for use on animals, primarily horses. The basis for this technique is the work of Dr. Moshe Feldenkrais (see also *Feldenkrais Method* in this chapter), in which movement is the key to reeducating the whole being.

Therapeutic Touch

Created by Dolores Krieger, PhD, RN, this energy technique is much like Reiki in that the practitioner is considered a conduit for universal energy. As hands are floating above the client's body, a search for energy "holes" creates an opportunity to "fill" them. Krieger's concept includes the use of prayer, meditation, and intuition to effectively treat patients.

Touch For Health

In cooperation and partnership with Dr. George Goodheart, Dr. John Thie created a simplified version of applied kinesiology for the lay person to use as a self-help system for health. The belief is that the body will heal itself if its energies are balanced. (See also *Kinesiology, Applied* in this chapter.)

Trager Method

Created by Dr. Milton Trager, this technique is based on a "mind-to-muscle" connection in which the practitioner "hooks up" on a mental level with the client. The technique involves rocking, shaking, and moving body parts through a natural range of motion. It is a gentle and nurturing approach to repatterning the body's condition via its mental connection using mentastics (or mental gymnastics). The idea is to present to the body a feeling of freedom from the limits it has set for itself by its own mental programming.

Trigger-Point Therapy

Studied and developed by Dr. Janet Travell, this technique is an offspring of acupressure and Shiatsu. It is an anatomically oriented, deep tissue, pressure-point technique used for spot work to relieve pain and increase mobility. Trigger-point therapy is based on neuromuscular stress points and uses deep digital pressure sustained for 5 to 30 seconds. It can incorporate stretching techniques to cause a release of the tissue.

Tui Na

Tui Na (also called acupressure massage) is widely used by the Chinese but only recently became known in the United States. It is a recipe-based treatment program combining acupressure therapy and massage techniques to treat ailments. The emphasis is on working with the energy meridians of the body.

Chapter Forty-Six

Holistic Nutrition

Nutrients

Basic Nutrients (Figure 46–1)

Proteins — compounds made up of chains of **amino acids** used for structure and in processes involving transport, movement, body defense, and regulation.

 Enzyme — a specific type of protein that catalyzes (accelerates) biologic or chemical reactions.

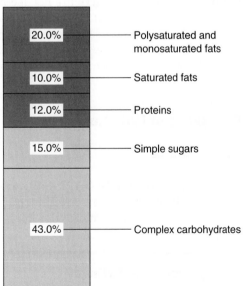

Dietary Goals

20.0% — Polysaturated and monosaturated fats

10.0% — Saturated fats

12.0% — Proteins

15.0% — Simple sugars

43.0% — Complex carbohydrates

Figure 46–1. These goals represent the percentage of a healthy diet that should be made up by the basic nutrients—fats, proteins, and carbohydrates.

Carbohydrates — primarily used as an energy source.
 Monosaccharide [*mono = one; sakcharon = sugar*] — a sugar made up of a single sugar molecule (e.g., glucose, fructose).
 Disaccharide [*di = two*] — a sugar made up of two monosaccharides bound together (e.g., sucrose, lactose).
 Polysaccharide [*poly = many*] — a sugar made up of more than two monosaccharides bound together (e.g., starches).
 Glycogen — a polysaccharide stored in animal tissues; consists of a long chain of glucose molecules; also called animal starch.
 Dietary fiber (cellulose) — a carbohydrate that cannot be digested by the human body and therefore passes through the gastrointestinal tract, helping to promote peristalsis and bowel regularity.
Lipids [*lipos = fat*] — used for energy, structure, and insulation.

> In general, vitamin and mineral supplements are not needed by an individual who eats a balanced diet. However, some supplementation is necessary in special cases, such as pregnancy, diseases in which the body has an increased need, or situations in which the soil or normal food sources in a geographic region are lacking a particular mineral (e.g., iodine).

Other Nutrients

Vitamins — accessory nutrients essential in small amounts for normal growth and metabolism; not produced in the body (except for vitamin D) and so must be obtained through the diet; water-soluble vitamins (B_1, B_6, B_{12}, C, and folate) must be ingested daily because they are excreted in the urine; lipid-soluble vitamins (A, D, E, and K) are stored in the fatty tissues of the body.

> Glucose is a six-carbon ring that, when broken in half by the body, becomes two three-carbon molecules of **pyruvate**. This pyruvate is converted into **lactic acid**.

Minerals — accessory nutrients needed by the body in small amounts for normal growth, structure, and function of the tissues; few are stored in the body, so they must be obtained through the diet; common minerals include calcium, sodium, chlorine, magnesium, and potassium; most minerals become **electrolytes** (substances that become ions when mixed in solution) in the blood or other body fluids.

Energetics of Nutrition

Energy Source

Adenosine triphosphate (ATP) — the energy "currency" of the body; energy is contained within the bonds that hold the three phosphate molecules bound to each other (Figure 46–2).

> Adenosine triphosphate (ATP) is synthesized in the cell using the energy contained in food. This energy can be transported via the ATP to wherever it is needed in the cell. Enzymes in the cell cleave off a phosphate group and release the energy, making it available to be used however the cell needs to use it.

Energy-Producing Pathways

Anaerobic (glycolytic) metabolic pathway — a very rapid pathway or process in which the body splits glucose molecules into two three-carbon chains, using the energy released to make two molecules of adenosine triphosphate; the body's pathway of choice when performing high-intensity

Figure 46–2. A schematic diagram showing one adenosine triphosphate (ATP) molecule.

exercises, during which oxygen delivery is not fast enough to keep up with the body's demand; produces **lactic acid** as a by-product.

Oxygen debt — the body's need for oxygen to neutralize the lactic acid that has been produced during glycolysis.

Aerobic metabolic pathway — a slower energy-producing pathway that uses fats, carbohydrates, or proteins that have been broken down from long chains of carbon into two-carbon chains and put into the mitochondria of the cell to produce adenosine triphosphate (ATP); **1 molecule of glucose yields 36 molecules of ATP.**

Chapter Forty-Seven

Holistic Principles

Principles of Holistic Practice

The term holistic refers to an emphasis on the organic or functional relation between parts and the whole. In Western medicine, it is common for health practitioners to specialize in certain aspects of health. For example, medical doctors focus on the physical body, psychologists and psychiatrists focus on mental and emotional health, and religious leaders handle spiritual health.

Modern holistic concepts involve the interrelationship between body, mind, and spirit. This "triad of health," within which the individual components play equal and important roles in overall health, has become the very essence of holistic practice.

In holistic practice, all aspects of health are intertwined. In many cultures (e.g., Oriental, Ayurvedic) health is determined by all environmental sources. Personal relationships, diet, exercise, attitudes, occupation, living space, and behavior patterns all contribute to an individual's health and well-being. The theory is that we are born into the world in a balanced state and our purpose is to maintain that balance throughout our lives. This balancing of body, mind, and spirit then becomes a lifelong effort and holds the key to good health.

Stress Management and Relaxation Techniques

The following are the most commonly used techniques to combat stress and its harmful physical and emotional effects. All of the following techniques are designed to put the body or mind in a state of relaxation, because healing comes from rest and balance.

Yoga — a system of stretches and exercises for attaining physical, mental, and emotional control and well-being.

Biofeedback — a series of exercises to promote conscious control of or awareness of the physiologic responses to stress, pain, or disease; normally involves the use of electronic instruments to monitor the desired effect.

Breath work — the use of breathing exercises designed to promote focus, energy, and the physiologic responses of relaxation; similar to biofeedback.

Visualization — promoting mental images through verbal guidance or meditation; has been proved to alter the physiology of the participant, which in turn affects emotional and mental states; the most used relaxation technique in massage; sometimes called "closed eye processes" or "mind journeys."

Exercise — one of the most commonly used stress reducers; creates an **endorphin** release and promotes physical health.

Meditation — promotes focus, balance, a state of peace, and a clearing of the mind; prayers, chants, fasts, and solitude are a few of the common forms being used; much like visualization and biofeedback in its effect.

Medication — use of valium, lithium, and other prescription drugs is common but not always healthful (can produce unwanted side effects) or natural (see *homeopathic treatments*).

Homeopathic or herbal treatments — natural and herbal recipes that counter stress without the side effects of most drugs; it is important to communicate with a doctor to avoid drug interactions if the client is under medical care.

Corrective Exercises

Assessment

An individual with muscle tightness or pain symptoms will often have a simple explanation that points to habits or lifestyle as the source of the problem. Whether these habits come from an occupation, hobby, or living conditions, it may be up to the massage therapist to help the client identify the problems and find a way to modify them. For example, a person with calf or ankle pain may be wearing the wrong shoes, a person with neck pain may be spending too much time with the phone held under his ear, and a person with chronic back pain may be sleeping in a poor position or on an old mattress. Identifying and correcting these problems is the first step before beginning or using corrective exercises.

> Remember that as a massage therapist you cannot diagnose or prescribe medications. Therefore, when using exercises in practice, you may only recommend certain positions or suggest certain exercises. For anything else you must refer the client to a physician or to another health care professional.

Exercises

Postural exercises simply help the client return to proper posture. Examples include chin tucks (for forward head), shoulder shrugs (for drooping shoulders), scapular adduction exercises (for forward shoulders), and lower abdominal exercises (for a posteriorly tilted pelvis).

Strength exercises help to strengthen weak muscle groups. Examples include bench presses (for pectoralis muscles), arm curls (for brachial muscles), knee extensions (for quadriceps muscles), and leg curls (for hamstring muscles).

Many other exercises exist for these and other muscle groups that are explained in more detail in other textbooks and in exercise manuals.

Massage Therapy and Bodywork: Theory, Assessment, and Application

1. The shaking technique is a variation of which technique?
 A. Percussion
 B. Pétrissage
 C. Tapotement
 D. Vibration

2. Promoting joint flexibility is one of the main purposes of:
 A. friction
 B. chucking
 C. rocking
 D. kneading

3. What form of massage is indicated for constipation?
 A. None; massage is contraindicated
 B. Clockwise effleurage
 C. Deep pétrissage
 D. Counterclockwise effleurage

4. Varicose veins appear as:
 A. small, thin blood vessels in web-like patterns
 B. red veins close to the surface
 C. protruding, irregular veins during rest
 D. protruding veins during exercise

5. Massage is indicated in which of the following conditions?
 A. Acute ankle sprain
 B. Varicose veins
 C. Spider veins
 D. Cirrhosis

6. In which of the following conditions is it important to receive a doctor's approval before giving a massage?
 A. Carcinoma
 B. Bursitis
 C. Chronic fatigue syndrome
 D. Asthma

7. What could tapotement of the thoracic area do in the case of a client with pneumonia?
 A. Increase expectoration
 B. Promote an asthma attack
 C. Spread the infection
 D. Cause the intercostals to spasm

8. Which of the following describes passive joint movement?
 A. The client lightly performs the movement without assistance
 B. The therapist performs the movement with no help from the client
 C. The client performs the movement with assistance
 D. The client relaxes and the therapist stretches the joint

9. What is the primary benefit of deep transverse friction?
 A. Stretches ligaments
 B. Promotes circulation
 C. Loosens joints
 D. Breaks up adhesions

10. Which of the following statements describes a therapist upholding professional ethics?
 A. Able to work successfully with clients and provide excellent service
 B. Able to adapt to and work with many personality types
 C. Concerned with public and client welfare and the quality of the profession
 D. Honest in all business dealings and able to promote an attractive business

11. In first aid, the acronym "ABC" stands for:
 A. assessment, breathing, and condition
 B. always be careful
 C. airway, breathing, and circulation
 D. assess the situation, be in charge, and call for medical help

12. In which of the following conditions is massage contraindicated?
 A. Fever
 B. Abnormal lumps
 C. Chronic inflammation
 D. Low blood pressure

13. In Oriental massage, a meridian is:
 A. an anatomical segment
 B. a channel in which chi flows throughout the body
 C. a measurement of time in relation to normal body rhythms
 D. the yin or yang quality of a body part

14. Which of the following techniques is performed on a client without touching the body?
 A. Polarity
 B. Reiki
 C. Feldenkrais
 D. Lomi lomi

15. Which of the following techniques is the Western version of acupressure and Shiatsu?
 A. Therapeutic touch
 B. Trager
 C. Jin Shin Do
 D. Trigger-point therapy

16. The infection precautions used in which of the following situations place a physical barrier between the caregiver and potentially infectious agents?
 A. Following the requirements of body substance isolation
 B. Treating third-degree burns
 C. Treating open wounds
 D. All of the above

17. What is the main function of carbohydrates in the body?
 A. Energy
 B. Tissue structure
 C. Insulation
 D. Nerve conduction

18. When assessing the current condition of a client, what is the main reason for observing the client's gait?
 A. It exhibits the client's attitude about himself
 B. It shows distortion during movement
 C. It demonstrates the client's posture
 D. It shows that the client is ambulatory

19. Exercise is considered one of the best stress reducers because it:
 A. causes an endorphin release
 B. changes mental focus
 C. stimulates circulation
 D. promotes metabolic activity

20. What is the most widely used massage technique?
 A. Effleurage (or gliding)
 B. Tapotement
 C. Pétrissage
 D. Deep tissue work

21. Which diagnostic tool in Western medicine provides the most detailed view of any of the body's tissues?
 A. X-ray (or radiography)
 B. Computed tomography (CT) scan
 C. Complete blood count
 D. Magnetic resonance imaging (MRI)

22. What is the most widely recognized physiologic effect of massage?
 A. Reduced mental stress
 B. Emotional relaxation
 C. Improved skin condition
 D. Increased blood and lymph circulation

23. Which of the following techniques would be most beneficial for a client with edema?
 A. Slow, repetitive effleurage
 B. Light pétrissage
 C. Vigorous gliding toward the heart
 D. Vibration

24. Which of the following techniques is most frequently used to enhance the level of relaxation during a massage?
 A. Relaxed breathing
 B. Biofeedback
 C. Visualization
 D. Vocal toning

25. A client with high blood pressure has received a doctor's approval for massage. Which of the following techniques would be most effective in reducing the client's high blood pressure?
 A. Vigorous vibration
 B. Pétrissage
 C. Deep tissue work
 D. Slow effleurage

26. Who developed the movements known as Swedish massage?
 A. Dr. Johann Mezger
 B. Ambrose Paré
 C. Per Henrick Ling
 D. Elizabeth Dicke

27. What is the initial procedure for an acute knee injury?
 A. Heat and elevate
 B. Splint and seek medical assistance
 C. Rest, ice, compression, and elevation
 D. Massage proximal to the injury

28. Yoga is an example of which form of stretching?
 A. Static (unassisted) stretching
 B. Passive stretching
 C. Reciprocal inhibition stretching
 D. Ballistic stretching

29. Massage is beneficial for paralyzed limbs because it:
 A. improves circulation and muscle tonus to the limb
 B. increases nerve sensations in the limb
 C. reduces pain in the limb
 D. stimulates motor nerve function

30. Which of the following techniques involves muscle response testing?
 A. Trigger-point therapy
 B. Trager
 C. Feldenkrais
 D. Touch for health

31. A client is complaining of ankle pain, and the ankle appears swollen. The client requests that you pay special attention to the ankle. What is the best response?
 A. Proceed with the massage as requested
 B. Work proximal to the ankle and work reflex areas, avoiding the ankle itself
 C. Palpate the ankle to determine pain tolerance and an appropriate treatment
 D. Work only on the ankle and reschedule the client

32. For proper body mechanics during a massage, what should be the main source of strength in massage movements?
 A. Upper torso
 B. Back
 C. Lower body
 D. Arms

33. Fats should make up approximately what percentage of a healthy diet?
A. 10%
B. 20%
C. 30%
D. 60%

34. Which of the following statements is true regarding massage therapy for a client suffering from chronic fatigue?
A. Massage should be very light and superficial to promote rest and relaxation
B. Massage should be vigorous to promote circulation
C. Massage is contraindicated
D. Massage should be stimulating

35. Which of the following strokes primarily breaks up adhesions in the muscle belly?
A. Friction
B. Kneading
C. Effleurage
D. Tapotement

36. Drugs that are used to destroy, break down, or limit the growth of living bacteria are called:
A. antibiotics
B. nonsteroidal anti-inflammatory drugs
C. chemotherapy drugs
D. analgesics

37. What is the best approach to a client with scoliosis?
A. Seek advice from the client's doctor and proceed with caution
B. Perform deep tissue work
C. Use only tapotement and compression on the affected area
D. Use light effleurage over the entire body

38. Which of the following statements is true regarding treatment for an elderly individual with fragile bones and very sensitive skin?
A. Massage is contraindicated
B. A gentle, short massage may be beneficial
C. A deep, invigorating massage will help stimulate the client
D. Massage should be limited to application of lotion only

39. Which of the following techniques is described as a vigorous, rhythmic movement?
A. Chucking
B. Rocking
C. Friction
D. Rolling

40. Which of the following modalities is most often used by nurses and is practiced with the hands above the body?
A. Trager
B. Therapeutic touch
C. Applied kinesiology
D. Craniosacral therapy

41. Which of the following terms best describes chi?
A. Vital life force
B. Lymph vessels
C. Energy meridians
D. Life blood

42. How does massage promote pain relief?
 A. It can stimulate an endorphin release
 B. It isolates the injury causing the pain
 C. It dissipates the pain response
 D. It shuts off the "gate" theory of pain

43. The technique of kneading is performed by:
 A. tapping the fingertips on the surface of the skin
 B. sliding the hands rapidly over the skin
 C. lifting, grasping, rolling, and compressing muscles
 D. pressing over the muscle tissue lightly but firmly

44. What are the main therapeutic effects of pétrissage?
 A. Rehabilitation of weak muscles and draws blood to the area
 B. Stimulation of nerves and increased circulation
 C. Drainage of lymph and increased metabolism
 D. Increased circulation and metabolism

45. Which of the following statements is true about the effect of massage on the immune system?
 A. Stress relief is known to increase T-cell production
 B. Vigorous massage raises body temperature to kill pathogens
 C. Deep massage promotes the production of vitamin A
 D. Massage of lymph areas breaks down toxins

46. The hacking technique is performed with which movement?
 A. Free wrist movement
 B. Bending elbow movement
 C. Circular finger movement
 D. Light vibrational movement

47. How often should you wash your hands in reference to a massage?
 A. Before the massage
 B. Whenever it is convenient
 C. After the massage
 D. Before and after the massage

48. When should you change the sheets on your table?
 A. Once a day
 B. When they look dirty
 C. After each massage
 D. Only when the client requests it

49. Why is proper draping an important part of good, professional business ethics?
 A. It ensures the client's privacy, which then builds a good reputation
 B. It is an important marketing tool
 C. It makes it easier to deal with difficult people
 D. It promotes oil and lotion absorption

50. How often should towels and sheets be laundered to prevent a rancid odor?
 A. Weekly
 B. Biweekly
 C. As often as time permits
 D. The same day they are used

51. If a new client refuses to fill out an intake form or questionnaire, what action would you take first?
A. Proceed with the massage and have the client fill it out later
B. Ask as many questions as necessary, and if the client gives enough information, proceed with the massage
C. Reschedule the appointment and have the client fill it out at home
D. Diplomatically refuse to work on the client until the correct paperwork is completed

52. Which of the following statements is true regarding treatment of a client with low blood pressure?
A. Only a light massage is appropriate
B. Massage is contraindicated
C. It is necessary to check with the client's doctor first and then proceed with caution
D. There are no contraindications; proceed as usual

53. Hydrostatic effect is defined as:
A. heat conduction through fluid movement
B. heat generated from fluid movement
C. fluid movement from one area of the body to another
D. an increase in inflammation

54. An individual's range of motion is best determined through:
A. assessment of joint movement
B. palpation of the joint
C. proprioceptive neuromuscular facilitation techniques
D. any form of stretching

55. Your client claims that he had a stroke last year. What is the proper course of action for massage?
A. Avoid the neck and head and proceed as usual
B. Do not massage the client; massage is contraindicated for strokes
C. Obtain advice from the client's doctor and proceed with a gentle massage
D. Focus on effleurage strokes to promote greater circulation

56. Cryotherapy initially induces which localized circulatory condition?
A. Vasodilation
B. Hypertension
C. Hyperemia
D. Vasoconstriction

57. For a massage therapist, which of the following is the most important aspect of personal hygiene?
A. Clean hands and nails
B. Good oral hygiene
C. Deodorant
D. A clean, professional image

58. What is the recommended treatment program for an elderly client compared to an average client?
A. Longer, less frequent massages
B. Shorter, less frequent massages
C. Shorter, more frequent massages
D. Longer, more frequent massages

59. Which of the following contributes to stress reduction during a massage?
 A. Reduction of parasympathetic activity
 B. Reduction of sympathetic activity
 C. Increase of stimulation and nerve activity
 D. Decrease of nociceptive impulses

60. Massage can reduce pain by:
 A. reducing conduction of the pain impulse
 B. affecting the cause of pain stimulation
 C. affecting the processing of noxious stimulation
 D. all of the above

61. Tamai Tempaka combined the traditional Chinese practice of acupressure and Western concepts of medicine to help create the healing technique of:
 A. Rolfing
 B. Shiatsu
 C. Reiki
 D. proprioceptive neuromuscular facilitation

62. The main focus of sports massage is:
 A. relaxation
 B. stimulation
 C. performance
 D. deep tissue work

63. Which of the following best explains why contracted muscles relax after a massage?
 A. Endorphin release
 B. Toxin removal from muscle tissue
 C. Mechanical effect on muscle tone
 D. Proprioceptive resetting of muscle tone

64. What is the most important effect in the use of hydrotherapy?
 A. Chemical changes to the pH balance
 B. Mechanical changes to muscle tension
 C. Fluid changes within the lymph system
 D. Thermal changes to promote circulation

65. According to Oriental concepts, which of the following five elements is associated with the small intestine?
 A. Metal
 B. Fire
 C. Water
 D. Wood

66. The stretching technique called proprioceptive neuromuscular facilitation uses:
 A. passive stretching
 B. isotonic contraction with resistance
 C. ballistic stretching
 D. isometric contraction with resistance

67. During pregnancy, it is important to place a pillow under the right hip of a client in the supine position because the pillow:
 A. helps the client lay comfortably on the side
 B. relieves pressure on the inferior vena cava
 C. relieves low back pain
 D. relieves sciatica

68. Rotation of the head as far as possible to the left is an example of:
A. passive movement
B. active resistive movement
C. active movement
D. proprioceptive neuromuscular facilitation

69. A client lying in the supine position raises his knees for comfort. What might this indicate?
A. Sore knees
B. A feeling of vulnerability
C. Low back pain
D. The client is ready to turn over

70. In which of the following conditions is the use of heat in hydrotherapy contraindicated?
A. Inflammation
B. Headache
C. Muscle adhesions
D. Menstrual cramps

71. In general, massage of the vascular system:
A. promotes vasoconstriction
B. promotes peristaltic action
C. decreases blood volume
D. promotes vasodilation

72. Why is it important to explain the draping procedure to the client?
A. It adds to the client's confidence and privacy and prevents embarrassment
B. The client is not knowledgeable enough to know what to do
C. It is required by law for purposes of consent
D. It promotes a professional reputation

73. Increased pressure in the axillary region can put excess pressure on the:
A. femoral artery
B. saphenous vein
C. brachial plexus
D. carotid artery

74. Yoga involves:
A. gentle stretching of a muscle until resistance is met and then holding for 10 to 20 seconds
B. stretching with the aid of another person
C. stretching in which a bouncing or bobbing motion forces tissue to release
D. stretching and exercises for attaining physical, mental, and emotional control and well-being

75. A therapist's body mechanics are extremely important in preventing injury, fatigue, and strain. Which of the following positions demonstrates good body mechanics?
A. Keep the knees bent and back straight
B. Keep the feet and knees close together and bend at the waist
C. Arms should stay close to the body while shoulders and wrists are extended
D. Balance on both feet and lean over, using the torso for balance

76. Which of the following is a general use or effect of heat?
 A. Reduction of circulation of blood and lymph
 B. Relief of cramps and muscle spasms
 C. Stimulation of both mental and physical stress
 D. Decreased cell metabolism

77. Hypovolemic shock is:
 A. a condition that results from loss of blood or body fluids
 B. a condition that results from loss of salt and body fluids
 C. a pathologic condition that results from a drug overdose
 D. a first aid technique for victims of heart attack

78. The abdominal thrust (or Heimlich) maneuver is used to:
 A. treat frostbite
 B. stop profuse bleeding
 C. dislodge an object from the throat
 D. remove poison from a wound

79. The most important effect in the use of hydrotherapy is the:
 A. thermal effect
 B. chemical effect
 C. mechanical effect
 D. personal contact effect

80. When working for a chiropractor, the client files:
 A. are private and for clinic use only
 B. are available for your use in marketing
 C. are proprietary as your clientele
 D. have no real value outside of the clinic

81. The most effective first aid for muscle injuries is:
 A. application of heat packs
 B. splinting with splints or a brace
 C. Swedish massage techniques
 D. rest, ice, compression, and elevation

82. Enzymes help to catalyze reactions within the body and are a type of:
 A. fat
 B. protein
 C. carbohydrate
 D. fiber

83. Deep massage to the gluteus maximus muscle might injure the:
 A. median nerve
 B. sciatic nerve
 C. brachial nerve
 D. sartorius muscle

84. Which of the following techniques uses exercises to promote awareness or conscious control of the physiologic responses to stress, pain, or disease?
 A. Biofeedback
 B. Visualization
 C. Yoga
 D. Tai Chi

85. For what type of burn is immersion in cold water contraindicated?
 A. First-degree burn
 B. Second-degree burn
 C. Third-degree burn
 D. Fourth-degree burn

86. Chains of amino acids that are used for body structure and in processes involving transport, movement, body defense, and regulation are called:
 A. carbohydrates
 B. lipids
 C. fats
 D. proteins

87. Which of the following techniques promotes relaxation immediately?
 A. Visualization
 B. Yoga
 C. Meditation
 D. Exercise

88. Calcium, sodium, chlorine, and magnesium are all examples of:
 A. minerals
 B. vitamins
 C. carbohydrates
 D. lipids

89. The first thing to do when you come in contact with an individual who may need cardiopulmonary resuscitation is to:
 A. call 911
 B. determine consciousness by tapping on the shoulder and asking, "Are you okay?"
 C. start the abdominal thrust (or Heimlich) maneuver
 D. give two quick breaths and then look, listen, and feel for breathing

90. Which of the following techniques immediately reduces the intensity of deep tissue massage?
 A. Tapotement
 B. Vibration
 C. Cupping
 D. Kneading

Part IV
Professional Standards, Ethics, and Business Practices

Chapter Forty-Eight

Ethics

According to *Webster's Dictionary,* ethics are "morals or moral principles; distinction between right and wrong; moral duty or obligations to the community."

According to the different Codes of Ethics used by many professional organizations, the following is a summary of what is generally accepted as ethical behavior in a health care field such as massage therapy. Each ethical quality is designed to promote, encourage, and protect the profession.

Ethics approaches three areas of focus:

1. The client
2. The individual therapist
3. The profession as a whole

Ethics involves principles such as dedication, commitment, honor, support, promotion, education, protection, improvement, uplifting, upholding, and respect for all areas of focus.

1. The quality of care and service to clients should be of the highest quality and competency available.
2. It is vital to protect client privacy and confidentiality by not discussing, divulging, or allowing others to obtain information of the client's personal, professional, or medical history or any other pertinent information concerning a client.
3. Physical privacy is also of utmost importance in treating a client. Provide draping in a manner that insures the client's privacy. Respect the client's right to refuse or alter their treatment. It is also important to be observant enough to attend to privacy issues at all times.
4. The therapist should avoid judgment, prejudice, and discrimination that would impede his or her ability to treat the client with respect and the highest quality possible.
5. To maintain and promote a competent and vital practice, continuing education is the way to stay updated in the profession, both for business as well as technique purposes. Continuing education is not only for the therapist's benefit, but it also leads to greater care for the client.
6. Business should be practiced in a manner to promote confidence, integrity, and honesty in all areas. Avoid any activity that would undermine or cause "conflicts of interest" that are not in the best interest of the client and the treatment he or she receives.
7. Business and the practice of massage therapy should always be done in accordance with any and all laws, regulations, and rules that pertain to the practitioner's established place of business and ability to practice.

8. The practitioner should maintain a high level of professionalism and integrity in all aspects of his practice and represent himself honestly within the scope of his profession.

9. It is in the best interest of the profession and the health care industry to educate and inform clients, the public, and other health care providers of the scope, limitations, contraindications, and benefits of the profession.

10. We are complimentary health care providers and work in tandem with all other health care providers for the cause of better health. It is vital to understand and include each discipline as a vital part of the holistic community. Avoid unjustly discrimination against other health care providers.

11. There are certain boundaries in the client-therapist relationship that should be honored and never crossed. Avoid any unprofessional or unethical behavior toward a client or any sexualization of that relationship, even if the client initiates it. In most cases, the client-therapist relationship involves vulnerability and promotion of the healing process, both physically and emotionally. A false sense of a relationship can develop, so it is the responsibility of the therapist to honor that and not take advantage of the situation. Hence the saying goes, "Don't date those you work on and don't work on those you date."

In conclusion, promote health as well as honor and respect the profession, the client and yourself as a practitioner.

Chapter Forty-Nine

Business Practices

Interprofessional Communication

As a massage therapist, it is your responsibility to stay within the scope of practice of the profession. Although there are some gray areas in the definition of massage therapy, it is still your duty to work only within the areas in which you are trained and licensed. Remember that massage therapy is a complimentary health care profession, not a form of alternative medicine. Therefore, at no time are we to view ourselves as an alternative to proper medical treatment. The scope of practice for the massage industry does not allow for diagnosis of disease, prescription of medication, or prescription of therapeutic exercise; these are all considered within the scope of medical practice. When appropriate, it is our responsibility to refer clients to those who have the training to accommodate their needs.

Following are general descriptions of several health care professionals (with their designated title abbreviations) that may be referred to for the health care needs of your clients.

Chiropractors (DC)

Chiropractors use a series of manipulations and techniques designed to adjust the structural or skeletal system for improved mobility and enhanced overall health. The basis of chiropractic medicine is the belief that disease and health problems are due to a lack of structural integrity, especially of the spine and the associated nervous system.

Occupational Therapists (OT or OTR)

Occupational therapists are professionals who evaluate self-care, work, play, and task performance skills. They use therapies and programs designed for rehabilitation of both well and disabled individuals experiencing physical or mental disabilities. The focus of occupational therapy is restoration, development, and maintenance of the ability to perform fine motor skills and daily tasks, particularly in the arms and hands.

Orthopedists (MD)

Orthopedists are medical doctors who have specialized in surgery and treatment of musculoskeletal conditions and pathology.

Osteopaths (DO)

Osteopaths are medical doctors who use traditional medical practices with a focus on the mechanical aspects of the body. Although osteopaths can prescribe medication, their training also includes the natural healing mechanisms of the body. Therefore, osteopaths also use treatments designed to correct body structures and the associated systems of the body.

Naturopaths

Naturopaths are holistic medical practitioners who use natural methods and diets to prevent and treat disease. Some of the alternative techniques may include homeopathy, massage, hydrotherapy, and natural herbal and vitamin therapy.

Nutritionists and Dieticians (RD)

Nutritionists and dieticians are usually licensed individuals whose expertise is in nutritional counseling. They use nutrition and diet in many conditions to both promote health and rehabilitate.

Physical Therapists (PT or RPT)

Physical therapists typically use mobilization, exercise, range of motion work, gait training, weight training, and other rehabilitation techniques to promote restoration of normal body movement after injury, surgery, or illness.

Psychiatrists (MD) and Psychologists (PsyD)

Psychiatrists are medical doctors who specialize in the diagnosis and treatment of mental disorders and diseases. Psychologists may also be known as counselors. They practice as observers and advisors in the emotional and belief mechanisms of the individual.

Religious Leaders

Religious leaders base their care on philosophical beliefs. These leaders focus on the moral and religious tenets of their faith and serve as counselors in their religion. Some are trained and licensed in psychology.

Income Reporting Procedures—Tax Information

Independent Contractor Versus Employee Status

Your status as an independent contractor or an employee will ultimately affect your tax situation and how your income must be reported. The following list of questions will help you determine your status for tax reporting:

- Who receives the money from the client?
- Who provides the equipment and supplies?
- Who controls the hours open for business?
- Who finds the customers?
- Who determines the price structure for clients?
- Is there a written contract between the business owner and therapist?

If the majority of the answers are "you," then you are probably an independent contractor. On the other hand, if the majority of the answers are "the business owner," you are probably considered an employee.

Tax Forms (Table 49–1)

Other Tax Information

Self-employment. A sole proprietor of a business is required to pay a self-employment tax that is generally an additional 7%. Accountants can help with individual circumstances.

Quarterly taxes. A business owner is required by the IRS to pay income taxes on a quarterly basis, based on estimated income.

Wages, tips, and barter. The IRS requires that all income be declared, whether it is from wages, tips, or the value of barter income.

Standard tax rates
- $0 to $18,550—15%
- $18,551 to $44,900—28%
- $44,901 to $93,130—33%

Business and Accounting Practices

Liability Insurance

It is recommended that each professional massage therapist obtain liability insurance for protection against potential lawsuits involving malpractice. As part of membership in a professional massage organization, $1,000,000 of aggregate insurance is commonly available at minimal cost.

Table 49–1. *Tax Forms*

Form	Who	Why
W-2	Employee of a company	Year-end wage and tax statement to submit with individual's tax return
1099	Independent contractor	Year-end wage and tax statement to submit with individual's tax return for any independent contractor wages in excess of $600; equivalent to the W2 form
Schedule K-1	Member of a business partnership in a company	Year-end wage and tax statement to submit with individual's tax return; equivalent to the W2 form
1040	Individual	Year-end tax return form; must be mailed by April 15th
1040ES	Self-employed individual	Used for estimated quarterly tax; must be submitted on April 15th, July 15th, October 15th, and January 15th
Schedule C	Sole proprietor of a business	Business profit and loss form for year-end tax return
Schedule SE	Self-employed individual	Self-employment tax form attached to the 1040 form

Licensing

As of November, 1999, 26 states require statewide professional licensing for massage therapists and technicians. Four additional states have passed licensing laws that are not yet in effect, and two states have legislation being presented to provide for licensing statewide. Many other states have jurisdictions within them (e.g., counties, cities) that regulate the profession.

Accounting

Unless the massage practitioner has an education in accounting, it is best to contract a professional business accountant for several reasons:

1. An accountant will provide services concerning taxes, accounting procedures, and bookkeeping practices and will provide legal representation concerning the business accounting.
2. An accountant can serve as an advisor on how to conduct business for taxes, record keeping for legal situations with medical and insurance needs, and efficient bookkeeping.
3. An accountant will save the practitioner time, effort, and money.

Reputation is the best way to locate a suitable accountant. Referral from someone using the services of a good accountant is usually better than thumbing through the yellow pages. Although the practitioner may have an educational background in business, effective bookkeeping and record keeping are still required for efficiency and productivity.

Session Record-Keeping Practices

It is necessary to create an efficient and comprehensive record-keeping procedure for IRS and other requirements, according to the individual business needs. Client files and records are key components to any good business.

There are two types of records used in massage therapy—client intake forms and SOAP notes. **Client intake forms** are completed at the beginning of the initial visit to obtain the client's personal information and history. The intake form should include the client's address, phone numbers, medical history, injury history, and current needs and should be evaluated before each treatment. **SOAP notes** are primarily used for daily charting purposes. Each client treatment, visit, or cancellation should be documented in these notes.

These records serve six major purposes:

> **The acronym "SOAP" stands for:**
> - Subjective—includes the client's description of his or her current condition (e.g., symptoms)
> - Objective—includes your observations, treatment, or evaluation of the visit
> - Assessment—includes a record of the changes in the client's condition as a result of treatment
> - Plan—includes recommendations for future treatment with long- and short-term goals

1. **Record keeping for the IRS.** Wise use of records can validate business and tax returns. The IRS can audit a minimum of 7 years of tax returns, so keep records from previous years on hand.
2. **Insurance reimbursement.** All insurance and legal reimbursement companies can request current medical records validating treatment of their client. These records should include SOAP notes, chart notes, and client intake forms and must be submitted upon request.
3. **Keeping up-to-date.** Maintaining and reviewing client treatment records can keep you up-to-date on a client's condition and assist in subsequent treatments.
4. **Tracking and trends.** If you monitor client intake forms, several items can help you

determine business trends. For example, information such as the number of new clients per month, the average number of sessions, the types of conditions being treated, and the number of out-calls can assist you in developing business plans.

5. **Marketing.** Looking for trends in where your clients are coming from may help you to determine what type of advertising is effective and can help you determine the best marketing plan.

6. **Liability.** In cases in which problems may occur, proper documentation of each visit can be to your advantage. Treatment information, including any record of physician contact, may prove helpful to you as well as the client if needed in litigation.

Legal and Ethical Parameters

First and foremost, it is the duty and responsibility of the practitioner to follow all policies, procedures, guidelines, regulations, codes, requirements, and laws regarding the practice and business of massage therapy as required by national, state, and local governing bodies. This includes understanding the scope of practice for massage therapy as well as for other related health care professions. As covered in Chapter 48, all massage therapists must:

- Represent their qualifications honestly, including their educational achievements and professional affiliations, and provide only those services that they are qualified to perform

- Accurately inform clients, other health care practitioners, and the public of the scope and limitations of their discipline

- Acknowledge the limitations of and contraindications for massage and bodywork and refer clients to appropriate health care professionals

- Consistently maintain and improve professional knowledge and competence by striving for excellence through regular assessment of personal and professional strengths and weaknesses as well as continued educational training

Professionalism

To achieve true professionalism, it is best to enhance your overall appearance, environment, and attitude to promote a sense of confidence, sincerity, and compassion, but only if that is part of your true nature. A wise man once said, "You can go on charm for about 15 minutes, then you had better know something."

Character

As stated by Lynn Lund, "Character is what you are willing to do when no one can see you and no one will find out." It is who you are and what you stand for. Webster's dictionary defines character as "the total of qualities making up an individual; moral excellence."

Ethics

Webster's dictionary defines ethics as "morals or moral principles; distinction between right and wrong; moral duty and obligations to the community." Standards for ethical behavior are generally provided by local licensing laws and professional organizations. Above all, ethical behavior as defined by the standards of the massage industry includes providing a safe environment, ensuring privacy and respect for the client, being honest in

business practices, exhibiting responsible behavior, and working within the scope of practice. It is also crucial to promote fair and equitable treatment for each client and to reject any immoral or indecent behavior. Always abide by the laws governing massage therapy in your local political division (i.e., city, county, or state).

Integrity

Webster's dictionary defines integrity as "the state of being entire; wholeness; probity; honesty; uprightness." Integrity also includes keeping commitments, being true to your values, and being honest with yourself.

Image

Who you are is portrayed constantly in how you look, act, and communicate. It is also demonstrated in your naturally chosen environments. The best way to portray the attitude of professionalism in business is through neatness, organization, and respect.

Communication

The ability to communicate can be one of the greatest attributes of any business person. It must be done with courtesy, respect, and empathy. The most important component of communication is listening (see Chapter 42).

Practice Questions

Professional Standards, Ethics, and Business Practices

1. What is the importance of maintaining SOAP notes for each client session?
 A. To monitor the progress of the client
 B. To stay within legal parameters
 C. To provide diagnostic information to the client's doctor
 D. For liability insurance requirements

2. Who is required to submit a Schedule C tax statement to the IRS?
 A. Contracted employees
 B. Sole proprietor businesses
 C. Corporations
 D. Partnerships

3. How does continuing education support professional ethics?
 A. It promotes business
 B. It tests commitment to massage therapy
 C. It is required for membership in professional organizations
 D. It promotes a higher standard in the profession

4. For proper hygiene, massage therapists should wash their hands:
 A. before each session
 B. after each session
 C. before and after each session
 D. whenever needed

5. The initials "DC" after an individual's name are used to indicate a:
 A. dietary clinician
 B. dietary counselor
 C. doctor of chiropractic
 D. doctor of cardiology

6. Which of the following statements in the code of ethics is generally used and accepted in the massage profession?
 A. Inform clients, other health care practitioners, and the public of the scope and limitations of your discipline
 B. Insure yourself with over one million dollars in liability insurance
 C. Provide treatment only when there is reasonable expectation that it will be advantageous to the therapist
 D. Conduct your business and professional activities according to strict business procedures

7. Which of the following is a year-end wage and tax statement submitted with an individual's tax return for independent contractor wages in excess of $600?
 A. 1099 form
 B. I-9 form
 C. 1040ES form
 D. W-2 form

8. Which of the following provides protection against potential lawsuits involving malpractice?
 A. State licensing
 B. Schedule C taxes
 C. K-1 form
 D. Liability insurance

9. Which of the following is a good reason to keep client records and files?
 A. Tax purposes
 B. Marketing purposes
 C. Liability

10. Which of the following is a medical doctor who specializes in the diagnosis and treatment of mental disorders and diseases?
 A. Psychiatrist
 B. Psychologist
 C. Orthopedist
 D. Naturopath

11. Which of the following tax forms is filed by self-employed individuals?
 A. W-2
 B. 1040
 C. 1065
 D. 1040ES

12. Which of the following standards goes against the code of ethics generally accepted within the massage profession?
 A. Refusing to treat any person or part of the body for reasonable cause
 B. Refusing any gratuities that are intended to influence a treatment for personal gain and not for the good of the client
 C. Discriminating against clients or other health care professionals
 D. Avoiding any activity that might be in conflict with the ability to act in the best interests of the profession

13. Prior to treatment, who can provide consent for a minor?
 A. A friend
 B. Any relative
 C. A legal guardian
 D. Any adult

14. Which of the following professions typically uses mobilization, exercise, range of motion work, gait training, weight training, and other rehabilitation techniques to promote restoration of normal body movement after injury, surgery, or illness?
 A. Medical doctor
 B. Physical therapist
 C. Dietician
 D. Occupational therapist

15. In which of the following situations would it be inappropriate to disclose confidential client information?
 A. At the request of the client's physician
 B. At the request of the client's insurance company
 C. When requested by the IRS
 D. When required by court order

Part V
Practice Examination

1. All effleurage strokes should be applied in which manner?
 A. Vigorous, cross-fiber movements
 B. Centripetal or toward the heart
 C. Centrifugal or away from the heart
 D. Counterclockwise, circular movements

2. The technique of kneading is performed in which manner?
 A. Tapping the fingertips on the surface of the skin
 B. Sliding the hands rapidly over the skin
 C. Lifting, grasping, rolling, and compressing muscles
 D. Pressing over the muscle tissue lightly but firmly

3. Proper draping is an important part of good, professional business ethics because it:
 A. ensures the client's privacy and comfort
 B. is an important marketing tool
 C. makes it easier to deal with difficult people
 D. promotes oil and lotion absorption

4. If a new client refuses to fill out an intake form, what action should be taken?
 A. Diplomatically refuse to work on the client until the form is filled out
 B. Reschedule the appointment and have the client fill out the form at home
 C. Ask as many questions as necessary, and if the client gives enough information, proceed with the massage
 D. Proceed with the massage and have the client fill out the form later

5. Range of motion is determined by:
 A. assessing joint movement
 B. palpating the joint
 C. using myofascial techniques
 D. using any form of stretching

6. What hormone does the pineal gland produce?
 A. Melatonin
 B. Prolactin
 C. Oxytocin
 D. Epinephrine

7. The mitral valve is also known as the:
A. aortic semilunar valve
B. pulmonary semilunar valve
C. bicuspid valve
D. tricuspid valve

8. Warts are a:
A. contagious infection of the epidermal layer of the skin
B. noncontagious infection of the epidermal layer of the skin
C. contagious infection of the subcutaneous layer of the skin
D. noncontagious infection of the subcutaneous layer of the skin

9. What causes poliomyelitis?
A. Viral infection
B. Bacterial infection
C. Autoimmune disorder
D. Genetic defect

10. Diabetes characterized by a deficiency of insulin due to lack of insulin production by the beta cells of the pancreas is called:
A. type 1 diabetes mellitus
B. type 2 diabetes mellitus
C. diabetes insipidus

11. In Oriental medicine, which of the following meridians is NOT paired?
A. Triple heater
B. Large intestine
C. Bladder
D. Conception vessel

12. The 1099 tax form is a statement used to notify the IRS of:
A. independent contractor wages
B. estimated quarterly taxes
C. business partnership taxes
D. employee wages

13. Which of the following conditions violates the code of ethics generally accepted by massage therapists?
A. Receiving gratuities
B. Dating a client
C. Being politically active
D. Being an independent contractor

14. Which of the following is a mechanical effect of massage?
A. Breaking down adhesions
B. Increasing cell metabolism
C. Reducing pain
D. Reducing nervous stress

15. Many of the medical terms used today take their origins from which of the following languages?
A. English and Greek
B. English and French
C. Greek and Latin
D. German and English

16. Your client arrives complaining of acute whiplash symptoms that are the result of a car accident the day before. The client thinks massage will help. What is the most appropriate course of action?
 A. Do not do any deep work, but light massage could help
 B. Use neuromuscular techniques for the cervical area
 C. Work the area with cross-fiber friction to reduce adhesions that might develop
 D. Refer the client to a doctor and reschedule

17. Massage can reduce pain by:
 A. reducing the cause behind pain stimulation
 B. affecting the processing of noxious stimulation
 C. reducing inflammation due to pain impulse
 D. promoting relaxation of stressed tissues

18. A birthmark or mole is called a:
 A. nevus
 B. papule
 C. blister
 D. vesicle

19. A thrombus is:
 A. a stationary blood clot
 B. a free-floating blood clot
 C. an area of tissue deficient in blood supply
 D. a swollen vein caused by an abnormal accumulation of blood

20. When rolling a bowling ball forward, the primary movement of the shoulder joint is:
 A. flexion
 B. extension
 C. abduction
 D. adduction

21. Standing on the tips of the toes is a movement that requires the ankle joint to go through:
 A. dorsiflexion
 B. plantar flexion
 C. eversion
 D. inversion

22. During an eccentric contraction, the muscle:
 A. contracts and shortens
 B. contracts and lengthens
 C. contracts but does not change length
 D. contracts as a result of reflex activation

23. Which of the following is NOT a function of the kidneys?
 A. Excretion of waste products in the urine
 B. Acid–base balance
 C. Maintenance of water balance
 D. Production of epinephrine

24. Sperm cells are carried from the testes to the prostate gland via the:
 A. vas deferens (ductus deferens)
 B. epididymis
 C. bulbourethral gland
 D. seminiferous tubules

25. The brachial plexus involves nerve roots:
 A. C1 to C7
 B. C5 to C8
 C. C5 to T1
 D. C2 to C8

26. An injury in which a tendon is partially torn is called:
 A. a sprain
 B. myalgia
 C. a strain
 D. gout

27. Carpal tunnel syndrome results from compression on the:
 A. median nerve
 B. radial nerve
 C. ulnar nerve
 D. peroneal nerve

28. An ulceration in the mucosal lining of the stomach or duodenum is called:
 A. a peptic ulcer
 B. a diverticula
 C. an aphthous ulcer
 D. a polyp

29. Which of the following conditions is characterized by softening of the bone and is called rickets in young children?
 A. Osteomalacia
 B. Osteomyelitis
 C. Osteogenesis imperfecta
 D. Osteoporosis

30. Which of the following statements concerning the purpose of gliding is NOT correct?
 A. It stretches deep muscles and fascia
 B. It is used to determine the client's pain tolerance
 C. It is used to evaluate the soft tissues
 D. It enhances venous blood and lymph flow

31. Which lever system is good for generating power but poor for generating speed?
 A. First-class lever system
 B. Second-class lever system
 C. Third-class lever system
 D. Fourth-class lever system

32. The natural pain controllers produced in the brain are called:
 A. analgesics
 B. endorphins
 C. interferential impulses
 D. polypeptides

33. Which of the following statements describes the primary use of friction?
 A. It is used to work the tissue around joint spaces and bony prominences
 B. It is often beneficial in postevent sports massage
 C. It is the primary stroke used to reestablish circulation
 D. It is only applied perpendicular to the muscle fibers

34. In which of the following conditions is massage indicated?
A. Abnormal lumps
B. Fever
C. Acute inflammation
D. Wryneck

35. Which of the following statements describes passive joint movement?
A. Joint movement that occurs when the client contracts involved muscles
B. The client performs a movement with the assistance of the therapist
C. The client relaxes and the therapist performs a movement or stretch
D. Joint movement with no resistance

36. Rotation of the head as far as possible to the left is an example of:
A. passive movement
B. active resistive movement
C. active movement
D. proprioceptive neuromuscular facilitation

37. Deep transverse friction does NOT:
A. broaden fibrous muscle tissue
B. break down adhesions
C. restore mobility
D. promote circulation

38. What is the definition of professional ethics?
A. The ability to successfully work with others and provide excellent service
B. The ability to interact successfully with many personality types
C. Promotion of public welfare, the client's welfare, and the reputation of the profession
D. Promotion of the legal and business standards of the profession

39. Which of the following statements describes cross-fiber friction?
A. Deep tissue work into muscle fibers
B. Light, rapid strokes along the muscle fiber
C. Oscillating movements across muscle fibers
D. Rapid strokes across multiple muscle groups

40. Static stretching is defined as:
A. gently stretching a muscle until resistance is met and holding it for 10 to 20 seconds
B. stretching a muscle 1 inch into the resistance and then holding it for a short period
C. stretching in which a bounce or bobbing forces tissue to release
D. vigorously stretching with the aid of another person

41. A therapist's body mechanics are extremely important in preventing injury, fatigue, and strain. Which of the following positions demonstrates good body mechanics?
A. Keep the knees bent and back straight
B. Keep the feet and knees close together and bend at the waist
C. Arms should stay close to the body while shoulders and wrists are extended
D. Balance on both feet and lean over, using the torso for balance

42. In Oriental medicine, which meridian runs up the middle of the spine?
A. Conception vessel
B. Liver
C. Governing vessel
D. Bladder

43. Bodywork of which muscle or group of muscles is effective in relieving sciatica?
 A. Hamstring muscles
 B. Quadratus lumborum muscle
 C. Quadricep muscles
 D. Gluteus muscles

44. What is the primary description and cause of tennis elbow?
 A. Tendonitis caused by impact trauma
 B. Ligament tear caused by a hyperextension strain
 C. Dislocation caused by a hyperabduction strain
 D. Fracture caused by chronic impact vibration

45. An individual with a hip replacement should avoid:
 A. abduction of the hip
 B. adduction of the hip
 C. flexion of the hip
 D. extension of the hip

46. Which of the following techniques is effective in the rehabilitation of a postacute anterior cruciate ligament tear?
 A. Cross-fiber friction and proprioceptive neuromuscular facilitation of the knee joint
 B. Trigger-point therapy on the sacroiliac joint
 C. Slow range of motion stretching of the ankle
 D. Deep tissue work on the quadricep muscles

47. The condition that develops when the placenta separates prematurely from the wall of the uterus is called:
 A. placenta previa
 B. abruptio placentae
 C. ectopic pregnancy
 D. radical mastectomy

48. Neuritis of cranial nerve VII usually causes paralysis to one side of the face and is called:
 A. Bell's palsy
 B. sciatica
 C. carpal tunnel syndrome
 D. referred pain

49. Deficiency of dietary iodine results in the development of:
 A. Cushing's disease
 B. diabetes mellitus
 C. a goiter
 D. myxedema

50. Muscular dystrophy is:
 A. a group of muscular disorders in which there is considerable muscle degeneration and weakness
 B. a disorder characterized by abnormal patterns of sleep, diffuse muscle pain and fatigue, headaches, and an irritable bowel
 C. characterized by spontaneous, involuntary muscle contractions
 D. characterized by destruction of acetylcholine receptors in the neuromuscular junction

51. A greenstick fracture occurs when:
 A. a bone is incompletely broken
 B. a broken portion of a bone is pushed into the bone
 C. a bone is twisted along its long axis and broken
 D. a bone is broken completely and protrudes through the skin

52. Blood traveling from the common iliac artery to the femoral artery must first pass through the:
 A. popliteal artery
 B. basilar artery
 C. external iliac artery
 D. peroneal artery

53. The outer white layer of the eye is called the:
 A. iris
 B. cornea
 C. conjunctiva
 D. sclera

54. Blood traveling from the subclavian artery to the brachial artery must pass through the:
 A. basilar artery
 B. deep brachial artery
 C. axillary artery
 D. cephalic artery

55. Which of the following is a rounded bump on a bone that is used for articulation?
 A. Condyle
 B. Epicondyle
 C. Crest
 D. Tubercle

56. Which of the following structures within the muscle provide information about the length or change in length of the muscle?
 A. Olfactory cells
 B. Golgi tendon organs
 C. Hair cells
 D. Muscle spindles

57. What muscles contract to produce upward rotation of the scapula?
 A. Lower trapezius and pectoralis minor muscles
 B. Upper trapezius and levator scapulae muscles
 C. Upper trapezius, lower trapezius, and serratus anterior muscles
 D. Levator scapulae, rhomboid (major and minor), and pectoralis minor muscles

58. Which muscle or muscle group helps to invert the ankle?
 A. Peroneal muscles
 B. Anterior tibial muscle
 C. Popliteal muscle
 D. Plantar muscle

59. The cells that support and protect the neurons in the central and peripheral nervous systems are called:
A. dendrites
B. gyri
C. pia mater
D. neuroglia

60. The squamous suture separates the:
A. two parietal bones
B. parietal and frontal bones
C. parietal and occipital bones
D. temporal and parietal bones

61. Highly vascular membranes that surround the inside of the joint capsule are called:
A. mucous membranes
B. epithelial membranes
C. serous membranes
D. synovial membranes

62. Which of the following is the pigment found in the epidermis of the skin?
A. Keratin
B. Myelin
C. Melanin
D. Periosteum

63. According to Dr. Hans Selye, what is the definition of stress?
A. Physical exertion beyond normal function
B. Mental or physical overload
C. The nonspecific response of the body to any demand
D. The body against itself

64. In American and European massage concepts, primary strokes should be applied as:
A. centripetal movements
B. centrifugal movements
C. repetitious movements
D. continuous movements

65. If a client experiences pain when laterally abducting the humerus, which muscle involved initiates the movement?
A. Trapezius muscle
B. Anterior scalene muscle
C. Deltoid muscle
D. Supraspinous muscle

66. If a condition is contraindicated, it is a condition that:
A. is acceptable for massage
B. makes massage inadvisable
C. requires medication
D. requires medical attention

67. Each person's reaction to pain is:
A. different
B. exactly the same
C. uncontrollable
D. very similar

68. For a sole proprietor of a business, when is it necessary to use the Schedule SE form?
 A. Quarterly estimated tax
 B. Year-end tax return
 C. Semiannual tax return
 D. Only when showing a loss for the year

69. Which of the following statements is true regarding the precautions that must be taken for a pregnant woman?
 A. Do not perform deep tissue work or abdominal kneading and do not lay the client flat on her back without proper cushions
 B. Any massage techniques may be used as long as the client is laying on her side and is comfortable
 C. Do not use effleurage strokes or heavy pressure on the abdomen
 D. The contraindications are the same as for all clients, just do not lay the client on her stomach

70. Local application of cold for acute pain, sprains, and trauma provides:
 A. an anticoagulant effect
 B. a numbing, analgesic effect
 C. a protective, inflammatory effect
 D. a consensual, reflexive effect

71. If a client with psoriasis requests a massage:
 A. wash the area with antibacterial soap and then proceed with the massage
 B. diplomatically explain that it is contagious and refer the client to a doctor
 C. complete the massage but avoid the affected area
 D. reschedule the massage until the client receives a doctor's approval

72. If a client with phlebitis requests a massage:
 A. complete the massage with caution and work lightly over the affected area
 B. refer the client to a doctor for approval and reschedule
 C. proceed with the massage but avoid the affected area
 D. proceed with the massage as usual; the condition is not a problem

73. Which of the following benefits is attributed to gliding?
 A. Promotes muscle tonus
 B. Stimulates muscular metabolism
 C. Improves blood and lymph circulation
 D. Breaks up deep fascial adhesions

74. What is the appropriate way to handle a client with impetigo?
 A. Clean the affected area with alcohol and proceed with the massage
 B. Avoid the affected area and complete the massage
 C. Proceed with the massage and explain how the client can treat the area
 D. Diplomatically explain the situation, refer the client to a doctor, and reschedule

75. Which of the following conditions is considered the leading cause of low back pain?
 A. Overworked upper back
 B. Weak abdominal muscles
 C. Stressed gluteal muscles
 D. Knee problems

76. What anatomical structure on the anterior neck should be avoided during a massage?
 A. Nerves of the brachial plexus
 B. Internal jugular vein
 C. Subclavian artery
 D. Sternocleidomastoid muscle

77. When massaging around the sartorius and adductor longus muscles, what anatomical structure should be avoided?
 A. Femoral artery
 B. Brachial plexus
 C. Subclavian artery
 D. Popliteal artery

78. While massaging a client, you notice a large, dark mole on his back that has suddenly changed in size and appearance in the last few visits. What is the best course of action?
 A. Tell the client that it might be cancerous and send him to a doctor immediately
 B. Proceed with the massage but avoid the area
 C. Diplomatically refer him to a doctor and reschedule
 D. Do a complete massage because moles are not contagious

79. Which of the following statements concerning varicose veins is INCORRECT?
 A. Varicose veins are enlarged and protruding as a result of prolonged back pressure
 B. Massage is beneficial if done proximal to the area
 C. Massage is not contraindicated as long as it is light
 D. Varicose veins occur mainly in the superficial leg veins

80. Which of the following muscles does NOT help flex the hip?
 A. Rectus femoris muscle
 B. Sartorius muscle
 C. Iliopsoas muscle
 D. Semimembranosus muscle

81. Which of the following is NOT one of the meninges?
 A. Arachnoid membrane
 B. Parietal pleura
 C. Dura mater
 D. Pia mater

82. What specialized center is located in the temporal lobe of the brain?
 A. Visual center
 B. Sensory cortex (general sensory control for the body)
 C. Auditory center
 D. Motor cortex

83. An individual with type B Rh-positive blood can donate blood to an individual with which of the following blood types?
 A. O Rh-positive, O Rh-negative, B Rh-positive, or B Rh-negative
 B. B Rh-positive, B Rh-negative, AB Rh-positive, or AB Rh-negative
 C. B Rh-positive, A Rh-positive, AB Rh-positive, or O Rh-positive
 D. B Rh-positive or AB Rh-positive

84. Immunity developed after coming in contact with the disease is called:
 A. active naturally acquired immunity
 B. passive naturally acquired immunity
 C. active artificially acquired immunity
 D. passive artificially acquired immunity

85. A median hernia is a herniation through the:
 A. linea alba
 B. diaphragm
 C. inguinal ligament
 D. femoral canal

86. Lou Gehrig's disease is:
 A. a disease characterized by loss of motor neurons that results in skeletal muscle weakness
 B. a progressive disease involving demyelination of the neurons in the central nervous system
 C. failure of the vertebral arch to close during early fetal development
 D. a viral infection of the coverings around the brain

87. A heart murmur can be defined as:
 A. an abnormal or irregular heartbeat
 B. inflammation of heart tissue
 C. the sound heard when blood escapes through a leaky valve of the heart
 D. uncoordinated contractions of the atria and ventricles due to damage to the conduction system in the heart

88. Partial dislocation of a bone from its joint is called:
 A. a strain
 B. subluxation
 C. atrophy
 D. dislocation

89. Hypersecretion of thyroid hormones that leads to weight loss, nervousness, diarrhea, tachycardia, and insomnia is called:
 A. Cushing's disease
 B. cretinism
 C. myxedema
 D. Graves' disease

90. An individual who smokes a lot is likely to develop:
 A. hyaline membrane disease
 B. emphysema
 C. apnea
 D. tuberculosis

91. An individual with myopia:
 A. is nearsighted
 B. is farsighted
 C. has crossed eyes
 D. has divergent eyes

92. Kyphosis is usually:
 A. an extreme or exaggerated curvature of the thoracic spine
 B. an extreme or exaggerated curvature of the lumbar spine
 C. an extreme or exaggerated curvature of the cervical spine
 D. a lateral curvature of the spine

93. Which of the following diseases is contagious?
 A. Muscular dystrophy
 B. Multiple sclerosis
 C. Glaucoma
 D. Impetigo

94. Which of the following immune cells are specialized lymphocytes that convert to plasma cells to produce antibodies?
 A. Immunoglobulins
 B. B cells
 C. Leukocytes
 D. T helper cells

95. An increase in cerebrospinal fluid that surrounds the brain is properly called:
 A. encephalitis
 B. meningitis
 C. hydrocephalus
 D. myelitis

96. In which of the following conditions is massage usually indicated?
 A. Postacute bursitis
 B. Acute whiplash
 C. Arteriosclerosis
 D. Rickets

97. In which of the following conditions is it important to receive a doctor's approval before giving a massage?
 A. Circulatory problems
 B. Carcinoma
 C. Chronic fatigue syndrome
 D. Bell's palsy

98. In which of the following areas should tapotement be avoided?
 A. Inferior gluteal area
 B. Upper lumbar muscles, inferior to the ribs
 C. Posterior area of the lower limbs
 D. Posterior thoracic area

99. When working with an injured limb, it is appropriate to massage:
 A. distal to the injury
 B. proximal to the injury
 C. over the injury
 D. inferior to the injury

100. Which area of the upper extremities should be avoided during a massage?
 A. Popliteal fossa
 B. Medial brachium
 C. Inguinal ligament
 D. Vagus nerve

101. Which of the following techniques is most beneficial for a client with edema who has a doctor's approval for massage?
 A. Tapotement
 B. Pétrissage
 C. Fast, rhythmic gliding
 D. Slow, rhythmic effleurage

102. For IRS purposes, which of the following forms is used by the sole proprietor of a business as a year-end profit and loss statement?
 A. 1099
 B. Schedule SE
 C. Schedule C
 D. Schedule K-1

103. What is the recommended technique for fibromyalgia?
 A. Kneading
 B. Light vibration
 C. Percussion
 D. Effleurage

104. Which of the following techniques is recommended to increase circulation in an amputee's stump?
 A. Vibration
 B. Tapotement
 C. Friction
 D. Gliding

105. A client with high blood pressure has received a recommendation from her doctor for massage. Which of the following techniques would be most effective for this client?
 A. Vibration
 B. Pétrissage
 C. Deep effleurage
 D. Slow gliding

106. Which anatomical structures are NOT involved in the femoral triangle?
 A. Sartorius muscle, adductor longus muscle, and inguinal ligament
 B. Femoral nerve, artery, and vein
 C. Great saphenous vein and inguinal lymph nodes
 D. Basilic vein and axillary lymph nodes

107. Effleurage can be described as:
 A. vigorous kneading
 B. long, flowing strokes
 C. deep, circular movements
 D. repetitive percussive movements

108. A client complains of being extremely fatigued and having a low-grade fever. He feels that a massage would help. What is the most appropriate course of action?
 A. Perform a relaxing Swedish massage
 B. Question the client to determine a cause and then create a treatment plan
 C. Get additional information and then proceed with the massage
 D. Explain the need to reschedule and refer the client to his doctor

109. What anatomical structure in the popliteal fossa would be cause for avoiding massage of the area?
 A. Great saphenous nerve
 B. Brachiocephalic vein
 C. Musculocutaneous nerve
 D. Tibial nerve

110. A client comes in with an inflamed, painful elbow. She requests that you pay special attention to the elbow during the massage. What is the best course of action?
 A. Proceed with the massage as requested
 B. Avoid the elbow but work proximal to it and work reflex areas
 C. Palpate the elbow, determine the extent of the pain, and then determine treatment
 D. Work only on the elbow area and reschedule for a full-body massage

111. An elderly woman who is small and stooped in posture is referred to you for help with her back pain. What is the most appropriate course of action?
 A. Assist her onto the table and give a full-body Swedish massage
 B. Use compression and cross-fiber work primarily on her low back
 C. Seek her doctor's advice before doing a light massage
 D. Find out if she has osteoporosis; if she does have osteoporosis do not work on her

112. A regular client indicates that she is under a doctor's care for a kidney problem. You notice that she has puffy ankles. What is the most appropriate course of action?
 A. Press a finger into the area to check for edema; if no edema then proceed with the massage
 B. Do only a light, full-body effleurage treatment for relaxation
 C. Proceed with the massage if the client feels okay
 D. Press a finger into the area to check for edema; if edema is present refer the client to her doctor

113. A client claims that he is suffering from chronic fatigue. What is the most appropriate course of action?
 A. Perform a light massage to promote rest and relaxation
 B. Perform a vigorous massage to promote circulation
 C. Do not perform massage; it is contraindicated
 D. Refer the client to his doctor before any massage

114. Massage is contraindicated in cases of intoxication because:
 A. it is hard to keep the client still and focused
 B. massage can spread toxins and overwork the liver
 C. the client has a decreased sensitivity to pain
 D. massage can overwork the circulatory system

115. When massage is part of treatment for a cancer patient, what is the main concern that must be addressed during the massage?
 A. Emotional state of the client
 B. Type of therapy that would be most appropriate
 C. Advice of the attending physician
 D. Length of the massage treatment

116. Any imprudent action, failure to act properly, or failure to take reasonable precautions is known as:
 A. irresponsible behavior
 B. negligence
 C. carelessness
 D. cognizant performance

117. What is done first if a client is in a supine position and complains of low back pain?
A. Have the client turn onto the side and work the low back first
B. Have the client breathe and visualize to alleviate the pain
C. Place cushions or pillows under the client's knees
D. Discontinue the massage and refer the client to a doctor

118. Which of the following massage styles is most appropriate for a client with asthma?
A. Deep and relaxing
B. Superficial and relaxing
C. Vigorous and stimulating
D. None; massage is contraindicated

119. Deficiency or malabsorption of vitamin B_{12} results in:
A. hemorrhagic anemia
B. sickle cell anemia
C. aplastic anemia
D. pernicious anemia

120. Muscles that are increasing in size are undergoing:
A. atrophy
B. hypertrophy
C. subluxation
D. degeneration

121. A fibroid is:
A. a benign tumor of the smooth muscle in the uterus
B. an accumulation of air in the pleural space around the lung
C. a blocked tear duct in the eye
D. a skin tumor

122. Coarctation of the aorta is described as:
A. inflammation of the aorta
B. a bulge in the aorta
C. an area of necrotic tissue in the aorta
D. localized narrowing of the aorta

123. When the brachial plexus or subclavian artery becomes compressed as it passes through the anterior and middle scalene muscles and under the clavicle and pectoralis minor muscle it creates the condition known as:
A. carpal tunnel syndrome
B. thoracic outlet syndrome
C. sciatica
D. Bell's palsy

124. Failure of the palatine processes of the maxilla bones to fuse during fetal development results in:
A. osteitis deformans
B. cleft palate
C. Osgood-Schlatter disease
D. myasthenia gravis

125. What causes cystic fibrosis?
A. Infection
B. Radiation exposure
C. Poor diet
D. Genetics

126. The term holistic is defined as:
 A. a form of alternative medicine
 B. an energetic concept of health
 C. the functional relation between parts and wholes
 D. the blending of Eastern and Western concepts

127. Which of the following techniques is unacceptable for a client with anemia?
 A. Deep effleurage
 B. Light gliding
 C. Tapotement
 D. Light pétrissage

128. Hypertension is another term for:
 A. stress
 B. high blood pressure
 C. muscular strain
 D. myocardial infarction

129. A client reports that she is currently on prescription medication. What is the most appropriate course of action?
 A. Do not proceed with the massage; it is contraindicated
 B. Research the condition; check with the client's doctor if needed
 C. Research the condition and proceed with a light massage
 D. Proceed as usual; medications are not a problem

130. Slight pressure on the carotid artery, similar to the pressure applied when wearing a tie, can cause which of the following conditions?
 A. Eye strain
 B. Headache
 C. Stress
 D. Fatigue

131. Which of the following groups of people are most prone to osteoporosis?
 A. Middle-aged men
 B. Postmenopausal women
 C. Paraplegics
 D. Postsurgery patients

132. Which of the following terms is the technical name for a heart attack?
 A. Myocardial infarction
 B. Hypertension
 C. Ischemic heart condition
 D. Ecchymosis

133. Which of the following treatments is appropriate for a client with a hematoma?
 A. Light massage over the area
 B. Massage distal to the area
 C. Deep tissue massage to break it up
 D. Normal massage, but avoid the area

134. A new client indicates on the intake form that he is HIV positive. What is the most appropriate course of action?
 A. Diplomatically refuse treatment because massage is contraindicated
 B. Obtain approval from the client's doctor and follow universal precautions
 C. Do only light massage or energy work
 D. Perform Swedish massage following universal precautions

135. Which of the following is considered a psychologic benefit of massage?
 A. Increased cellular metabolism
 B. Relief of stress
 C. Promotion of homeostasis
 D. Improved pH balance

136. Water is the best medium for hydrotherapy because:
 A. it can be used in solid, liquid, and vapor forms
 B. it can be used in a hot or cold state
 C. it is the best medium for heat conduction
 D. the body responds well to water

137. Only light work is appropriate for clients with osteoporosis because these clients:
 A. are elderly
 B. have brittle bones
 C. have cancer
 D. have flexible bones

138. In the case of a pregnant client, in which of the following conditions is massage contraindicated?
 A. Lumbar pain
 B. Toxemia
 C. Edema
 D. Constipation

139. Which of the following effects is a primary benefit of pétrissage?
 A. It can promote improved muscle tonus
 B. It revitalizes dry skin by promoting circulation
 C. It increases innervation of the afferent nerves
 D. It soothes and relaxes superficial muscles

140. Hydrotherapy can be used to influence visceral function by:
 A. applying heat or cold as close to the organ as possible
 B. using a salt rub to increase circulation to the organ
 C. applying heat or cold to the skin related reflexively to the organ
 D. performing massage while the hydrotherapy is applied

141. The letter "S" in the acronym "SOAP" stands for:
 A. subjective
 B. symptom
 C. syndrome
 D. schedule

142. Which stance is most efficient during a massage?
 A. Straight legs
 B. Seated
 C. Leaning over
 D. Bent knees

143. Which of the following is NOT a general effect of heat?
 A. Dilation of the peripheral blood vessels
 B. Increased rate of blood flow
 C. Increased pulse rate
 D. Decreased metabolic activity

144. Which of the following modalities uses applied kinesiology?
 A. Therapeutic touch
 B. Tellington touch
 C. Touch for health
 D. Trager

145. What is the primary type of heat transference used in hydrotherapy?
 A. Current
 B. Convection
 C. Conversion
 D. Conduction

146. A friend has just suffered a serious ankle injury. What should you do?
 A. Help your friend put weight on it to determine if it is broken
 B. Wait 48 hours, then apply heat for 20 minutes four times a day for pain relief
 C. Use ice, compression, and elevation immediately and then get medical help
 D. Recommend that your friend take an analgesic for relief of pain and inflammation

147. When using alternating hot and cold hydrotherapy:
 A. the maximum effect can be achieved by using short, intense alternating applications of equal length
 B. caution must be used to ensure that total therapy lasts no more than 10 minutes
 C. reflexively related organs can be suppressed in their functions
 D. the greatest benefit is achieved within the first 48 hours after an injury

148. In Oriental medicine, which meridian runs down the body and ends at the second toe?
 A. Stomach
 B. Spleen
 C. Bladder
 D. Gallbladder

149. Which of the following stretching techniques is no longer recommended?
 A. Static stretching
 B. Ballistic stretching
 C. Reciprocal inhibition stretching
 D. Strain–counterstrain stretching

150. In which anatomical areas are pain receptors least common?
 A. Skin
 B. Arterial walls
 C. Joint surfaces
 D. Organs and deep tissues

151. A code of ethics can be defined as:
 A. moral beliefs
 B. governing laws
 C. universal truth
 D. business practices

152. Which of the following diseases is contagious?
 A. Emphysema
 B. Impetigo
 C. Asthma
 D. Eczema

153. A massage therapist who works in a hospital and is frequently exposed to blood and other body fluids is most likely to contract:
A. hepatitis A
B. hepatitis B
C. sickle cell anemia
D. hemophilia

154. Which of the following conditions is a noncontagious skin disorder characterized by silvery, plaque-like scales on the scalp and boney prominences?
A. Lupus erythematosus
B. Scleroderma
C. Psoriasis
D. Decubitus ulcer

155. What causes rickets in young children?
A. Lack of vitamin D
B. Lack of calcium
C. Bone infection
D. Unknown

156. Which ligament connects the distal fibula with the talus?
A. Medial collateral ligament
B. Transverse carpal ligament
C. Nuchal ligament
D. Anterior talofibular ligament

157. Where does the gluteus medius muscle insert?
A. Greater trochanter
B. Medial epicondyle
C. Olecranon process
D. Linea aspera

158. Which lobe of the brain contains the motor cortex?
A. Occipital
B. Frontal
C. Parietal
D. Temporal

159. Which of the following muscles helps to flex the shoulder joint?
A. Brachioradial muscle
B. Anterior deltoid muscle
C. Infraspinous muscle
D. Brachial muscle

160. The wave-like movement of the digestive tract is called:
A. mesentery
B. eccentric contractions
C. peristalsis
D. serosa

161. According to the IRS, which of the following items is taxable?
A. Gifts
B. Charitable contributions
C. Barter
D. Supplies

162. Hypercurvature of the lumbar spine is called:
 A. kyphosis
 B. scoliosis
 C. lordosis
 D. spondylolisthesis

163. Visceroptosis is:
 A. a disorder of the eye
 B. distention of the abdomen
 C. inflammation of the viscera
 D. the lining of the abdomen

164. Tapotement is effective in toning muscles because it:
 A. causes the muscles to contract and then relax
 B. reduces the amount of lactic acid in the muscles
 C. breaks up fascial and muscular adhesions
 D. promotes circulation of blood and lymph

165. Which of the following terms describes the condition that results when stress goes beyond the body's normal elastic limits?
 A. Strain
 B. Disease
 C. Distortion
 D. Distention

166. In Oriental medicine, which meridian ends on the fifth finger?
 A. Heart
 B. Small intestine
 C. Triple warmer
 D. Large intestine

167. Which of the following definitions represents the philosophy of yin and yang?
 A. Life is adversity
 B. Dynamic balance in all things
 C. Good and evil
 D. Karma

168. Which of the following massage modalities is considered a nontouch technique?
 A. Polarity
 B. Feldenkrais
 C. Trager
 D. Therapeutic touch

169. When massaging a client with Bell's palsy, what area of the body should be massaged with caution?
 A. Axilla
 B. Posterior triangle of the neck
 C. Femoral triangle
 D. Inferior to the ear

170. Janet Travell and Bonnie Prudden developed:
 A. Esalen massage
 B. myofascial release
 C. neuromuscular therapy
 D. trigger-point therapy

Answer Key

Part I: Human Anatomy, Physiology, and Kinesiology

Multiple Choice Questions

1. C	20. C	39. A	58. A
2. B	21. C	40. A	59. B
3. B	22. A	41. B	60. A
4. B	23. D	42. B	61. B
5. B	24. A	43. C	62. A
6. C	25. B	44. D	63. B
7. D	26. B	45. A	64. B
8. C	27. C	46. C	65. B
9. A	28. A	47. A	66. C
10. C	29. C	48. A	67. D
11. B	30. C	49. A	68. A
12. D	31. A	50. B	69. C
13. A	32. D	51. C	70. C
14. A	33. A	52. A	71. A
15. B	34. C	53. C	72. D
16. B	35. C	54. A	73. D
17. C	36. A	55. A	74. D
18. A	37. D	56. A	75. B
19. D	38. A	57. D	

Matching Questions

1. V	9. X	17. Q	25. F
2. Y	10. T	18. AA	26. FF
3. H	11. EE	19. U	27. N
4. L	12. D	20. B	28. Z
5. W	13. K	21. G	29. O
6. P	14. DD	22. M	30. A
7. BB	15. R	23. E	31. CC
8. I	16. C	24. S	32. J

Fill-in-the-Blank Questions: Muscle Origin and Insertion

1. zygomaticus
2. O. zygomatic arch
3. O. temporal fossa
 I. coronoid process of the temporal bone
4. O. ligamentum nuchae, C7-T3
5. O. manubrium of the sternum, clavicle
 I. mastoid process of temporal bone
6. serratus anterior
7. I. corocoid process of scapula
8. O. C1-C4
 I. sup. medial border of scapula
9. infraspinatus
10. I. middle of medial humeral shaft
11. O. Long head–supraglenoid tubercle
 Short head–coracoid process of scapula
12. I. ulnar tuberosity
13. pronator teres
14. O. above lat. epicondyle of humerus
15. supraspinatus
 I. greater tubercle of humerus
16. O. inferior angle of scapula
 I. medial lip of bicipital groove
17. I. bicipital groove of humerus
18. O. pubic spine
 I. costal cartilages 5, 6, 7
19. O. lower 8 ribs
 I. abdominal aponeurosis, iliac crest
20. quadratus lumborum
21. gluteus medius or gluteus minimus
22. O. anterior sacrum
 I. greater trochanter of femur
23. O. A.I.I.S.
 I. tibial tuberosity
24. O. medial lip of linea aspera
25. O. bodies of lumbar vertebrae
 I. lesser trochanter of femur
26. O. A.S.I.S.
27. I. linea aspera on posterior femur
28. O. pectineal line (on sup. ramus of pubis)
29. O. anterior body of pubis
 I. proximal medial tibial shaft (pes anserinus)
30. biceps femoris
31. O. medial and lateral epicondyles of femur
 I. calcaneus via the tendo calcaneus
32. O. posterior tibia and fibula
 I. calcaneus via the tendo calcaneus
33. tibialis anterior
34. flexor hallicus longus
35. O. upper 2/3 of lateral fibular shaft
 I. base of 1st metatarsal & plantar surface of 1st cuneiform

Review Activities

1. Right atrium → tricuspid valve → right ventricle → pulmonary semilunar valve → pulmonary trunk → pulmonary arteries → lungs → pulmonary veins → left atrium → bicuspid valve → left ventricle → aortic semilunar valve → aorta → body
2. Mouth (oral cavity) → pharynx → esophagus → stomach → duodenum → jejunum → ileum → cecum → ascending colon → transverse colon → descending colon → sigmoid colon → rectum → anus
3. Iliopsoas, pectineus, tensor fascia latae, rectus femoris, sartorius, adductor longus, adductor brevis, adductor magnus
4. Latissimus dorsi, teres major, teres minor, posterior deltoid, infraspinatus, pectoralis major (sternal head), triceps (long head)
5. Biceps femoris, semitendinosus, semimembranosus, sartorius, gracilis, gastrocnemius, plantaris, popliteus
6. Frontal lobe → personality, judgment, planning & speech; contains the motor cortex
 Parietal lobe → determines distances, sizes & shapes; contains the sensory cortex
 Temporal lobe → contains auditory and olfactory centers; memory
 Occipital lobe → contains visual center
 Insula lobe → integrates cerebral activities; may assist in storing memory
7. Cell wall → gives structure; contains cell contents regulates incoming/outgoing substances
 Cytoplasm → fills the cell; contains nutrients and building blocks
 Nucleus → contains genetic material
 Ribosomes → responsible for reading and decoding RNA to synthesize proteins
 Endoplasmic reticulum → collects manufactured proteins then packages and ships them to areas within the cell
 Golgi apparatus → stores, sorts, modifies, and delivers products of the cell that are to be excreted
 Mitochodria → synthesizes/produces ATP
 Lysosome → digests foreign or damaged cells and organelles
 Centriole → supervise cell division by aiding the distribution of DNA into the daughter cells

Index

Note: Page numbers followed by f indicate figures; page numbers followed by t indicate tables. Entries followed by "define" provide the definition only.

A
A-, defined, 98t
Abdomen, as site to avoid during massage, 185
Abdominal aneurysm, contraindications/indications for, 187
Abdominal cavity, described, 3
Abdominal thrust maneuver, for airway obstruction, 219
Abdominopelvic cavity, described, 3
Abducens nerve, 53t
Abduction
 defined, 26
 horizontal, defined, 26
Abruptio placentae, 165
Abuse, substance, contraindications/indications for, 194
Accessory nerve, 53t
Accessory organs, 81–82, 82f
 defined, 79
Accommodation, defined, 55
Accounting, 258
Acetylcholine, defined, 50
Acid(s), defined, 6
Acne, 130
 contraindications/indications for, 187
Acquired immunity, defined, 74
Acquired immunodeficiency syndrome (AIDS), 156
 contraindications/indications for, 190
Acromegaly, 147
Acromioclavicular joint, type of and bones that comprise, 27t
 cromioclavicular ligament, defined, 29
 tin, defined, 31
 ̇ated charcoal, to deactivate poison, 223
 ̇artificially acquired immunity, defined, 74
 ̇ ̇ ̇rally acquired immunity, defined, 74
 ̇ ̇sport, defined, 8

Acupressure, 227
Acute, defined, 125
Ad-, defined, 98t
Addison's disease, 148–149
Adduction
 defined, 26
 horizontal, defined, 26
Adductor brevis muscle, 44t
Adductor longus muscle, 44t
Adductor magnus muscle, 44t
Adeno-, defined, 98t
Adenoid(s), 76
 defined, 73
Adenoma(s), defined, 129
Adenosine triphosphate (ATP), 236, 237f
Adhesion(s), inflammation and, 128
Adipose tissue, defined, 9
Adrenal cortex, defined, 61
Adrenal glands, defined, 60
Adrenal medulla, defined, 61
Adrenaline, defined, 50
Adrenocorticotropic hormone, defined, 59
Adulthood (19 years to 60 years), 122
Aerobe(s), defined, 127
Aerobic metabolic pathway, 237
Afferent arteriole, 85
Afferent (sensory) neuron, defined, 52
Age, as risk factor for disease, 126
Agonist (prime mover), defined, 32, 95
AIDS, 156
 contraindications/indications for, 190
Airway obstruction, first aid for, 219
Albino, 12
Albumin, in urine, 86
Alcohol rub, defined, 216
Aldosterone, defined, 61
Alexander technique, 227
-algia, defined, 98t
Alignment, defined, 184